The Hypercomplex Society

Steve Jones
General Editor

Vol. 5

PETER LANG
New York • Washington, D.C./Baltimore • Bern
Frankfurt am Main • Berlin • Brussels • Vienna • Oxford

Lars Qvortrup

The Hypercomplex Society

PETER LANG
New York • Washington, D.C./Baltimore • Bern
Frankfurt am Main • Berlin • Brussels • Vienna • Oxford

Library of Congress Cataloging-in-Publication Data
Qvortrup, Lars.
The hypercomplex society / Lars Qvortrup.
p. cm. (Digital formations; v. 5)
Includes bibliographical references and index.
1. Information society. I. Title. II. Series.
HM851 .Q86 303.48'33—dc21 2002151167
ISBN 0-8204-5704-3
ISSN 1526-3169

Bibliographic information published by **Die Deutsche Bibliothek.**
Die Deutsche Bibliothek lists this publication in the "Deutsche
Nationalbibliografie"; detailed bibliographic data is available
on the Internet at http://dnb.ddb.de/.

Hotel Pro Forma: *The House of the Double Axe*. 1998.
Photo: Roberto Fortuna
Cover design by Dutton & Sherman Design

The paper in this book meets the guidelines for permanence and durability
of the Committee on Production Guidelines for Book Longevity
of the Council of Library Resources.

© 2003 Peter Lang Publishing, Inc., New York
275 Seventh Avenue, 28th Floor, New York, NY 10001
www.peterlangusa.com

All rights reserved.
Reprint or reproduction, even partially, in all forms such as microfilm,
xerography, microfiche, microcard, and offset strictly prohibited.

Printed in the United States of America

Contents

Introduction vii

Part I—Hypothesis

ONE
The Hypothesis of Hypercomplexity 3

Part II—Frames of Self-Observation

TWO
The Practical Self-Observation of the Hypercomplex Society:
The Cohesive Force of Polycentrism 21

THREE
The Aesthetic Self-Observation of the Hypercomplex Society:
Theocentrism, Anthropocentrism, and Polycentrism 50

FOUR
The Pure Self-Observation of the Hypercomplex Society:
The Emerging Orthodoxy of Paradoxicality 92

Part III—Media of Self-Observation

FIVE
Communication, Media, and Public Opinion
of the Hypercomplex Society 125

SIX
The Communication Medium of the Hypercomplex Society:
The Digital Network 163

SEVEN
The Culture of the Hypercomplex Society 191

Notes 211

Bibliography 217

Index 227

Introduction

In May 1990, I met Professor Daniel Bell at Hotel Newfoundland in Saint John's, Newfoundland. He was the first speaker at the "Bridging the Gap" conference on the so-called information society, and for some reason I was invited as the second speaker. Consequently, we were both staying on the same "executive business floor." My room was next to Daniel Bell's, and we had access to the same "executive" breakfast and service area, with strawberries in addition to coffee and rolls in the morning and champagne at the end of the day.

Before going to the conference I had studied Daniel Bell's major publications, including *The Coming of Post-Industrial Society* and *The Cultural Contradictions of Capitalism*, and, thus prepared, I spent two wonderful days in discussion with Professor Bell. However, although filled with inspiration, I also felt that there was something not totally satisfactory in the theory of the postindustrial society. Thus, on my way back to Denmark I decided to write a publication that would answer two of the problematics posed by Daniel Bell's theory. First, I wanted to change the negative or defensive "post" of "postindustrialism" to a positive concept encompassing our current society. To characterize it only by what was absent was for me a sign of sociological defeatism. Second, and related to the first point, I wanted to provide an alternative answer to the problem presented in *The Cultural Contradictions of Capitalism*, that our society is developing toward a state of dis-integration. I could recognize the characterization of our current society as a differentiated society. But I could not accept the answer, that re-integration should be achieved through the cohesive force of religion.

Since my meeting with Daniel Bell I have published a number of books in Danish related to the above-mentioned subjects, but not explicitly answering the two aims that I had set. During my work I have

studied and been inspired by the German sociologist Niklas Luhmann, who in the mid-1990s visited my university in Odense, Denmark. In Luhmann's work, I found an answer to the second of my two questions: that there are cohesive mechanisms in a functionally differentiated society, which presuppose neither external or independent factors, such as ontological or transcendental universals, nor a single internal factor such as religion or politics. However, he provided little help in answering the first question: how to replace the negative prefix "post" with a positive one. Luhmann insisted that our current society is part of the "Neuzeit" as opposed to the pre-modern "Altzeit," thus covering a period of several hundred years, while I was convinced—and still am—that signs of a paradigmatic change from modernity into a new structural and epistemological era—a new social structure and a new episteme, to use Michel Foucault's concept—have emerged during the twentieth century.

Recently, a change of career—although an undramatic one, from one university to another—gave me a two-month summer vacation without the need to prepare for the next semester. Based on the findings from the 1990s I present this book as an answer to Daniel Bell—an answer to Bell, in gratitude to Luhmann, one might say. First, instead of "postindustrialism," I suggest the label "hypercomplexity." Thus, instead of observing society as postindustrial, I propose to observe it as a hypercomplex society. Among other things, this implies that one must give up the theory of labor as the core theory of society. My contention is that it should be replaced by a theory of complexity. Second, instead of looking back in history for some integrative force—religion according to Bell; lifeworld according to Jürgen Habermas; the market (or, with the words of Karl Marx, "the civilising force of capital") according to Adam Smith, Bill Gates, and many others; or the state according to socialist theoreticians—I realized that the very way in which the problematic concerning social integration was posed was wrong. Social integration, i.e., society's communicative reproduction and observation of itself as society, is not necessarily achieved by some "central unit," "force" or "belief." Social integration may indeed be the result of the differentiated social subsystems' communications and mutual observations. The level of complexity of society is not a problem looking for a solution. On the contrary, complexity is the solution. Stability is not achieved by the provision of a strong center, but through the provision of means for mutual observation. This is, by the way, the main reason for the importance of currently emerging new media technologies, with the Internet as the basic example.

The functional objective of society is not to create "order" out of "chaos," but to manage complexity by complexity. According to Per Bak's book from 1996, *How Nature Works,* such systems can be characterized by their "self-organized criticality." They are themselves highly complex. They develop through different phases of equilibrium and change. They have self-stabilizing mechanisms such as memory. And they are self-referential, which means that their observations of themselves and of their environment happen through self-observation. For social systems, the medium for self-reproduction is communication, not life. It is the aim of the present book to identify the self-reproductive mechanisms of such a society—to find a label for its self-identity, that is, for society's society; and to characterize its communication media in relation to these reproductive and epistemological functionalities.

Acknowledgment

I would like to express my gratitude to Stephen Dobson. Patiently he has corrected my Scandinavian-English into something much closer to English-English[1] (except of course this sentence). Also, I would like to thank my oldest daughter Camilla. Since she was born in 1975 she has been my primary channel to the rapid changes of the cultural self-observation of contemporary society.

I

Hypothesis

ONE

The Hypothesis of Hypercomplexity

Introduction

What should we call the society that we are entering? Is it the "information society," as stated by Daniel Bell, and echoed by Alvin Toffler and a vast number of government reports? Is it a utopian "global village" in which everybody—if the bandwidth is large enough—are neighbors, as suggested by American high tech gurus Dertouzos and Negroponte? Is it, with a concept from Bill Gates's *The Road Ahead,* a phase of "frictionless capitalism," or are we foreseeing a global collapse such as claimed by the French architect Paul Virilio? Is it, as argued by German sociologist Ulrich Beck, the "risk society"? Or should we use the term "network society," as in Manuel Castells's three volumes from 1996–98, *The Rise of the Network Society, The Power of Identity,* and *End of Millennium*?

In this book another name is suggested (cf. Qvortrup 1998): The "hypercomplex society." The basic thesis of this book is that we are confronting a growing level of complexity, and that social complexity in fact represents the basic problem and challenge of our current society. Consequently, analytical approaches based on, e.g., theories of labor (David Ricardo, Karl Marx, and others) or theories of action and communicative action (Jürgen Habermas and others) should be replaced by an analytical approach based on a theory of complexity. The understanding of the society of the twenty-first century—whether it is called an "information society," a "network society," a "knowledge society," a "learning society"—must then take complexity as its guiding concept. Thus, the differentiation of our current and emerging society is not primarily based on classes determined by the ownership of means of production, but on classes—or, rather, processes of inclusion

and exclusion—shaped by the ability to manage complexity. Thus, classes and social inequalities do not disappear, but society is differentiated according to new principles. The basic "civilizing influence" in current society is not capital, which governs the organization of production processes. The basic civilizing influence in society is the continuous development of functionally differentiated subsystems as a way of handling complexity, the evolutionary principle being that external complexity can be managed only by the development of a matching level of internal complexity. Again, this does not necessarily lead to greater social equality, but to the development of new mechanisms of social inequality, and the creation of a society characterized by a paradox: The only ideological constancy is the constant absence of a guiding social ideology. Finally, the paradigm of the hypercomplex society does not foresee a utopian future based on the principle of a classless society. It does not understand modern society as a social field divided between systems and lifeworld, developing toward a future, utopian state defined by the principles of communicative action, consensus, and unlimited mutual understanding. And, most certainly, it does not accept that the way toward this utopian state, whether it is called communist, communitarist, or simply fully modern, will be through some kind of state-based dictatorship in which inequalities are dismantled and rationality assumes a dominant position. According to the theory of the hypercomplex society, we are developing toward a society with a large number of functionally differentiated centers, i.e. a polycentric society, in which the stabilizing factor is not a central guiding body or social ideology, but communication-based processes of coordination. Stability is then not the outcome of order and centralization, but of a high level of complexity and decentralization. Here, information and communication technologies are not understood as determining factors, but as socially shaped technologies formed by the need for decentered processes of mutual observation and coordination among social sub-centers.

Thus, the concept of the hypercomplex society is based on a paradigm of complexity, and not on paradigms of work or of communicative action. But "complexity" is not a new concept. On the contrary, complexity and complexity management are concepts rooted in the rationalistic ideas of eighteenth and nineteenth century philosophy. However, the concept of complexity and the ideal of complexity reduction as the outcome of rationality are redefined within this paradigm. Originally, this new approach to the understanding of complexity management was introduced by Herbert A. Simon. With the concept of

"bounded rationality" he realized that the ideal of the omnipotent "rational man" belonged to the optimistic belief in progress. It was rooted in a classical European rational philosophy transferred to scientific theories of management in the twentieth century, and it celebrated the modern organization as the triumph of scientifically based order, or—in a totally different context—it celebrated in political theories the socialist state as a societal organization, transforming a chaotic society into a planned paradise, founded upon "dialectical materialism" as the basis of "scientific socialism." It is an illusion that organizations and societies are developing, or should develop, toward a final state in which they are guided by one central instance of unlimited rationality. When organizational and social procedures develop, they do so not in order to reach a final state of total control or stability, but in order to compensate for their bounded rationality. Thus, a "final, utopian state" does not exist per se; it exists instead as a dynamic state of equilibrium in which mechanisms and procedures for mutual observation and communication have developed to neutralize tendencies toward social entropy.

Thus, Simon is one source of inspiration, and the parallel development of complexity theories from Norbert Wiener's original theory of cybernetics to so-called second-order cybernetics represents another. The understanding that social systems are not guided by any external subject, but can be guided or formed only by themselves, is essential to the understanding of hypercomplex society. Actually, the idea of second-order cybernetics represents a bridge between Simon's concept of bounded rationality and the main inspirational source of this book, the German sociologist Niklas Luhmann's analysis of modern society.

For Luhmann, the starting point is complexity theory, and he arrives at an analysis of ways in which complexity can be dealt with. Luhmann has demonstrated how modern society, through social evolution, has developed into a social system with significant capacity for complexity management. If one should summarize his rich analysis of social systems in one—although rather long—sentence, it would be: current society is developing toward a polycentric and thus polycontextural social system, which applies different codes of self-observation related to different positions of observation, in order to manage an increasingly complex environment (Luhmann 1996b, p. 44). Its self-produced environment is complex in the sense of space because we live in a global society. It is complex in the sense of time because we live in a society that changes at an ever-increasing rate.

However, on at least one important point my concept and analysis of

the hypercomplex society is different from Luhmann's theory of modern social systems. We cannot, as Luhmann suggests, limit ourselves to observing the current society as a modern society, differentiating only between tradition and modernity, or between "Altzeit" and "Neuzeit." According to my analysis, a new phase has emerged since the twentieth century. It is different from modernity because complexity has been replaced by hypercomplexity, anthropocentrism by polycentrism, unlimited rationality by bounded rationality. Here, my basic source of inspiration is Michel Foucault and his concept of "epistemes," of historical periods characterized by a certain social epistemology, i.e., a system of discourses and knowledge horizons (Foucault 1975). While Luhmann talks about modernity's multiplication of societal epistemes, Foucault maintains that a certain historical period is characterized by one specific episteme (Teubner 1989, p. 737f). These two views can be combined, if the premise is that the hypercomplex society is characterized by an episteme of polycentrism.

It is however important to emphasize that this concept of a hypercomplex, polycentric society differs from the observation of our current society as a "postmodern" or "postindustrial" society. My aim is not to identify "absences" or "negations" from earlier phases, nor is it the desire to locate potentialities in which anything goes compared with the implicitly claimed limitations and restrictions of modernity. The paradigm that I present in this book focuses on identifying the positive social characteristics of an emerging society. This is not a society that can be characterized primarily by its difference from something well known. It is an emerging social system that can be identified according to its own structures and dynamics. The term I have coined for this emerging social system is the "hypercomplex society."

The Hypercomplex Society

But what is hypercomplexity? A short definition says that hypercomplexity is complexity inscribed in complexity, e.g., second-order complexity. As an example, hypercomplexity is the result of one observer's description of another observer's descriptions of complexity, or it is the result of a complex observer's description of its own complexity (Luhmann 1984, p. 637 [1995, p. 471] and Luhmann 1997, p. 139; see also ibid., pp. 876 and 892).

Based on this concept, in the words of Niklas Luhmann already referred to, the emerging society can be characterized as a polycentric and

thus polycontextural social system, which applies different codes of self-observation related to different positions of observation: The economy applies the code of profit and loss; the religious system the code of transcendence and immanence; the scientific system the code of truth; the political system the code of power; and so on (Luhmann 1996b, p. 44). This means that the concept of universal "truth" or consensus is replaced by the need for transjunctional operations, which make it possible to switch codes and to decide which code is appropriate for specific social operation. One precondition for this is that a code must be capable of observing the world (and itself) as the differentiation of other codes (i.e., creating a hypercomplex operation).

When a society developing toward hypercomplexity observes itself, it does so by identifying a change in social semantics from *anthropocentrism*, which was introduced in the Italian Renaissance and reached its peak with the modern philosophy of Kant, based on the transcendental subject as the center of social observation and communication, to a social semantics based on *polycentrism*, which was implicitly prepared by the phenomenological theory of the German philosopher Edmund Husserl (1859–1938) at the beginning of the twentieth century, and developed by among many others the German American mathematician Gotthard Günther (1900–1984), the English logician George Spencer Brown (1923–), American second order cyberneticians such as Heinz von Foerster (1911–2002), and in the social sciences in particular by the already mentioned German sociologist Niklas Luhmann (1927–1998). In each of their fields of research they have contributed to the as yet unfulfilled self-identification of society as hypercomplex.

Finally, a number of social domains in the current hypercomplex society can be investigated. For instance, business organizations develop a growing number of observational codes (drawing upon the economy, but also upon ethics, ecology, etc.) in order to handle their hypercomplex social environment. In addition to economic accounts, they use, e.g., ethical accounts or ecological accounts to match external complexity with observational complexity. Art has moved from a linear perspective (and a normative definition of aesthetics) to a polycentric perspective (and a reflective definition of aesthetics). The so-called public sphere has changed from a "place"—a lifeworld—in society, in which "common sense" (consensus) is expected, into a specific metalevel observation and communication system based on public opinion, which isn't an essential thing but is an observation and communication code based on the distinction between the public and the private.

In the public sphere we do not agree, but we observe each other according to special criteria.

However, before turning toward these aspects of the hypercomplex society, I shall present the basic hypothesis of hypercomplexity in more detail.

The Hidden Problems of Complexity in the "Information Society": From Tradition-Based to Decision-Based Social Structures

Descriptions and analyses of modern society are not usually based on thoroughly elaborated theories; instead they are the result of superficial labeling, whereby a single phenomenon is used as the basis for a generalized term: Some call the current society a "risk society" (Beck 1986), apparently because of the large risk potential of modern technologies. Others use the phrase "information society," either because of the dissemination of information and communication technologies or because of the asserted amount of "information" in society.

The label "risk society" has already been critically discussed (e.g. Luhmann 1991). But what about the label "information society"? If the label is used because of the dissemination of information and communication technologies, we should also be able to talk of the "steam engine society," or "electricity society." However, a certain type of technology does not characterize society's social structure, and even if it did—or if it had influenced the development of its social structures in a certain direction—the characterization of society should be based on the form of social structures, not on a new or dominating technology. If the label is used on the basis of the large amount of "information" in society, "information" is presumed to be a quantifiable thing, a sort of liquid that can be sent through pipes and stored in containers. However, this has nothing to do with the accepted scientific definition of information as a matter of probability (Shannon and Weaver), popularized in Gregory Bateson's definition of information as a difference that makes a difference.

Still, it seems to be the basis of the self-understanding of "information society" gurus that information is a thing or a substance similar to material wealth, and the more we have, the better off we are. The "machine system" producing this material wealth is digital technology because it transforms analog materials into a common denominator, digital substance.

Understood in this way digital technologies represent the peak technology of anthropocentrism. The anthropocentric society is based on a belief in the unlimited power of human reason, which again is the unfolding of the principle of the universal language of the transcendental subject (cf. Leibniz's *characteristica universalis*). It is exactly the universal language that has been brought into reality by digital machinery. Consequently, according to Nicholas Negroponte, we are entering a global society based on the principles of a "local digital community" (Negroponte 1995, p. 19). Here, with the support of digital machinery, the implicit claim is for an extreme individualism with tailor-made commodities, individualized information channels, flexible organizations and personalized interaction systems, which can be realized within the framework of the simple social structures of a traditional local community. The line of reasoning is that digital machinery can translate the universal reasoning capacity of the human being into a global brain.

The same vision was presented two years later by Negroponte's colleague at MIT, Michael Dertouzos. In his book *What Will Be*, he foresees "a twenty-first-century village marketplace, where people and computers buy, sell and freely exchange information and information services" (this vision is basic to the book and thus repeated three times, first by Bill Gates in the foreword and then twice by Dertouzos himself; cf. Dertouzos 1997 pp. xiii, xv, and 9f). The information society will consist of a huge number of such village marketplaces, which can integrate banks, health care services, etc. and at the same time connect "people at a hundred million computers who might join together for a truly global event" (ibid., p. 15).

But what about the complexity problem occurring from the connection of hundreds of millions of people within the simplistic social structure of a village marketplace? It is obvious that the potential problem to tackle, when all humans' social actions are made communicatively accessible, is how *not* to let this happen and to avoid a global complexity death. Dertouzos seems partly aware of this problem: Opening one's e-mail system to the global community can be compared to opening the front door of one's private home and inviting everybody, all six billion individuals, inside for a chat and a cup of tea (ibid., p. 91).

My conclusion is that information and communication technologies don't present gateways to a golden global village community, where unlimited amounts of information run in the streets, as did milk and honey in former utopias. Instead, in the so-called information society we are confronting an immense challenge to social complexity exactly

because so many social actions have become communicatively accessible. What began with the emergence of the "civilizing influence of capital" (cf. Karl Marx), the journeys of discovery in the sixteenth and seventeenth centuries and the printing press reaches its peak with the global digital economy, global mass tourism and terrorism, and the global broadcasting systems of the twentieth century and the broadband Internet of the twenty-first century.

The complexity problem is the basic challenge of the information society, and it can be managed only partly by electronic filters, search engines, etc. First and foremost, what is required is the development of our social structures and institutions into complexity-management systems that must be much more sophisticated than they are today. Information and communication technologies play a paradoxical role. On the one hand, they are reasons for the emerging problems because they accelerate "electronic proximity" (cf. Dertouzos). On the other hand, they represent the necessary tools for handling the problems because the only way to manage social complexity is to establish communication-based couplings between people and institutions. Thus, a sophistication of society must go hand in hand with a sophistication of information and communication technologies. Therefore, the first and most important challenge is to develop an analysis and an understanding of society that matches the level of social complexity. But let me emphasize that there is no contradiction between the analysis of society and the development of the tools of information technology. On the contrary, the latter can take place only on the basis of an appropriate description of society. My hypothesis of an emerging hypercomplex society is meant as an exploratory guide into the complexities of our current society.

The Hypothesis of the Hypercomplex Society

As argued, I suggest labeling the current society the "hypercomplex society." I have chosen this concept not simply because current society is becoming "more complex" than earlier societies, i.e. individuals have communicative access to more actions than individuals living in earlier societies. For me, "complexity" is a relative, not an absolute, concept, and it is a question not only of the number of elements in the observed environment, but also of the coupling capacity of the observer. Furthermore, I would be highly skeptical about comparing a traditional, closed society integrated by systems of rumors with a global

society based on the mutual observations of the market. The question of which of the two is more complex is meaningless, because it presupposes that a common standard exists. The reason for choosing the concept of hypercomplexity is the assumption that the so-called information society is based on another mechanism of structuration than in earlier societies: It is based on informed decisions, rather than on *ex ante* given principles.

The hypercomplex society is a society in which almost all structures are created through decisions, and not by "traditions," "destiny," etc. (cf. Luhmann 1996; Luhmann 1997, pp. 1088–1096). Take the everyday example of parents who buy mobile telephones for their children. The reason for this is that we—parents and children—expect that what we do should find its rationale in decisions and not in destiny. We let our children stay in town late at night because we are in potential communicative contact, implying that we are in a position to react to any situation with a decision. Our children—so we think—are not in the hands of blind destiny because we are "there," or to be more precise, because their actions are communicatively accessible. Similarly, organizational behavior is based on what is called calculated risk. We want to—and we believe that we are able to—make decisions for ourselves and for our children and/or organizations (to make "informed choices"), and therefore information is needed. We don't accept that they are in the hands of God or some other external power.

This may be the implicit raison d'être of the concept of the information society. In order to make decisions—to do this and not something else—information is required. And to meet this requirement, immense amounts of data must be available.

In a general sense, this represents the transition from a social semantics based on universal transcendental or ontological forces to a society based on decisions made by social agents, i.e., the transition from theocentrism to anthropocentrism. Anthropocentrism—the idea that the human being is the rational decision-making center of society—has been an ideal ever since the Renaissance, and it achieved a dominant ideological position with the age of enlightenment. The analysis so far, regarding the transition from a tradition-based to a decision-based society, counts only for the transition from traditional to modern society, i.e., to a society based on the belief in unlimited human rationality. Thus, the ideal that social structures are created through decisions represents a necessary, but not a sufficient, criterion for current society as hypercomplex. An additional criterion must be sought.

Here, I would suggest that we apply the factor of social complexity.

With the development of modern infrastructures, and in particular through new media, not least the global Internet, human as well as organizational individuals have access to social actions on a worldwide basis. If society can be defined as comprising all actions that are communicatively accessible, our current society is a globalized one. We have, in the words of Hans-Magnus Enzensberger (Enzensberger 1993), communicative access to an immense number of civil wars, and we have all experienced the fact that we live "in a society" with those people whose actions are communicatively accessible, e.g., it is a well-known fact that television-based images of refugees force us to feel socially responsible for people with whom we earlier had no communicative contact. The same goes for enterprises, even the smallest, which *de facto* act in a global market.

However, this is still a quantitative argument. The important aspect—and that which represents a difference that makes a difference—is that those actions that are communicatively accessible cannot be reduced to one observational criterion. While European anthropologists in the eighteenth century traveled abroad with observational and analytical expectations founded upon the distinctions of cultivated/natural and civilized/wild, they returned with the conclusion—or rather, after centuries of observation-based reflections, they were forced to conclude—that they had not met "natural" or "primitive" people, but *other* cultures. Thus, their observational experience did not confirm expectations that the unknown other represented a contingent set of phenomena compared with European cultural necessity, i.e., that the unknown environment and its inhabitants represented a deviation from an earlier, already fully developed European civilization and that they lived in a state of primitivism, which could be observed and analytically included in some earlier evolutionary phase in the already fully developed position represented by the observer. Instead, what they observed, or what they through their observations were forced to conclude, was the meeting of different cultures, i.e., of two sets of contingent phenomena: the European culture and one out of a vast number of other cultures.

This experience, which still has not been accepted by all observers in the so-called Western world, can be divided into three aspects. First, it was gradually realized that a complex observing system met an equally complex observed system. Second, it was realized that instead of a division between an active observer and a passive observed, the assumed passive observed system appeared to be actively observing as much as the original observing system. Consequently, the situation developed

into mutual observation and adaptation. Third—and this was by far the biggest cultural shock—it was gradually realized that compared with other cultures, the "Western" or "civilized" observers did not represent an ontologically or transcendentally more central, natural, or universal standard for observations. Actually, the implicit conclusion to be drawn was that no universal observational standard existed. The only possibility remaining was to simultaneously observe the other and to observe one's own observations, knowing that the observed other is doing the same.

As a consequence, the understanding of the problem of complexity has changed. The days have passed in which it was realistic to assume that environmental complexity could be tackled by a powerful, centralized rational subject. Today, the belief in unlimited rationality has been replaced by the concept of bounded rationality (Simon 1997), reflecting the social fact that in every decisional situation the number of possibilities, not only for observation-based conclusions, but also for determining the premises of observations, exceeds the capability to make decisions.

Thus, these are the two factors that qualify as criteria for the concept of an emerging hypercomplex society. The first is that society is based on the ideal of informed decisions. Through the realization of this ideal, a traditional theocentric society, based on and structured by an ontologically or transcendentally given external "force," is replaced by a modern society, in which every individual expects to be capable of reaching informed decisions, either as an individual human being, as an organization, or as a collective decision-making body, united either in a utopian *volonté general* or as a dystopian sociotechnical control machine. This modern society can be termed the "anthropocentric" society.

The second qualifying factor is, however, that the very nature of social observation has changed, because the belief in the existence of a universal standard of observation must be given up. A given phenomenon may always also be observed otherwise. The ideal of a universal language or a universal principle, which has driven European thought from Leibniz's *characteristica universalis* to the positivism of the twentieth century, must be given up not because of practical difficulties in creating this language, but for purely theoretical reasons.

However, the conclusion is not that "anything goes," as some postmodernists have suggested. It is not that rationality must be given up, but that the ideal of unlimited rationality must be replaced by the concept of bounded rationality, i.e., that a state of hypercomplexity is

constituted by the mutual observations and self-observations of complex systems. Or put differently, first-order cybernetics, pointing toward an external steering subject, must be replaced by second-order cybernetics, i.e., stating that the principle of order for any given social or psychic system can be seen only as the outcome of the operations of that system itself. Such systems themselves produce their elements, relations, and conditionalizing forces. This second criterion of qualification supports the transition from anthropocentrism to polycentrism, i.e., from a society that believed in the transcendentally given rational human being as the center to a society that observes itself as a social system with an immense number of communication centers and codes. No individual can couple himself or herself to all these potentialities. Consequently, the starting point of communication is not to establish a connection, or a "link," but to deconnect, i.e., to reduce the number of couplings to one's social environment. Ironically, just as the ideal behind the name must be given up, this social condition is labeled the "information society."

Summary

The present book is based on two hypotheses, which are to be developed and tested in the following chapters.

The first hypothesis is that a new social paradigm is emerging in our current society, i.e., the paradigm of hypercomplexity. Hypercomplexity can be defined as second-order complexity, in the sense that it is complexity referring to or being inscribed in complexity. It is not my contention that our current society "is" a hypercomplex society, but that hypercomplexity is a category that can explain a growing number of observation and communication processes in this society. Thus, the premise is that this concept can and will be empirically tested in this book, i.e., that a large number of facts can be explained by the concept of hypercomplexity, and that hypercomplexity constitutes an adequate framework for society's observation of itself as society.

The second hypothesis is that hypercomplexity supports a theory of development based on three phases or trends, where each is characterized by a dominant social semantics governing the understanding of society.

The first phase can be called *theocentrism*. Theocentrism characterizes a society that can be observed from within an observational mode constituted by a universal entity sitting in an external position:

God or destiny. This observational position was introduced by Plato's metaphor of human life as the life of the cave dweller, a pale shadow of divine reality. But how can this God, who sees and causes everything, be characterized? "Deus est sphera, cujus centrum ubique, circumferentia nusquam"—God is a sphere whose center is everywhere, and whose circumference is nowhere—the conservative French philosopher Pascal, who fought against the emerging anthropocentrism, put it in his view of Plato's thesis. The social semantics of theocentrism was translated into a social order based on a stratified society with God at its apex and the church and the feudal state as religious and political systems of integration, both legitimized by God.

The second phase can be called *anthropocentrism*. Anthropocentrism characterizes a society that can be observed only from within an observational mode constituted by a universal internal position, i.e., from an observational point that is itself part of the complexity of the social system. Here, God as the universal perspective of observation (or, as I would prefer to say, the universal "observation optics") is replaced by the universal human being—the transcendental subject—as the universal observation optics. In November 1486, this observational position was introduced by the Renaissance philosopher Giovanni Pico della Mirandola. "I have placed thee at the centre of the world, that from there thou canst more easily observe what exists in the world around thee" (Pico 1942, p. 348), according to Pico in what seems to be a brief phase of illusion God says to Adam, while in reality it is humanity that has entered God's position at the center of the world and expects to maintain this position without any further assistance of God. The understanding of this new, modern social semantics was crowned by Immanuel Kant's theory of the transcendental subject as the constituting factor of pure, practical and aesthetic reason. It was put into practical reality by Rousseau's idea of a *contrat social*, the social contract, the principle that constituted the political reality of the nation-states of the nineteenth and twentieth centuries, and it is still very much the ideal of aesthetics, policy, business, and culture.

Finally, the third, currently emerging phase can be called *polycentrism*. Polycentrism characterizes a society that cannot observe itself or its environment from a single observational position—or, rather, from within a single observational perspective or "optics"—but has to employ a large number of positions of observation, each using its own individual observational code to manage its own social complexity. This implies that no universal point of observation can be found. Furthermore, this means that a large portion of these observations are observations of

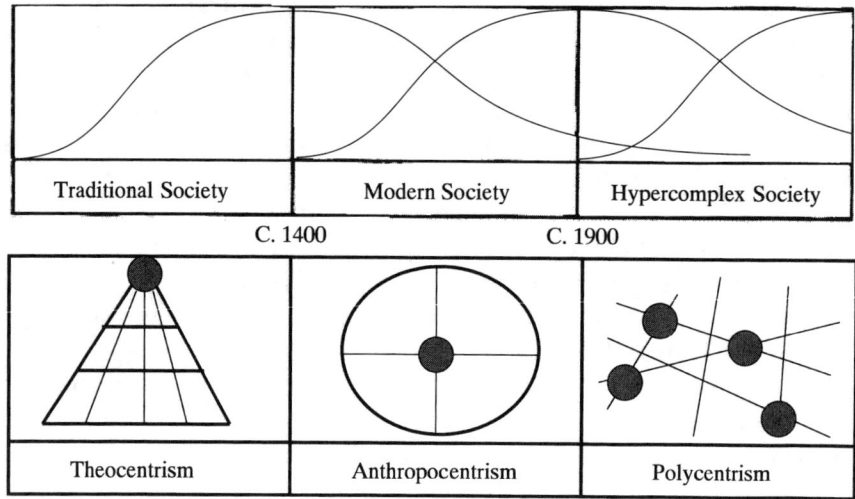

Figure 1. Traditional, modern, and hypercomplex society

observations: of others' observations and of the observer's own observations. The ideal of a centralized (broadcasted) observation and communication system is replaced by the ideal of polycentric and polycontextural observation and communication systems. This observational position was introduced by Edmund Husserl's critique of the Kantian epistemology at the beginning of the twentieth century. As he summarized his position in his *Cartesian Meditations* from the 1930s: "wäre das Eigenwesentliche des Anderen in direkter Weise zugänglich, so wäre es bloß Moment meines Eigenwesens, und schließlich er selbst und ich selbst einerlei" (Husserl 1963, p. 139). What Husserl says is that if I had the same access to the other's consciousness as I have to my own, then the other would cease to be foreign, and would instead be a part of me. Critically referring to Kant, Husserl implies that this is of course *not* the case, and that as a consequence the transcendental subject does not exist. The consequences for our understanding of society were elaborated by Niklas Luhmann, and summarized in the already quoted characterization of the social conditions of hypercomplexity from 1996, his lecture *Die neuzeitlichen Wissenschaften und die Phänomenologie* given in Vienna's City Hall on May 25, 1995, to celebrate Husserl's lecture in the same place 60 years earlier: "Die moderne Gesellschaft ist ein polyzentrisches, polykontexturales System. (...) Es muß also (...) transjunktionale Operationen geben, die es ermöglichen, von einer Kontextur (...) in eine andere überzuwechseln und jeweils zu markieren, welche Unterscheidung man für bestimmte Operationen akzeptiert

bzw. rejiziert" [Modern society is a polycentric, polycontextural system. (. . .) Consequently there must be transjunctional operations, which make it possible to go from one contexturality into another, still marking which differentiation is accepted or rejected for specific operations] (Luhmann 1996, p. 44).

These two hypotheses and the resulting idea of a social development from a traditional, theocentric society via a modern, anthropocentric society to the currently emerging hypercomplex, polycentric society are substantiated and defended in the remaining six chapters. In chapters 2, 3, and 4 the social development of frames of self-observation is summarized within the three classical Kantian realms: practical, aesthetic, and pure reason. In chapters 5, 6, and 7 the social shaping of media of self-observation is presented. In chapter 5, an understanding of communication, media, and public opinion specific to the hypercomplex society is suggested in critical discussion of dominating anthropocentric theories such as communication and media theory based on Harold Laswell and his successors, and consensus-praising sociology based on Jürgen Habermas. In chapter 6 the Internet is analyzed as the communication medium particularly shaped by the hypercomplex society. Finally, in chapter 7, culture is analyzed as the generalized self-observational medium of society, i.e., as the meta-optics of society's self-observation. We observe ourselves through the codes of economics, politics, science, art, ethics, etc. But we also observe ourselves as society through culture, and through these self-observational and self-correcting processes the concept of culture has changed from having been a tool for social identity into becoming a tool for social comparison.

II

Frames of Self-Observation

TWO

The Practical Self-Observation of the Hypercomplex Society: The Cohesive Force of Polycentrism

Tradition, Modernity, Hypercomplexity

In his four books on knowledge and the sociological studies of conceptual phenomena like "culture," "religion," "ethics," "society," with the common title *Gesellschaftsstruktur und Semantik*, Niklas Luhmann makes a distinction between society's "structure" and its "basic semantics" (Luhmann 1980, pp. 9–71).

In identifying the "structure of society" he identifies different forms of differentiation, namely, segmentary differentiation (e.g., tribal society), center/periphery differentiation (e.g., imperial society), stratified differentiation (e.g., societies structured according to differences in rank), and functional differentiation (the differentiation of our current society into autopoietic but structurally coupled systems defined by their function in society) (Luhmann 1997, p. 613). Supporting this identification of forms of differentiation is a theoretical assumption of complexity, that the differences between the mentioned forms of differentiation represent the difference in complexity in a society. What is concealed, therefore, is a conception of evolution, that society on the basis of structural change changes its potential to absorb uncertainty by building systems of internal, secondary complexity (Luhmann 2000, p. 222).

With respect to society's "semantic," Luhmann asserts that a society rules over a "horizon of meaning," where, as he puts it, the whole of

the world "rudimentarily" is accessible. "Meaning" can be seen along three dimensions: a case dimension ("meaning" as the difference between different perceptions of reality), a time dimension ("meaning" as a difference between past and present) and a social dimension ("meaning" as the difference between us and them). Luhmann calls such a horizon of meaning a society's "foundational semantic" (Luhmann 1980, pp. 34–35).

Between society's social structure and its semantic there is a relationship, even if it is only indirect. Sometimes, social semantics develop at a faster rate than the structure of society and present new possibilities; on other occasions they halt development as they become locked in the maintenance of obsolete traditions. However, the social structure is not accessible "in itself," but only from within a given matrix of interpretation.

According to my own definition, which is only slightly different from Luhmann's 1980 definition, a social semantic represents a society's "formatting" of its self-observation and its observation of the other, and not least of society's own social structure. This definition of the social semantic, although strongly inspired by Luhmann, is perhaps more in keeping with the French sociologist Michel Foucault's concept of "episteme" than with Luhmann's concept of a society's fundamental semantic.[1]

When in this book I draw a distinction between the traditional, the modern, and the hypercomplex society, this distinction is based on an assumption of structural change. While the traditional society builds upon a differentiation between ranks or castes—i.e. between high and low—the modern society, which goes forth from the 1400s, is characterized by a gradual displacement of stratified differentiation by functional differentiation. As a consequence, the earlier order of ranks or castes, where the religious system was uppermost and justified the lower-level systems, is displaced gradually by a society where the functional systems separate themselves and provide reasons for their own functions: The economic system makes itself independent, the art and science systems emancipate themselves from the dominance of religion, the political system is self-justified by a theory of power (whether power is based on the rule of a monarch or on a social contract) and so on.

Furthermore, I introduce a distinction between modernity and hypercomplexity. This is based on the assumption that dealing with complexity in the course of the twentieth and the twenty-first century takes on new forms because society's subsystems and society as

a system of systems to an increasing degree are oriented toward and thematize their own complexity: science loses its certainty and repeatedly thematizes its concept of truth. In art, the idea of "natural beauty" of former times is transformed into something very unnatural. The moral distinction between good and evil begins to doubt its own criteria. Society's perception of progress and development is no longer without ambiguity. In other words, systems don't observe merely their environment, they observe the criteria for their own observations. They become hypercomplex.

At the same time, I operate with the distinction between theocentrism, anthropocentrism, and polycentrism that I presented in chapter 1. These three concepts are the terms for a society's dominant format of interpretation, and—with the additional remarks made above—are semantic correlates to the development from tradition to modernity and to hypercomplexity.

From Tradition to Modernity

This book is primarily about the hypercomplex social condition. I think, however, that for comparative purposes it can be interesting to look at another dramatic change: the social transformation from a traditional to a modern society, which had its starting point in the fifteenth century Italian Renaissance and reached its peak in the eighteenth and nineteenth centuries.

The transition from traditional to modern society—which in technological terms can be called industrial society—lasted several hundred years. The decisive cultural change was the gradual replacement of the belief that God was the structural and semantic center of the world by the belief that man, i.e., human reason and creativity, was the central force and observational format of the world. Gradually, one ceased to celebrate God as the creator of the world. Instead man with technology in his hand was capable of creating an artificial culture. Little by little a theocentric society was replaced by an anthropocentric society, in which art could no longer talk on behalf of God, but represented the vision of the human being. The world was seen from an anthropocentric perspective, the basic concern being the emancipation of the individual.

However, not only did this transition last several hundred years, it also occurred as a complex process of actions and reactions. For instance, Blaise Pascal (1623–1662) represents a logical reaction to this transition, and as a strong supporter of tradition he was against the use

of perspective in painting: For linear perspective—this representation of the anthropocentric way of looking at the world (cf. chapter 3)—leads human attention away from the divine perspective, asserted Pascal. And therefore it was just as logical that the critique of modern civilization as the critique of a civilization that believed that everything in the world was or could be created or at least regulated by man was the new point of criticism for those who celebrated tradition. For instance, the Danish philosopher Søren Kierkegaard stated that to celebrate a democratic form of government, i.e., a political form that placed man in the center, was to put God to one side, in the sense that it was to look completely away from God. The opposite was the case for supporters of the new order: They celebrated human rationality, progress, the victory over irrationalism and superstition, and they cultivated the truly beautiful in man. Mankind was made the fundamental measure of pure reason's scientific perception, practical reason's political and moral perception, and aesthetic reason's measure of taste. In all fields, humans were the standard. Secularization was therefore the main goal for emancipation: "Religion is the opium of the people," said Marx with a focus on the political domain.

This grand and long-lasting transition started in northern Italy in the fifteenth century, and one of its early representatives was—as already mentioned in chapter 1—Giovanni Pico della Mirandola. "Tu, nullis angustiis coercitus, pro tuo arbitrio, in cujus manu te posui, tibi illam praefinies." "Thou, coerced by no necessity, shalt ordain for thyself the limits of thy nature in accordance with thine own free will, in whose hand I have placed thee," as Elizabeth Livermore Forbes translated this famous passage (Pico 1942 p. 348).[2] With these words, in his oration on *The Dignity of Man, De hominis dignitate*, in November 1486, Giovanni Pico della Mirandola introduced the modern individual.

The speaker in the quotation is God, and the person he is speaking to is Adam.[3] God has just finished creating the world, but something is still missing. He needs a creature who, independently of himself, can observe his creation and has the capacity to "think through the rationality (of Creation), love its beauty and wonder at its greatness" (Pico, p. 48f). This being is *Man*—in today's understanding: the individual—who must therefore be placed in a position that is on the one hand different from God's and on the other hand gives him the best possible vantage point. "I have placed thee at the centre of the world, that from there thou canst more easily observe what exists in the world around thee," God says, for the same reason, to Adam (ibid.).

But what does it mean to stand at the center of the world? On the

face of it, one would think that the center of the world could be identified as a fixed point: the place from which everything can be observed and understood. This view was rejected by the astronomy of the fifteenth and sixteenth centuries. Not only is the earth not the center of the universe, but no such absolute center exists. The more we seek this absolute point, the clearer it becomes that it does not exist, not even in philosophical terms.[4] In the first place, to stand at the center of the world also means to stand at the center of oneself (because "I" too am part of the world); secondly, to stand at the center of the world requires that one must *oneself* fix a center and from this provisional center constantly discuss and locate what is central.

It follows, therefore, that if the individual human being is to stand at the center, he or she (in the following: he) must be free. This means that to be an independent—i.e. self-dependent—observer (and only the self-dependent observer can constantly renegotiate his own vantage point), he must in a radical sense be free, and this is only the case if the individual produces his own freedom. This is precisely why the individual human being, in God's greeting to Adam, is characterized by deciding his own nature in accordance with his own free will. His observation must have as its basis the perspective of the individual, grounded in self-observation. It was precisely the same complex of problems that the visual artists of the Renaissance tackled with the introduction of linear perspective. This too articulates the problem of man as the independent observer who looks at God's creation through man's supremely individual perspective. And here too, the cost of this radical emancipation is discussed—cf. Christ's accusation to his disciples in Leonardo da Vinci's *Last Supper* that "one of you shall betray me;" for according to the picture the accusation is made not against Judas as the traitor, but against Judas as the representative of humankind; as humankind—the independent, self-creating individual—must necessarily betray the old theocentric order (see chapter 3 for a detailed analysis of this painting).

So this is Adam's situation. One is tempted to pursue the story to its logical conclusion, when Adam is expelled from Paradise. For only there, placed outside of God's creation, can the individual human be free in the sense of self-dependent and abandoned to his own free will.

But this was in a certain sense also Pico's own situation. At the age of twenty-four, Pico, who was a prosperous, unusually gifted Italian count, had drawn up 900 theses, a comprehensive work, "on the highest mysteries of Christian theology, on the profoundest questions of philosophy, on unknown disciplines" (Pico, p. 60), and then sent out a

general invitation to a public disputation, to be held in Rome in 1487. Everyone was welcome, and Pico bore the expense.

As Cassirer says, the 900 theses are about "metaphysics and theological dogmatics, mathematics and astrology, magic and cabbalistic speculation, the history of philosophy, church history, natural history," (Cassirer 1927). It is to Cassirer's merit that he points out the likelihood that this apparently eclectic accumulation of subjects meant neither that Pico represented premodern thinking nor that there is a discrepancy between the small *Oratio* and the rest of his extensive output. On the contrary, argues Cassirer, there is a unity in Pico's work. For Pico "the chief thing is not to prove man's substantial *similarity* with the world; it is rather, precisely within this similarity, and without prejudicing it at all, to point out a *difference*" (ibid.). This difference of course represents the difference between free humankind and surrounding nature, which is governed by necessity. More importantly, however, it represents the individual human as self-dependent observer. The individual stands outside—that is the difference. But with the introduction of this independent observer who makes his observations by means of his own self-created judgment, the universe changes its nature. The differentiation in the form of an all-embracing hierarchy is superseded by differentiation in the form of a decentering because everything can be observed by the individual, who does not observe from any specific place, but solely from the position of his own judgement. "No place in the universe differs in its nature from any other—and each can with equal right claim to be the center of the world" (ibid.). And the same applies to time. Time too is without center: "As in space no point has an absolute precedence or privileged value over any other, as each, with the same right, or lack of right, can be regarded as the center of the world, so are the moments of time equivalent to each other. What is the nature of man, and in what his specific dignity consists, can be judged only when we dissolve the fixed temporal distinctions, the now, the before and after—when we comprehend past, present, and future in a single vision. And in such a kind of "seeing together" there is first revealed the full meaning of human freedom" (ibid. p. 37).

As an introduction to the public disputation, Pico wrote his *Oratio*. But the meeting was never held. Instead of an impartial disputation of the manuscript, Pope Innocent VIII set up a commission that condemned 13 of the theses as being "of dubious orthodoxy." After further complications Pico was arrested and imprisoned. However, after a time

he was released and able to return to Florence, where he died in 1494, just thirty-one years old.

But let us return to the quotation: The modern individual, writes Pico, not coerced by any form of necessity, must decide his own nature in accordance with his own free will, which has been bestowed by God. According to Pico the central characteristic of the modern individual is that he is free. However, this freedom is a two-edged sword: On the one hand it is a freedom that we ourselves determine; on the other it is a freedom by which we are ourselves determined, in whose hands we are placed. Freedom is, to use a modern term, "autopoietic"; it creates itself from and through itself; and the more extensive it becomes, the more it limits its own expression.

This two-edged freedom is directed both inward and outward—toward the environments of the modern individual, external and internal nature, and toward the modern individual human itself. It was important for Pico to analyze these consequences, not, I would like to emphasize, to place himself normatively at the forefront of a "simple modernity," which unconcernedly pays homage to freedom and takes the lead in progress without a thought of the costs, but to analyze freedom and anthropocentrism—with the costs they entail—as the distinguishing marks of the modern human being, which it cannot abandon without abandoning its own modernity. Freedom as opposed to necessity is an inevitable and painful condition for the modern individual, as is anthropocentrism in opposition to theocentrism—not in the sense that we can do nothing, but in the sense that we cannot transgress these boundaries without betraying ourselves. The modern is thus reflexively modern from the very outset.[5]

It is important for Pico to demonstrate that the individual is free in relation to nature. In the *Disputationes in astrologiam divinatricem* he rejected so-called prophetic astrology, the astrology that claimed—and still claims—that the individual's fate is determined by the heavenly bodies. Not only is it a confusion of *causa universalis* and *causa proxima* to believe that the heavenly bodies influence the character and fate of human beings; it also follows from such confusion that the individual is unable to shape his or her own fate.

But the individual is also free in relation to internal nature. As a *human being*, the individual is not nature, and only as nonnature is he great, Pico emphasizes. "There is nothing great about man except his spirit and soul (...). If you fall back into the body and look up to the heavens, you see that you are a fly and something even less than a fly,"

he states in his *Disputationes in astrologiam divinatricem*. The individual human being is, as the Danish theologian Johannes Sløk has said in his book about Pico, "equal to God in the sense that he has unrestricted freedom to create his own character" (Sløk 1957).

This of course does not mean that the individual is free *of* or *from* nature. On the contrary, in this situation the individual is the victim of his own freedom because freedom represents a temptation to do violence to one's own natural basis. This is where the dilemma of freedom makes its appearance. The point is, however, that one does not overcome this dilemma by denying the difference between human beings and nature, either by making nature human (giving it human rights) (Luc Ferry 1992), or by making human beings natural (i.e., making them an undifferentiated element in the biosphere). The basis of modern civilization is that the human being is different from nature. And we must therefore distinguish uncompromisingly, Pico emphasizes, between the world of nature, where everything is bound together in law-governed necessity, and the world of human individuals, where freedom is the supporting premise. The duty of humans to nature is therefore a duty to themselves; if they fail to respect the necessity of nature, they will betray their own freedom.

But human beings are also free in relation to themselves and to other human beings. What is at issue here is the relationship between the good and the rational. If the human being is first and foremost good, he is subject to the metaphysics of goodness; but if he is first and foremost rational, the good too must be justified by human reason.

Accordingly, Pico's introduction of free will is also a questioning of the metaphysics of the good. "It is better to will the good than to know the true," said Petrarch in the mid-fourteenth century, following Plato.[6] Now, however, the good as the highest governing principle was being questioned. "What is the good and the true?" asked one of Pico's contemporaries, Ficino. The good can be connected with the will, while the true can be referred to the intellect, and these two are opposites. The intellect "combines with things by referring them to itself, the will by referring itself to the things," he wrote in his *Theologia platonica* of 1489. Consequently, we are "by virtue of reason a law unto ourselves, and as free men can follow our own direction." Thus, it would perhaps be better to will the good than to know the true, but it is the condition of the freedom-loving human being to seek the true, even at the expense of the good, and to justify the good with arguments that do not arise from the good itself.

So, once more the price the modern human being must pay for its

freedom is high. It cannot simply do the good, but must constantly *justify* the good. And what is justified is not in the deepest sense good, because it is not simple or spontaneous, but calculated good.

Humankind is thus free in the sense that it is abandoned to its own freedom, which arises from reason. But as Ficino said, the intellect refers everything to itself; it even refers the *human being* to itself, that is, to self-observation; and when everything else is observed—nature for example—it is observed by a rational faculty observing itself. Self-observation is therefore the basic structure of human reason, both when it relates to itself and to other human beings and when it relates to what lies outside the individual as a human being: nature. The foundation is self-observation, and the doubt, shame, anxiety and, ironically enough, the unfreedom that originate from it. As was evident from the dispute concerning the difference between the good and the true, the good is not, according to orthodox thinking, something of which one can have "knowledge." One does not have knowledge of the good, one *is* or is not good. "Of every tree of the garden thou mayst freely eat; but of the tree of the knowledge of good and evil, thou shalt not eat: for in the day that thou eatest thereof thou shalt surely die," thus God said to Adam, according to *Genesis*, before he created Eve. But the serpent, which was more sly than any beast of the field, tempted Eve, and both she and Adam ate of the tree of knowledge. "And the eyes of them both were opened, and they knew that they were naked; and they sewed fig leaves together, and made themselves aprons." For what they observed after eating of the tree of knowledge was themselves.

The Functional Differentiation of Society

Reference and Self-Reference

How long does it take for a society to become modern? There are indications that in the case of Europe, 400 years were to pass from the time modernity was first proclaimed until we seriously began to understand and accept the consequences of the modern human being as self-observing. The modern human being observes itself, and in philosophy, the sciences and art, it observes its own self-observation. Only recently, however, this form of observation—self-observation or second-order observation—has entered "the architecture of theory, but also the self-understanding of the modern, at the point that was formerly occupied by natural or transcendental premises" (Luhmann

1990, p. 717. See also Luhmann's discussion of the modernity of science, ibid., pp. 702–719).

With self-observation, the human being wins its freedom. But the price is a renunciation of both naturalness and goodness as rational criteria and ethical imperatives (ibid., p. 701). In addition, the freedom that the modern individual has won is a freedom to which it has in the same instant *surrendered* itself.

Pico's point of departure is that the modern human being determines its own nature. This is the basic determination—or perhaps one should say the claim—that we take as our starting point. Without it, it is pointless to talk about a modern human being as a free human being. It means that as a modern individual, one is referred to oneself, and that reference to anything else and anyone else will always be through a self-reference. The self, as Kierkegaard said in *The Sickness Unto Death*, is "a relation that relates itself to its own self."

The System of Functionally Differentiated Subsystems

In Europe there was a huge social and cultural upheaval in the period from the fifteenth to the nineteenth century.

In the long period before the upheaval, the individual, and society and its institutions were grounded in one overarching factor: God. And because society and the individual were grounded in God, there was no need to explain them for their own sakes.

The greatest narrative of this pretransformational order is the story of the creation, as told in Genesis: "In the beginning God created the heaven and the earth." What God did was make differences, and name these differences, i.e., to indicate which differences made a difference. The church represented this order. God, the Almighty, had an earthly representative, the pope, and from the pope radiated the power of the Almighty in a global hierarchy. Politics represented this order: The supreme political ruler had been appointed and justified by God, and his legitimacy had been granted by God. The economy represented this order: Its aim was to gather the greatest possible wealth, to accumulate property and gold, not in order to reproduce itself, but as a way of honoring God. Science represented this order: Its mission was to study and preserve knowledge, such as it emanated from God. Pictorial art represented this order: It was without depth because its order had not been constituted by the individual artists, but by God, for whom everything is equally large and equally small, equally near and equally far.

But at the end of the fifteenth century the great shift began. It was so radical and significant that we are still trying to come to terms with it by writing histories of it. How was this shift manifested? In the field of Christian faith, man could no longer understand himself as a result of God's creation, for in that case where was free will? Erasmus of Rotterdam (1469–1536) took up the challenge around 1500, when he wrote the treatise *On Free Will*, where he emphasized that redemption arises in a cooperation between the will of God and the will of man, at least in the sense that man could say either "yes" or "no" to what leads to salvation.

Where did Martin Luther (1483–1547) stand in this matter? He too reacted to the questioning of tradition by the Renaissance and humanism, but in a way that was at once parallel to and yet quite different from that of Erasmus. One could say that his questioning was a questioning of the here and now; not of man's relationship with God, but of his relationship with the church as an organization. For Luther, the relation of early modern man to God is modern inasmuch as it is the personal affair of the person concerned. He or she does not need a priestly caste as mediator. In particular, this means for example that one cannot buy indulgences. One must personally bear one's sin. With Erasmus and Luther, then, almost 500 years ago, personal freedom and a personal consciousness of sin were born as two sides of the same coin. Freedom is a burden, because it goes hand in hand with an awareness of sin.

Politics detached itself from divine authority, and in his book *The Prince*, Niccolò Machiavelli (1469–1527) taught that modern politics was not the operationalization of God's will, but the management of power. However, it was only later, with Rousseau's book on the social contract, that truly modern guidelines were provided for how a plurality of free individuals could jointly, through rationally based dialogue, articulate a social ethics, a "social contract."

Science was no longer to study and preserve knowledge as an emanation from God. It was on the contrary to be based on empirical observation and critical reasoning. This led Giordano Bruno (1548–1600), for example, following Nikolaus Copernicus (1473–1543), to acknowledge the infinity of space. But if space is infinite, there can no longer be any center, and in that case God has become homeless: He is not the creator of the universe, much less its authoritative midpoint. This realization too was made more seriously a point of contention in the course of the next few decades as science drew up totalizing world systems, and the anecdote of the French scientist Pierre Simon Laplace's (1749–1827)

presentation of his comprehensive work, the *Système du monde*, is appropriate. When Napoleon asked where God might be in this world system, Laplace answered: "I have no need of that hypothesis" (the story is retold in Prigogine and Stengers 1979).

The economy changed its form. From the accumulation of wealth in the name of God and managed by the church, it became a thoroughly secular (i.e., self-justifying) circulation and accumulation of value. As early as 1758 François Quesnay (1694–1774) argued in his *Tableau economique* that modern society is based on an economic system with its own autonomous laws, a reproductive flow of goods and money among society's three main economic classes: farmers, property owners and the so-called "sterile" class of artisans, merchants, wage workers, etc. There was a further break with external powers with Adam Smith's (1723–1790) discovery of the market's "invisible hand" and David Ricardo's (1772–1823) demonstration in his theory of the value of labor, where value too found its source in the labor of humans; and the secularization of economic science culminated with Karl Marx's (1818–1883) *Das Kapital*, according to which it is accumulation that "is Moses and the prophets."

Everywhere God was banished—in pictorial art too with so-called linear perspective. What is it that artists seek to express with linear perspective? The crucially new is that the picture is the artist's picture, not God's. This aspect is explored in depth in chapter 3. As in politics, economics, and science, the picture no longer speaks on behalf of God; it is not God's picture, it does not reproduce his view. On the contrary, it speaks on behalf of the individual human being: It is the individual's picture of the world.

From Modernity to Hypercomplexity

From the "Human Being's Society" to "Society's Society"

In recent years the labeling of society as "modern" or "industrial" has been challenged by terms such as "postmodern" or "postindustrial." Although these names signal a change, they also express a theoretical embarrassment. Changes have been notified, but not yet conceptualized.

What is the theoretical point of focus for the understanding of society, when the conceptions for *modern* society of the seventeenth, eighteenth, and nineteenth centuries are no longer fitting, and when the currently fashionable labels such as "postmodernity," to say nothing of

the highly superficial perception of society as the "information society," do not help us in understanding contemporary society?

One of the consequences of the changes that have taken place in the 1900s is that it is no longer possible to describe society from an external position, either through the theocentric vision of God or from humankind's anthropocentric perspective. The assumption of the view of God or the human being—as the universally divine or universally human—has lost its validity for societal description.

This insight has many sources. Through anthropology's meeting with the "wild," which on closer inspection revealed itself not to be a negative mirroring of the European form, but on the contrary, the expression of equally complex, distinctive cultures, Eurocentric blindness became evident and new ways of self-observation became possible. As an expression of this, art began to look inward instead of outward. Instead of merely observing the certain existence of the outer world, art made self-observation its fundamental concern.

Sociology had reached a corresponding insight already before the turn of the century with Durkheim. In several works, perhaps most clearly in *Les Règles de la méthode sociologique* (1895), he asserted that sociology is a science in its own right because social life cannot be explained by psychological factors. We must, as he said, give up "the anthropocentric postulate." Society creates itself through itself, even though this fact "upsets mankind to give up its unlimited power, which it has for such a long time given itself" (Durkheim 1972, p. 18).

One philosopher who took up the challenge was the German Edmund Husserl (1859–1938), who in his work increasingly distanced himself from Kantian transcendental philosophy, i.e., the view that the world can be described from the perspective of an external transcendental subject. On the contrary, it is important to understand that the world can be described only by an observer who himself is in this world, and that the description of the world is therefore a self-description. The subject making the constitution must, as the Danish Husserl expert Dan Zahavi has put it, "become mundane, since the objective world can only be constituted by a subject, who is embodied and socialised" (Zahavi 1997 p. 82).

A consequence of this is that social theory can no longer occupy a privileged position above the world. The sociologist is not a scientific God above normal people, but a person among others, who tries to find a suitable position from which to observe, well aware that no divine position exists. When describing the labyrinthic society, one is

oneself trapped in the labyrinth. The only possibility for the theoretical description of society is to find a good position of observation inside the labyrinth, as Luhmann has noted with a certain cynical irony. The sociologist therefore represents, as Luhmann emphasizes with the title of the book, which marked the symbolic completion of his authorship, *Die Gesellschaft der Gesellschaft*, society's observation of itself as society.

Hypercomplexity

As already noted, on the basis of society's enormous communicative reach, it cannot find its center in an absolute rationality, whether this rationality is incarnated in the state, the organization, or the individual genius with scientific or artistic talent. Indeed, even the assumption that society's midpoint or ground cell is the human being—connected with the concept of the "transcendental subject" and this subject's theoretical, practical and aesthetic ability to make judgments, is now obsolete.

I have myself proposed the completely different term of the "hypercomplex society" (Qvortrup 1998). The basic assertion behind this term is that we are entering the so-called information age, where we are exposed to greater and greater complexity in our world. The involvement with a more and more complex world is the greatest challenge of our time. We have, via the media, as the German social commentator Hans Magnus Enzensberger remarked some years ago, a view of innumerable civil wars (Enzensberger 1993). We are subject to laws, which before being problematic in their consequences, are problematic because they are impossibly opaque. We live in a society that—irrespective of what we wish—is part of global society and cannot be reduced to the locality's distinction between those in our immediate vicinity and others. We are part of a global market where a change in the foreign currency rate in Singapore exerts an influence on the level of employment in Sjælland in Denmark. Our environment is part of the risk society's complicated optic, where the threats we face are not single dangers, which destiny has thrown upon us, but multiple risks, for which we believe we ourselves—for complicated and indirect reasons—are responsible.

What is the fundamental question in such a society? The fundamental challenge is complexity; namely the situation of there being more points of connection in the world than we are able to connect to as a society. The special thing about this challenge is therefore that complexity cannot be removed or neutralized. It is not a realistic project to build

up an even greater capacity, devise far more rules and regulations, and employ even more bureaucrats, as it was believed in the twentieth century. This marks a break with industrial society's self-understanding. This was based on the belief that by pushing human rationality to its extreme, our world could be tamed. One proposed, what were believed to be, in principle, realistic goals, such as the removal of need, unhappiness, catastrophe, sickness, which were different terms for complexity. But in a hypercomplex society it is not possible to set such a corresponding goal, i.e., the removal of complexity. We cannot fence off our relationship to the world and declare global society as canceled. Conversely, we cannot develop organizational or legal mechanisms that, through a single logic, such as the political-administrative, can make the global society manageable. Therefore, the question of complexity has become a topical subject for the analysis of society—for pessimists and optimists alike.

But why should this condition be called "hypercomplex" and not just "complex"? The answer I have developed in my book about the hypercomplex society is that hypercomplexity is a term for complexity of a different power, namely the complexity of complexity. In only a few places in his work does Luhmann use this concept (cf. my references in chapter 1 above). The first time one meets with this concept is in his main theoretical work from 1984, *Soziale Systeme*. He defines hypercomplexity in the following manner: "We term *hypercomplex* a system that is oriented to its own complexity and seeks to grasp it as complexity" (Luhmann 1984, p. 637; English translation, p. 471). Correspondingly, he says in *Die Gesellschaft der Gesellschaft*, that when one observer describes another's description of complexity, hypercomplex systems arise (Luhmann 1997, p. 139; the concept is also found on pp. 876 and 892). This condition of hypercomplexity appears to arise when a functionally differentiated society describes itself: A functional system describes another functional system, which describes a third, which again describes the first and so on, and at the same time each describes this complex system of mutual descriptions.

Polycentrism

The concept of hypercomplexity represents a way of expressing a developmental tendency in the present condition of society: The ground structure in society is not a relationship between a center of control and rationality and a world of disorder that is to be brought

into control. The ground structure is that there are established structural connections between particular complex systems, and that it is complexity itself in this system of structural connections that creates a temporary stability.

This means that the idea and belief in a universal, not-to-be-abandoned principle—the human principle—is replaced by the acceptance that it is no longer possible to find a privileged position or perspective from which the world can be described. Anthropocentrism is replaced by polycentrism, the monocentric society by a multicentered society.

The background for this development is the growth in complexity. With the growing opportunity of making connections through transport, trade, media, and information systems, it means that everything taking place in the world gradually becomes communicatively accessible: Society becomes a global society. And in relation to such a complexity, a single standard or perspective is not adequate. We cannot manage this incredible complexity if we in the end seek a single principle, either God or Man. As already indicated, the anthropologists discovered this in the 1800s: They traveled abroad with a universalist European perspective, i.e., measuring the world according to a European standard. The expected result was a fundamental difference (or differentiation) between "us" and "the other," the civilized and the primitive. But they discovered that the foreign social world under observation couldn't be reduced to "the primitive," i.e. to the negative value of "the European" in the sense of "the civilized." The social world could not be contained in a simple, negatively defined category, but consisted of an other, equally complex culture. For this reason, the European ruling class's perspective had to be replaced by one justified by self-observation, i.e., observing the foreigner while knowing that this foreigner was observed in a manner that was in itself just as "peripheral," i.e., just as random. Each observation could in other words have been done differently. This doesn't mean that each observation is contingent, and that we therefore in principle don't know anything with certainty. Instead, it means that each foreign observation implies a self-observation.

This experience is articulated not least in art. Where anthropocentric art celebrated the central perspective's naturalness, the artists of the late nineteenth and early twentieth centuries, e.g., the Impressionists, placed self-observation on the agenda as art's fundamental concern. The water lilies painted by Monet are not nature's water lilies existing in themselves, but water lilies as they exist through Monet's observation. The phenomenon under observation is Monet's

own observations of the world, his "impressions." Art turns inward, anthropology likewise, and science and politics lose their anthropocentric naturalness.

The Controversy over Modernity and Hypercomplexity

Just as the highest principles were attacked in the transition from tradition to modernity, human rationality and beauty—the modern gods—are being challenged in the transition from the modern to the hypercomplex society, i.e., from industrial society to the so-called information society. The celebration of natural beauty, rooted in human taste, is replaced by a critical and skeptical art, which cultivates neither music's natural harmony nor the pictorial image's glowing proportions. The belief that the human is at the center of society, setting norms, is replaced by the insight that the human belongs to the surrounding world. This is because society's building blocks are not humans, and a social system cannot be explained by such and such a number of human individuals. "Society is the encompassing system of all communication, which produce themselves autopoietically, when in a recursive network of communications, new (and always different) communications are the whole time created" (Luhmann, 1997 p. 72).

Behind this, as already mentioned, lies the growth in opportunities for communicative connections, i.e., the growth in complexity. And therefore it is just as logical that our time's conservative cultural debate is a fight against complexity, as Pascal's was a struggle against the linear perspective—i.e., anthropocentrism—in painting. It is just as logical that our time's optimists venerate complexity's unlimited growth. Correspondingly, it does not come as a surprise that the global digital network—the Internet—has become the preferred icon of cultural commentators taking either a critical or an optimistic stance. It is indeed the Internet that symbolizes the ultimate global communication and is therefore the icon for our time's hypercomplexity: criticized by the skepticists, praised by the optimists.

Some regard these developments in a critical light, while others are more positive and praiseworthy. Some assert that the new information and communication technologies represent the ultimate reason for the collapse of human culture. The Franco-Italian social commentator Paul Virilio has studied, for example, the growth in complexity represented by the increase in speed, and the critical analysis he has developed he has called "dromology": With optical fiber cables our world is accessible at the speed of light, and the complexity that one could hold at a

38 FRAMES OF SELF-OBSERVATION

distance because of the slowness of time collapses in the form of the simultaneous presence of everything: "Today we have implemented the three divine attributes: the simultaneous presence of everything, the moment, the immediate" (Virilio 1998, p. 27). The result is a potentially catastrophic situation, without the support of older eschatological beliefs in the future: "Through interactivity, networks and globalization, which the revolution in the means of transmission brings, we have created the possibility of a catastrophe, which is no longer specific, but general. A catastrophe has been prepared, which will occur everywhere at the same time" (Virilio 1998, p. 89).

Ironically, one encounters precisely the same kind of simplification among techno-gurus such as Bill Gates, Nicholas Negroponte, and Michael Dertouzos, but—naturally enough—under the opposite sign. We find the Day of Judgment replaced by a 1,000-year kingdom, and where the cause of the catastrophe for Virilio is found in the simultaneous presence of everything in the global network, as it represents the highest imagined degree of complexity, it is now seen to be the precondition for the realization of the best of all worlds. All three—Gates, Negroponte, and Dertouzos—celebrate the global, digital communication web because it makes possible unlimited growth in complexity (communicative tempo and range). Bill Gates talks enthusiastically of "frictionless capitalism," i.e. of a capitalism that via broadband reception can be perpetually speeded up. Negroponte presents similarly naïve scenarios of the global "digital intimate community" (Negroponte 1995, p. 19). The dream society for Dertouzos is a digital village marketplace stretching across the globe, "a twenty-first century's village marketplace, where people and computers buy, sell and freely exchange information and information services." (in Dertouzos's introduction to Bill Gates 1995, p. xv).

Just as the struggle was previously between critics and optimists of rationality, between critics and optimists of civilization, today it is between critics and optimists of complexity. The interesting point is not which of the parties is correct. The interest lies in the realization that irrespective of whether they are or are not conscious of it, it is the phenomenon of complexity that is the central topic of contention—complexity in space understood as the presence of everything around one point (the digital village marketplace) or complexity in time understood as the presence of everything in a single moment, as in Virilio's dromological "now." Exactly as the struggle over the transition from the traditional to the modern society was a struggle over the place of the individual in the world—a struggle for or against rationality,

beauty, progress, and so on as the natural standards—so today the struggle is for or against complexity. A theory about contemporary society must therefore take as its point of departure the phenomenon of complexity, while from a practical perspective the question posed must be, how should complexity be managed?

Society's Wealth

One of the consequences of the transition from the industrial society to the increasing predominance of the hypercomplex society is that the understanding of the creation of wealth in a society can no longer take as its basis the relationship of exchange between the human and the material world. This means for example that the labor theory of value is no longer adequate as the central concept for understanding the wealth of a society.

As late as the middle of the 1700s, the dominant view was that the source of a society's wealth was land and working it to release its fertility. According to the French physiocrat Quesnay, there were three sources of capital: firstly creatures, agricultural buildings, and the like; secondly the landowners' property in the form of permanent improvements made to the land (drainage, fences, etc); and lastly the so-called floating or working capital represented by the wages of workers, the cost of seeds, and so on. If one follows Quesnay's sophisticated *Tableau economique,* it is evident that most of the capital is re-circulated in the form of wages and payments to the so-called sterile class (craftspeople etc). The excess—profit—comes from the earth, i.e., from the harvest, not from the work. Here we find the key to wealth in the traditional society's agricultural economic optic (Blaug 1962).

Already in 1776, the physiocrat's view of a society's wealth was challenged by Adam Smith, who introduced his *Wealth of Nations* with the following assertion: "The annual labour of every nation is the fund which originally supplies it with all the necessaries and conveniences of life which it annually consumes" (Smith 1976, p. 10). But it was in 1817 that this opening thesis was first developed by the English economist David Ricardo into a fullworthy theory about labor value. He showed how Adam Smith, in spite of his intentions, mixed use value with exchange value. Ricardo made the following determination: "The value of a commodity, or the quantity of any other commodity for which it will exchange, depends on the relative quantity of labour which is necessary for its production" (Ricardo 1971, p. 55).

It is only in recent years that a new source of wealth has been introduced: not land, not physical work, and not the means of production, but knowledge. One of the pioneers in understanding knowledge as a source of wealth is Fritz Machlup, who in 1962 published his pathbreaking investigation of knowledge work and the circulation of knowledge in the U.S.A., *The Production and Distribution of Knowledge in the United States* (Machlup 1962). His investigation was nevertheless limited by an extremely wide and so-called "subjective" definition of knowledge. Daniel Bell in 1973 therefore proposed that knowledge should be defined more narrowly and "objectively," i.e. as it has materialized itself in the form of books (Bell 1973, pp. 174–177). The drawback with this definition was that the dynamic aspects of knowledge were omitted. More recently, the economist and theoretician of organizations Peter F. Drucker has worked on the development of an economic paradigm with "knowledge" as its central category. In 1989, he summed up his work on the so-called knowledge economy: "[K]nowledge has become the capital of a developed economy, and knowledge workers the group that sets society's values and norms" (Drucker 1989, p. 169). But, even though expressions such as "knowledge economy" and "knowledge worker" are now more frequently encountered, most of the works on the knowledge economy keep to the micro-plan and limit themselves to investigating the significance of knowledge in the reproduction of organizations, while study of the "political economy of knowledge" is still in the absolute earliest phase.[7] What is basically knowledge on a national scale? How is it measured? How does knowledge circulate in a society? How is a network of specialized knowledge-producing institutions (universities, research institutions) and knowledge-distributing institutions (educational institutions) established? Of these things, we still know very little.

The Nation-State or Procedural Community?

Another consequence of the transition from modernity to hypercomplexity is that we must redescribe "social order," i.e. what makes society a society.

A dominant conception is that "society" is the same as "nation." The idea is based on the view that there are two parts, namely the territorially defined cultural community, which has grown organically from below, and a political-administrative system, the state, imposed from above, which surprisingly not only fit together, but continue to do so.

The state provides stability to the culture, and the culture is a source of legitimacy to the state. The difficulty is that these two parts are well on their way to growing apart from each other. The stabilization processes in the hypercomplex society increasingly take on the character of what Ilya Prigogine in the natural sciences has called "dissipative structures," i.e., structures that on the basis of their complexity—and precisely not because of their simplicity—are a source of temporary stabilizations. Niklas Luhmann's social theoretical conception in answer to this is the self-regulating system of "differentiated functional systems," which stabilize themselves via an incredible number of communication processes, i.e., by mutual observations and decisions. The sense of community is formed where communication processes are stabilized on the basis of common codes or themes. Here, the conception of society as a nation-state that is formally based on a social contract and in real terms on a cultural essence, more strongly interfaces with the view that society is in real terms all the actions that are communicatively accessible and formally is based on a procedural community. In Europe we are familiar with these two views from the debate about the European Union: Are we experiencing a steadily stronger overnational territorialism, which threatens the cultural essence of nations, or is the European Union a community of procedures that support the procedures that are already a reality on the basis of communicatively accessible actions, and cannot be limited to the local area, region, or nation, but are of a boundary-crossing character?

Organizations and Enterprises

Already in 1945, the American information theoretician Herbert A. Simon proposed the concept of "bounded rationality" in his book *Administrative Behavior*. With this he moved organization theory into the hypercomplex age.

However, for many years after the book's publication Simon was neither understood nor given just recognition. Also, in the world of organizations the first reaction to the growth in complexity in the world was to meet external complexity with bureaucracy. Private enterprises developed horizontal specialization and vertical lines of command based on a strict hierarchy, and public institutions created detailed rules and procedures, based on the belief that surrounding complexity could be met and balanced by a similar amount of internal bureaucracy-based complexity.

It is only in recent years that other organizational strategies have seriously been put on the agenda. Instead of building up a greater and greater competence toward complexity in an enterprise, decentralization has been attempted. Instead of introducing more and more rules, the attempt has been to create greater flexibility, based on the premise that pressures from the surrounding world aren't necessarily to be met by making boundaries and exclusions, but through adjustments leading to accommodations. Instead of observing the surrounding world through one single optic—profit/loss—one has supplemented economic accounting with ethical accounting, "green" accounting, and so on. Instead of decision-making centers facing steadily increasing pressure, they have experimented with decentralized decision-making structures. Instead of inflexible principles and immutable traditions, organizational learning has gained a place on the agenda because shared learning is a precondition for coping with change. Indeed, one even operates with a concept of second-order learning, i.e., referring to learning processes based on self-observation. In other words, it is clear that in the field of organizations, the presence of the hypercomplex society and complexity has become a challenge requiring new principles to deal with it.

What is the background for this development? It is the transition from the modern society, industrial society, to the hypercomplex society of our time. In industrial society the large majority of organizations and enterprises worked with physical things: The employees, as Daniel Bell has put it, battled with nature and with processed nature. Today, most organizations and enterprises deal with signs. The employees don't work with a material world, but communicate by making and managing symbolic representations. This is in itself a sign that the task is to manage complexity.

This has consequences for the concept of leadership of our time. Leadership is no longer a privilege or the birthright of an individual, for the simple reason that a single person is unable to interpret all the information with which an organization is bombarded. Leadership today must be a collective decentralized function; otherwise the organization has little chance of making an evaluation and adjusting itself to the demands of surrounding society, which is continually changing.

The background for this change in fundamental organizational principles is, as said, the transition to the hypercomplex society. For a long period up until the 1700s, everything was to be explained according to the principle of God. All events, large or small, had their root in "destiny" or the "will of God." Political leaders and leaders of organizations

were leaders on the basis of a higher power. They weren't to be elected by the people, but were born with privileges. The name of the organization was "collegium," a community of like-minded individuals, and the head of the collegium—the warden or ephor—was the leader on the basis of a birthright or inherited characteristics. Here, we have the theocentric style of leadership.

From the Renaissance and through to the Enlightenment of the 1700s, man was placed at the center. Social relations were to be explained in a rational manner, and explanations were demanded of everything. Science, common sense, and public speech were put on the agenda. Also, in enterprises and organizations, rationality and science triumphed, in the Prussian army as much as in the growing number of industrial enterprises. With this the foundation for the industrial society and the anthropocentric leader was created. The rational man as the rational and professional leader was placed in the center. One of the foremost exponents for this kind of leader was Henry Ford. Both internally within the Ford Motor Company and in relation to customers, scientific principles were applied. Internally, all activities down to the smallest detail were to be studied with a stopwatch and time chart, and thereafter combined as rationally as possible, i.e., through a strict division of labor, a clear chain of command, and a task segmenting production line. Enthroned at the apex was embodied reason: the professional leader, Mr. Ford. Even the market was observed according to the principles of reason: Why produce hundreds of different models, when it was most rational to produce one model with one color: the black Ford Model T.

Today, organizations and the world in which enterprises find themselves, both externally in terms of the market and internally in terms of their systems of communication, have become so complex that Fordism is no longer adequate. With respect to the external world, the market for example has transformed itself. Customers no longer make their purchases on the basis of one criterion, the price, but look at the commodity's style, i.e., if it fits the consumer's own self-image as a person. This makes the relationship between the producer and the customers multivariable. When the customer looks to see if the commodity contains ecological values, or if the manner in which it is manufactured meets animal ethical standards, the customer represents in reality what one can call a "wandering gaze." In a changeable manner, he observes himself in the search for "inner values," selecting from an assortment of commodities to find the qualities to match these values. And the obverse: In a changeable manner the customer observes

the assortment of commodities to find the life values that he can then apply to himself as his "own" personal lifestyle.

In this way, the commodity's brand name becomes as important as its content, and for the producer it is important to keep oriented toward—and stimulate—the customers' constantly changing image of themselves. The producers have to organize their production and their work on the basis of a long series of different and ever-changing customer values and tastes. This requires knowledge to understand a hypercomplex world, and with this an apparent paradox arises because the only thing that can reduce the complexity is more complexity in the enterprise in terms of an increased collection of information. In order to absorb external complexity, dynamic systems of secondary or internal complexity must be established.

In this hypercomplex, polycentric society an enterprise cannot depend only on economic estimates to find out how it is to survive. It has to make use of a whole range of "optics," or ways of seeing itself and the surrounding world, so that it can evaluate itself and the world, e.g., ethically, environmentally and politically. To make these optics more precise, they are converted into accounting systems and budgets: not just economic accounts and budgets, but also ethical accounts, "green"accounts, and so on. If it is to appear particularly fine, a "holistic" account is put together. When enterprises formulate ethical or green accounts, it is not in other words because their ethical or ecological conscience has increased, but because they need to observe their world and themselves on the basis of more nuanced criteria than was previously the case.

A consequence of this is that enterprises must give up the principle of a single privileged leader, a single set of impossible-to-change rules, one single over-ordinate decision-making organ, one way of looking at the world, etc. Leadership is therefore to be distributed throughout the organization. Other workers and colleagues are to exercise leadership themselves in self-governing groups, using flexible network systems and telework. Telework is not then primarily a way of working from home, but a way of managing complexity: Decisions are spread around, so that it is the individual workers who, wherever they are—through consultation with their colleagues—decide where, when, and how the work is to be done.

A second consequence is that work for the individual worker changes its character. Traditional repetitive and mechanical work is replaced to an increasing degree by work that doesn't just attempt to deliver a pre-specified output, but also makes sure that the output matches steadily

shifting expectations. The work demanded increases twofold, so to speak, because one works both with the product and with planning that the product meets expectations. The work becomes, to use a systems theoretical term, output producing as well as self-regulating. Generally, the consequence will be that the work becomes more challenging and self-developing, and results in more independence. But at the same time, it will probably be experienced as more of a burden, and—not least—a burden in a new manner. Like the customer, the worker will operate with a "wandering gaze," where he or she will observe in a shifting manner the work product and the work process. Fellow workers will be given greater responsibility to work in a holistic manner, while at the same time they must come to terms with an incredible amount of variable information and pass through numerous processes of change if they are to keep abreast of changes in their field of work. Where before one talked mainly about physical injuries at work, in the years to come a situation will develop with an overrepresentation of psychological injuries caused by the increasing burden of complexity.

Technology to Manage Complexity

According to Daniel Bell, information and communication technologies represent society's answer to the growing problem of complexity. "The major intellectual and sociological problems of the post-industrial society are those of 'organized complexity'–the management of large-scale systems, with large numbers of interacting variables, which have to be coordinated to achieve specific goals" (Bell 1973, p. 29). What is required is not energy technology, but what Bell calls "intellectual technology." "In this society today, millions of persons daily make billions of decisions about what to buy, how many children to have, whom to vote for, what job to take, and the like" (Bell 1973 p. 33). The swiftly increasing systems of computers and the telecommunications network are the answer to this challenge.

But is this global digital machine, today symbolized by the Internet, merely a tool that our contemporary society uses to solve its problem of complexity? No, in a strange manner the Internet is both an answer to and a reinforcement of the problem of complexity. As a decentralized observation and communication system, it is the answer to the challenge of complexity, refusing centralist answers. At the same time, however, the electronic net reinforces the problem because it makes the communicative range even greater, and therefore gives us access to

even more actions, to which we must relate. The digital revolution, in other words, is neither the cause of a frictionless millennium, nor a threat to the breakdown of "cyberworld." It is an answer to society's increasing complexity, an answer that, ironically, both solves and reinforces the problem (see chapter 6).

From Nuclear Family to Negotiated Family

Since the end of the Second World War, the family has developed from an understanding of itself as a nuclear family to become increasingly based on the ideal, or perhaps reality, of the so-called "negotiated family." From an apparently natural relationship between the biological pair and their children, the family is increasingly founded upon a contract. The explanation is simple, but the consequences are complicated. The explanation is found in how the family has also experienced the increasing pressure of complexity, not least because women have entered the labor market. Today, in a normal Danish family, two careers are to be developed at the same time as the family's traditional task of caring and nurture is in principle still the same. This means that there is a far higher degree of complexity because it can no longer be taken for granted that there is "somebody at home." As a consequence, the life of the family has to be planned on the basis of negotiations between free individuals with equal rights: Who does what, when, and according to which rationality? In such families, the maintenance of "natural" roles does not count as an argument. This seems to be the main background for why the family has become a negotiation-based organization with a democratic, collective leadership.

This gives obvious advantages, and there can be no doubt that they must be regarded as a sign of progress for civilization, not least because sexual discrimination and unequal treatment with respect to rights and opportunities have in principle been removed. However, there are also disadvantages, which must be considered. The greatest is simply that the qualitative difference between the family and the organization has disappeared. An organization can be defined as a social system based on making an entrance and later leaving: One can be a member of an organization and one can lose or give up the membership, both as a combination of one's own and the organization's decisions; e.g., I apply for employment in a given enterprise or for membership in an association, and the organization reaches a decision. I cancel my membership or give in my notice, or the organization makes me redundant or excludes

me. The precondition that the organization can function in such a manner is that the individual is free, i.e., that society is such that the person can enter and leave the organization.

There can be no doubt that the family in the post Second World War period has to an increasing extent acquired organizational traits: One becomes a member or cancels the membership, decisions are made according to democratic procedures, and one makes membership conditional upon the fulfillment of demands placed on other members. And it is not just the family's adult members who have these rights; the children are also treated to a great extent as free individuals with rights based on negotiation.

This stands in opposition to the view that the family is something other than an organization. The family as an obligated and obligating community is a qualitatively different kind of social system from an organization. The adults cannot make their children "redundant" if they don't live up to expectations, and the child cannot lay off the parents or cancel membership in the family if he or she is unhappy with conditions. The reason is precisely that the family cannot build upon the premise that it is made up of free individuals: Children are not free because they don't possess the strength to be free. Of course, with concepts such as the "competent child," an attempt has been made to conceal this. Still, however, the question is simply, at what point has the child gained the necessary skill to be "competent" enough to look after his or her own freedom?

There are a number of consequences of treating children as competent children, i.e., as individuals with adult rights. For instance, the ideal that the relation between the adult and the child can be termed among other things "upbringing" is replaced by a tendency toward the ideal of relations based on negotiation, where it is reasoned that it feels wrong to assume that one party is more competent or possesses greater rights than the other party. Also, the expectation of the adult's duty to care matched by the child's obedience is likewise replaced as a tendency by the principle of negotiated relations. Children as equal members of the family organization are not willing to accept imposed commands, demanding instead qualified arguments.

Now, it is only in the fewest of cases that such principles are fully implemented. But even if one accepts that there is a difference between children and adults, and social relations between parents and children take this into account, this doesn't solve the problems connected with adults, in this context parents, who do have the right to enter and leave the family. Two important questions are, what kind of obligations do

adults have with respect to their nonbiological children, and what kind of expectations of an obligated and obligating community can children demand from so-called "paper parents"?

The Complexity of Complexity

As a conclusion to this short overview of society redescribed, cf. Table 1 (and also of the redescription of society's self-description) it is important to emphazise that society has not just developed toward a higher *degree* of complexity, but that—and this is probably not in itself new, but has perhaps been radicalized on the basis of the increasing tempo of change—can be called the complexity of complexity. Not only does the polycentric social semantic it has developed toward a new *condition* that on its own represent a high degree of complexity, but it exists alongside other social semantics. Children can in their everyday lives maneuver within the negotiated family, while on the weekend—when visiting their biological father who now lives with his new wife and children—they should be able to act in accordance with the nuclear family's principles of roles, scripts, and benefits; and lastly, on celebratory occasions with grandparents and the extended family, they should be able to live up to the expectations of the dynasty and of being together with several generations under a care-based authority structure and sexual division of labor. Correspondingly, the generations meet as representatives for three different forms of the production of social wealth, just as network-based organizations could scarcely function if they didn't rest upon a solid foundation of bureaucratic order. One type of complexity is added to and must observe other types of

Table 1

Social Semantic	Society's Wealth	Social Order	Society's Organizations	Society's Family
Theocentrism	Land (ownership)	Caste/rank hierarchy (natural order)	Collegium (multigenerational career)	Dynasty
Anthropocentrism	Work (industry)	Nation state (social contract)	Bureaucracy (life career)	Nuclear family
Polycentrism	Knowledge (complexity management)	Communicative accessibility (procedural community)	Network (change of career)	Negotiated family

complexity. We are no doubt all familiar with network-oriented career people, who on the one hand are keen to praise the highest degree of flexibility, while on the other hand wouldn't be able to hold together a complex existence if the trains and planes didn't—according to complex timetables—arrive on time.

THREE

The Aesthetic Self-Observation of the Hypercomplex Society: Theocentrism, Anthropocentrism, and Polycentrism

Introduction

In this chapter I will exemplify the basic distinction between theocentrism, anthropocentrism, and polycentrism with examples from the art domain. In the first section I will present the transition from theocentrism to anthropocentrism, while in the second section I will present the transition from anthropocentrism to polycentrism, with particular emphasis on interactive multimedia art.

It is my contention that it is misguided to speak of "modern art," "postmodern art," "postindustrial art" etc., when these concepts "modern," "postmodern" and "postindustrial" are sociologically inspired designations of historical periods. It is not correct to assume that to a certain historical period one can find a corresponding artistic "ism." This is not to reduce the significance of concepts such as modernism or postmodernism. These concepts can function as labels—although they normally lack conceptual conciseness and their assumed relationship with sociological categories is often misguided—for artistic trends, i.e., designations of artistic expressions with an unintentional or intentional common aesthetic form. However, it is not true that for a sociological period there is a corresponding artistic category. Art is not indebted to society and cannot be "deduced" from it. Art is a closed system—an autopoietic or self-referential system, Niklas Luhmann would say—whose particular function (i.e., "way of functioning," not "task") is to observe the world

based on a code that differentiates between form and ground. Art makes observations of form based on criteria that are specific to art. Within particular art "isms," particular types of form-observations are made.

These form-observations—and the historically or genre-specific forms of form-observation—are motivated in themselves. This does not imply that there is no correspondence with the social system. On the contrary, structural couplings can be found, if not in other ways, then in the sense that society—in addition to all other kinds of self-observation—observes itself through art as a medium for self-observation. Society thus observes itself for example through economics, politics, justice, science; appearing as economic society, political society, society governed by law, and knowledge society, respectively. Similarly, society giving aesthetic form to itself becomes society for itself through art, for instance representing certain aesthetic values (so-called Danish design, South European culture, North American architecture, etc.). In addition historical and geographical self-descriptions are formed within these many codes of self-observation. One can write the economic or political history of society, or with a geographical distinction, one can differentiate between different synchronic economic and political systems. Similarly, within a specific social system one can argue about the most adequate economic, political, or judicial description of the system. Although the social system can be observed in different ways—artistic discord pertains to this among other things—the ways in which the observations are made cannot, from an *ex post* position, be described as erratic. Processes of interference develop between the social system and the system of art, and as contingent as such structural couplings seem to be for contemporaries, as logical and filled with necessity they appear to be when entered into the book of history.

The conclusion of this theoretical introduction is that a certain artistic phenomenon can be described on the basis of its societal preconditions, i.e., that which is uttered through the artistic articulation, and from its substantial preconditions, the qualities of the medium through which artistic utterances are made. In other words, one can identify the artistic phenomenon's "epistemological" conditions, i.e., the social conditions for the artistic articulation, the social circumstances that are being reflected. However, one cannot deduce from a socioeconomic basis a corresponding aesthetic superstructure. The only possibility is to identify cases of structural couplings, i.e., to explore specific examples of interferences between mutually closed, autopoietic systems, for instance society's economic or political system interfering with the art system. Thus, the only possibility is to say "something." "Economy"

and "art" are not connected via causal mechanisms. For the determination of specific aesthetic forms is always the matter of art itself, despite the way in which it appears through the retrospective rationalizing optics of history.

From Theocentrism to Anthropocentrism

When he had completed his work, the Creator desired there might be someone to contemplate the reason of such a great work, love its beauty and admire its greatness. He therefore resolved finally, although all was already completed (. . .) to create mankind.

—Giovanni Pico della Mirandola,
Oration on the Dignity of Man

A New Vision

When God had created the world with its land and seas, plants, beasts, and angels, there was still one thing missing, according to Giovanni Pico della Mirandola, who was introduced in chapter 2: someone who could contemplate and admire this creation. That is, someone who was neither land nor sea, plant, beast, nor angel, but who stood outside. For only from without can the world be admired as a structure. And therefore he created the human being.

This means that according to Pico and his contemporaries, man's crucial faculty, which distinguishes him from all other creatures, is the ability to apprehend the world in a perspective that is neither the world's own nor God's. For that which is one with the world's perspective cannot see the world, and that which shares God's perspective cannot admire what God has created.

Yet this process, in which the vision of man developed, took place less in the time of the creation of the world than in Pico's own time. The humankind he describes is not humankind as such, but the modern human. That is why the first subject of this chapter is the genesis of modern vision. For we have unique documentation of the development of vision in the fifteenth century: the art of painting. By studying painting after painting we can see how the eye that the human turned on the world was revolutionized.

We take as our point of departure a picture from the premodern period,

as we know it for example in Danish church murals. In the pictorial representation of the Middle Ages—and artistically the murals reflect the worldview of the late Middle Ages—"depth becomes surface," as Paul Virilio has written in his book *La machine de vision*. "All the figures, even all the infinitely small details—or the context, one could say—stay at the same level of reading or vision" (Virilio 1989).

So it is with most of the murals in the Danish churches. Everything is equally clear, nothing is foreground or background, everything is at the same level. These pictures thus represent absolute authority, that which sees all, whether it is large or small, near or far, high or low. The vague does not exist, nor do depth or distance, and there is no difference in the intensity of light. Everything is equally clear. What these murals reproduce is, in other words, the vision of the Almighty, not that of the artist himself.

Concurrently with the Danish murals—"concurrently" in the chronological sense but, as we shall see, by no means in terms of social history—the art of painting was revolutionized in northern Italy. The rules of so-called linear perspective were formulated by the architect Filippo Brunelleschi (1377–1446) as a practical tool, in the architectural drawings his artisans were given in his unprecedented, bold church buildings. Soon afterward the principle was popularized by Leon Battista Alberti in his small treatise *Della Pittura*. The discovery immediately won acceptance in painting—or perhaps one should say that it had developed concurrently in painting as another expression of the intense scientific and cultural debate of the age—and was exploited with rapidly growing mastery, culminating in Leonardo da Vinci's famous *Last Supper*, painted in the years 1495–98. Within about 50 years the skills we today consider natural were acquired: the spatial and atmospheric perspective of the picture, the differences in the intensity of light, the depiction of the human figure as a psychologically unique individual.

But what is it that makes a difference? The difference is that these new, modern pictures show the artist's and not God's view. It is the artist who uses linear perspective to express his presence; who uses changes in the concentration of light and the contrast between the clear and the vague to show his view. The depth of the picture is not, as has been erroneously believed, a mirror of the depth of reality. The depth of the picture is the artist's depth, and by introducing himself as the center of the picture, outside the picture, the artist has placed an incendiary device under God's absolute authority.

There is nothing to suggest that this was done intentionally. The new way of painting was not the result of a new point of view in the political

or religious sense, it did not speak on behalf of any "political correctness." On the contrary, there is everything to suggest that it was a form of expression coming to life despite the artists' religious views. They were driven to change their perspective by the age's new departures in knowledge; they could as it were not do otherwise, but the ideological consequences of this are unlikely to have been clear. On the contrary, a tension was introduced into the picture. On the one hand, it no longer spoke on behalf of God. In its perspective it was not the image of God, it did not reproduce God's view; it spoke on behalf of the human being, it was the individual's picture of the world, and thus the individual's picture of himself as unique. On the other hand, the picture still paid tribute to God, and its motif was God the Almighty. The best of the pictures of the age quiver with this internal tension.

From the Theocentric toward an Anthropocentric Perspective

As a point of departure for illustrating these issues, and the development of linear perspective in particular, I will take a group of pictures from the fourteenth and fifteenth centuries. To provide the best possible basis of comparison, and to avoid the effect that differing motifs could have on the artistic treatment, I have chosen a number of pictures with the same motif—the Last Supper. In addition, the artists in most cases used the same technique, fresco. The order in which the pictures are presented is not chronological, but represents a clear sequence in terms of ideological development.

Although these pictures have the same motif, they are stylistically so different from each other that it is no exaggeration to say that they represent fundamentally different epochs. While the first picture is clearly premodern, the last three are just as obviously from our own era, while the second, by Giotto, is from a transitional phase. The crucial difference lies in their use of perspective. The pictures by Andrea, Leonardo, and Tintoretto were painted according to the rules of linear perspective, while the picture from Mørkøv in Denmark is, as we would say, "out of perspective" or "without perspective."

In the Danish mural—as in thousands other European pictures from the same period, including an example from the Church of Our Lady in Kritsa, Crete—the disciples are seen *en face* and without any visible spatial distribution. The table is shown both from the side and the top, and the objects on the table are shown from their most characteristic angles: the plates and knives from above, the bottles and glasses in profile. In other words, no particular point of observation is indicated. The

Figure 2 Mural in Mørkøv Church, Denmark, painted around 1450. Anonymous. © The Danish National Museum

motif is seen from many different observation points, i.e., by an observer who is everywhere and who can see everything. This observer is God, as defined by Plato: the God whose center is everywhere and whose circumference can never be reached.

By comparison, the picture by Giotto represents an interesting transitional phase between premodern and modern painting (White 1967 [1957], pp. 57–71). The human figures are clearly distributed in the space, and there are also signs of linear perspective in the bench and the building. On the other hand, it is obvious that Giotto has not fully mastered the techniques of linear perspective. The flatness of the space is striking, and most conspicuous of all are his difficulties with the haloes of the disciples, which resemble large plates, sometimes appearing to cover their faces. It is clear that in Giotto's time there was as yet "no fixed theory of perspective construction. There were no set rules to be obeyed or broken" (ibid., p. 60).

By contrast, Andrea del Castagno's picture appears at first glance to be a perfect example of linear perspective. Yet closer scrutiny reveals some clear problems (ibid., p. 198f). There are six square marble panels on the back wall, and they seem to be repeated—i.e. as squares—on

Figure 3 Mural in Capella Scrovegni, Padua, painted in 1305 by Giotto del Bondone. © Scala Archives

each of the two side walls. As a result, viewed in perspective, the whole space should have the form of a perfect cube. But there are 34 arches in the decorative frieze under the ceiling on the back wall, while there are only 17 in the depth dimension, i.e., along the side walls. Similarly, the ceiling with its tilelike decorations does not seem to harmonize with the rest of the room, nor do the disciples, on the benches on which they are seated, seem to fit the cube or, if we are to believe the decorative friezes, a box that is twice as long as it is broad. Finally, the table is painted in a very simple way, in silhouette and with the tabletop at eye level, avoiding the difficulties of a perspective view of plates, etc.; and the disciples appear as motionless figures without any particular psychological characterization (cf. Leinz 1979, p. 79). It is especially striking that Judas—as in the Danish mural, and in innumerable other pictures from the same period—rather than being characterized psychologically, has been separated from the other disciples and placed on the reverse side of the table. Of course it is possible

Figure 4 Mural in the Cenacolo di Sant'Apollonia in Florence, painted in 1445–55 by Andrea del Castagno. © Scala Archives

that the rules of linear perspective have been broken deliberately, but it is difficult to find a convincing artistic reason for this. So it is most likely that this fresco is an example of a work by a Renaissance artist who was on his way to mastering linear perspective.

Leonardo's fresco of the Last Supper on the end wall of the refectory in Santa Maria delle Grazie in Milan is not only one of the most famous pictures of the Renaissance, it is also a picture in which the illusion of perspective seems perfectly created. Linear perspective in the room in which the supper is held is supported by the aerial perspective of the landscape in the background and by the light and shade, and the painting is convincingly integrated in the refectory, almost like a trompe l'oeil.[1] The perspective furthermore underscores the basic message of the fresco, since the vanishing point is exactly behind the head of Jesus. Finally, the figures are vividly psychologically characterised, and to achieve the highest possible degree of realism Leonardo has left out the haloes, whose effect is replaced by the light and the vaulting above the head of Christ.

All the same, on closer examination not everything is perfect. For example, it has been pointed out that there is a contradiction between on the one hand the relationship between the real architecture of the refectory and the painted architecture of the fresco, and on the other

58 FRAMES OF SELF-OBSERVATION

Figure 5 Mural in the refectory of Santa Maria delle Grazie in Milan, painted in 1495–98 by Leonardo da Vinci. © Scala Archives

hand the correct observation point according to linear perspective, which is 4.6 meters above the floor height of the refectory (Kemp 1990, p. 49, and Kubovy 1986, p. 141). Some art historians have said that this and other ambivalences are the result of the technically insoluble dilemma that there is only one correct observation point, while the viewers of the picture could move freely around the refectory. As a result, Leonardo "has done his ambiguous best to preserve the illusion, but even he must admit ultimate defeat" (Kemp, p. 49). However, I would rather follow Kubovy's analysis, according to which the mismatch between the trompe l'oeil effect and the correct observation point produces "a 'difficult' work of art, one that forces you to engage in mental work to overcome the obstacles." This is all the more obvious if Lillian Schwartz is correct in saying that one originally entered the refectory through a now walled-up door at the "right" observation level and then proceeded to the lower floor height (Schwartz 1995). According to Kubovy, "the result is a vibrantly tense work full of foreboding. Leonardo used perspective to elevate the viewer to an extraordinarily high center of projection, thus achieving a feeling of spiritual elevation" (Kubovy, pp. 145 and 148). The effect is a spiritual elevation

Figure 6 Oil painting in San Giorgio Maggiore in Venice, painted in 1592–94 by Jacopo Tintoretto. © Scala Archives

of Jesus, it should be noted, compared to that of the lowly, humble human observer.

My last example was painted almost a hundred years later, in 1592–94, by Jacopo Tintoretto, regarded by many as the greatest of the so-called Mannerist painters. His *Last Supper* is one of his final pictures. While, in the picture of Leonardo, the observer was still placed beneath the level of Jesus and the disciples, his implicit position in Tintoretto's picture is quite different. Here it is the observer who is in the superior position. Not only has the observing "camera" been lifted in the air, it has also been moved to the right side of the motif, and an oil lamp casts dramatic light over the scenery from overhead in the background, while at the same time swathing the scene in smoke, from which angels seem to be materializing. There appears to be no background in the picture, only a "tunnel of darkness without end." "Space here is not a measurement, not an artefact of perspective, but a kind of infinite music. (. . .) With Leonardo, Christ was still center; here He is caught up in the force which sets the world spinning" (Wolf and Millen 1968, p. 114f).

In Tintoretto's picture the artist is so preoccupied with his own abilities that he almost forgets the religious motif he is painting, or he is so

strongly affected by the development that began with the early Renaissance that he is unable to fall back on a harmonious, trusting faith in God. The implicit message in the Leonardo, that anthropocentrism and theocentrism are latently in conflict, is fully expressed in the Tintoretto.

The Human Being at the Center

For many years the construction of linear perspective has been interpreted as the discovery of an existing reality. Linear perspective is a "fact" that was only waiting to be discovered by humans. More specifically, linear perspective has been viewed as an expression of progress achieved through the development of science and technology. Piaget, for example, saw linear perspective as a historic victory, which is repeated in the course of each person's ontogenetic development. Linear perspective is accordingly an expression of maturity, and the European world matured in the fifteenth century.

However, an alternative approach has recently been suggested. In an article entitled "Visual Perception in People and Machines," V. S. Ramachandran proposes that linear perspective is one of many possible ways of organizing and constructing reality, i.e., one of several possible visual tricks (Ramachandran 1990). In this view linear perspective is not an abstract example of progress, but a conscious or unconscious choice, i.e. one of several possible ways of seeing the world.

If this view is correct, the question is then why this organizational principle has been chosen. What is the meaning of linear perspective? Or, to put it differently, what is the meaning-bearing difference between the first two and the last three pictures shown above?

The basic difference is the point of view. Every picture is both an utterance about something and an utterance about itself. Every communication is both a communication and a communication about communication (Watzlawick, Beavin, and Jackson 1967). It says what it is, and it says how it is what it is. Every utterance is also someone's utterance. In the case of a painting, its aesthetic organization implicitly tells us whose picture it is.

Whose signs are the early paintings of the Last Supper? These pictures are God's signs—or, more precisely, they are signs of a nonlocalizable observer. As has once been said, a straight line is a segment of an infinitely large circle. In such a circle the center cannot be localized. Similarly, all objects and persons in the premodern paintings, regardless of their spatial position, have the same size,[2] and the pictured objects are not ordered according to any spatial structuring principle.

These pictures have no localizable center of observation. The nonlocalizable observer is God: the universal observer for whom everything is observable, and for whom everything has the same size and is of equal importance.

The alternative to the nonlocalizable observer is the individual observer, i.e., the individual artist. And as a member of the audience, i.e. as a "viewer" observing the artwork, one must place oneself in the artist's position—at what the theory of linear perspective calls the "correct observation point," which can be reconstructed by analyzing the individual picture. This is incidentally true both in the literal and in the metaphorical sense. One can geometrically reconstruct the artist's observation point; but one can similarly aesthetically reconstruct the artist's point of view, the "meaning" of the picture. As a matter of fact, this represents the ideological revolution of the fifteenth century: the construction of anthropocentrism, of humanity at the center.

The Betrayal of Jesus

This ideological revolution has innumerable implications. One particularly important, but unintentional, consequence is that the artist is put in God's place. He or she becomes divine.[3]

For me this is especially clear in Leonardo's *Last Supper*. As I have already demonstrated, this fresco is a perfect example of linear perspective, and gives us a unique example of people characterized as psychologically different individuals. All the technical skills acquired in the period are found in this picture.

But there is an even more profound dimension in Leonardo's *Last Supper*. His painting represents the very moment when Jesus says: "One among you will betray me" (Matthew 26:21; Mark 14:18; John 13:21). We all know that the traitor is Judas. Tradition therefore required that Judas should be furnished with a special characteristic, and a frequently used ruse was to place him on the opposite side of the table, as did not only the Danish mural painters, but also Andrea del Castagno in the early Renaissance. This ruse attained almost dogmatic status in painting.

But Leonardo approached the problem differently. Not only did he choose a different solution, which might have been coincidental, but he fought a hard struggle to avoid the traditional positioning of Judas. We can see this if we look at the preliminary sketches for *The Last Supper*. In the sketches Judas is in his traditional place, on the opposite side

of the table from the other disciples. It is, however, clear that Leonardo was not satisfied with this solution, so he "integrated" Judas among the disciples, where he sits fourth from the left. However, he is shown leaning on his elbow over the table, so a shadow is cast over his face. Thus he is part of the group, yet is at the same time outside it. This is important, because Judas is not a particular person; he could be anyone. For the real drama in Leonardo's picture is that every human being is potentially the Judas who betrays Jesus. This includes Leonardo himself as an artist as well as the public who look at and celebrate Leonardo's picture, and of course those who ate their daily meals in the refectory, as symbolic participants in the Last Supper. They all represent the modern person, who must therefore always reflect upon him- or herself as a potential Judas.[4] The implicit statement of Leonardo's *Last Supper* is thus that by intervening in God's position as the universal observer, and by changing the way the world appears accordingly, the modern person potentially betrays God. For the same reason Jesus does not address any particular person in the picture, but everyone, including the artist and the public who are viewers. His gaze is not turned on Judas or anyone else. Judas is not eternally the preordained sinner, and Jesus is not concerned with the discussion or the pouring of wine, but turns his gaze toward the public.

For me, it is this that distinguishes this special picture from other versions of the Last Supper: it depicts not only a crucial moment in the life of Jesus, making full use of all the technical conquests of Renaissance art; it also reflects the basic dilemma for the modern, anthropocentric human: Placing oneself at the center of the world is to put oneself in the position of God.

The Differentiation and Self-Reference of Art

The radical change in the artist's position, which can be identified as the latent content of Leonardo's *Last Supper*, and which then and later developed into a clear change in the artist's social position, was indirectly articulated by Leon Battista Alberti in his classic book of 1435 on the art of painting, *Della Pittura*, with the following revealing metaphors: "Painting possesses a truly divine power"(§25), "The virtues of painting (...) are that its masters see their works admired and feel themselves to be almost like the Creator" (§26) (Alberti 1972 [1435]).

As a consequence of this change in painting, one can no longer speak of an "objective" world, viewed from a "neutral" observation point. On the contrary, in this new situation it is necessary to make a conscious

choice from among different perspectives. If this is forgotten, instead of developing a system of differentiated subsystems, each acting according to its own specific functionality, a set of anthropocentric normativisms emerge, each claiming its specific divine status: The politician becomes divine; science becomes holy; art is made sacred; the architect, designer, engineer, programmer are installed as incontrovertible "pundits" who, as representatives of one or another world-leading position, confuse their individual standpoints with a scientifically or ideologically legitimated universalism. In order to avoid being trapped by neo-normativism, it is necessary to act with irony in its philosophical sense (cf. Kierkegaard), i.e., to combine hetero-reference with self-reference. However bothersome it may be, it is necessary for the modern artist always to make the work of art refer both to an external object and to itself as a work of art, i.e., to make a statement and at the same time question this statement. The work of art is from this point on a choice, and this choice must be reflected by the work itself—as in Leonardo's art.

But the work of art as "intervention," as aesthetic choice, must also be reflected upon from now on. When art no longer speaks on behalf of God, but on behalf of the artist representing the art system (designated by "aesthetics," "taste" etc.), art must articulate a code for itself as art. Codes like "the beautiful," "the harmonious," "the sublime" therefore make their appearance, i.e. codes that refer to and legitimize themselves solely in terms of themselves.[5] The most significant art theoretician of the age, Leon Battista Alberti, discusses this issue explicitly: He replaces the older principle of *verisimilitude*—the greatest possible resemblance to the subject of the work—with the principle of *convenienza* or *concinnitas*, which is an internal principle, i.e., a principle of internal correspondences in the work of art. The painter "must first and foremost take pains to ensure that all the parts are in accord; and so they will be if in quantity, in function, in type, in colour and in all other respects they correspond in one beauty" (quoted in Panofsky 1969, p. 26).

From Anthropocentrism to Polycentrism

The "Unnaturalness" of Contemporary Art

Zur Selbstverständlichkeit wurde, daß nichts, was die Kunst betrifft, mehr selbstverständlich ist, weder in ihr noch in ihrem Verhältnis zum Ganzen,

nicht einmal ihr Existenzrecht. Die Einbuße an reflexionslos oder unproblematisch zu Tuendem wird nicht kompensiert durch die offene Unendlichkeit des möglich Gewordenen, der die Reflexion sich gegenübersieht. Erweiterung zeigt in vielen Dimensionen sich als Schrumpfung.

In this way Theodor W. Adorno introduces his last work, *Aesthetic Theory* (Theodor W. Adorno 1970). He begins by stating a fact: that art has lost its obviousness, or naturalness. This statement is followed by what could be called a tragic judgment. The argument is that the alternative to naturalness, to spontaneity, is reflection. The conclusion is that the loss of spontaneity is more important than the capture of new potentials.[6]

This is how a contemporary philosopher speaks, whose philosophical foundation is negative dialectics (Adorno 1966), e.g., the dream that behind a reflective and reflecting surface, one can find a layer of authenticity. According to Adorno, this layer can be approached only if reflection is neutralized, and he believes art is a special medium representing a potential route of access to this authentic layer.

In the present section, I want to look closer at the claimed "unnaturalness" of twentieth-century art, i.e., to analyze the field of uncertainty in which contemporary art operates. My starting point is that although the premise behind Adorno's judgment—that art is no longer self-evident—seems to be correct, the conclusion is not. The extension of art does not necessarily lead to a reduction. On the contrary, it is an old experience that the forms of art that have created new understandings have normally appeared as problematic for the contemporary audience. With its linear perspective, Masaccio's *La Trinità* from 1425–26 (Santa Maria Novella, Firenze), apparently the first perfect realization of anthropocentric art techniques, was experienced as a provocation and was actually not spontaneous at all, being based as it were on deep theoretical and architectural reflections. Even though today we know them as banalities, the provocative nudity of Rafael's angels was far from evident for contemporaries. Before becoming prototypes for wallpaper patterns and Ikea furniture, the Impressionists were condemned for their evident distortions, and before Picasso's destruction of linear perspective in his portraits became the model for the strip cartoon *Peanuts* or the Mac OS icon, the accusation was an overreflected reduction of potentials.

Thus, I do not share Adorno's conclusion. But his registration of an intensified state of uncertainty in contemporary art can be productive, not however as a sign of disintegration, but as a sign of a new

transition, similar in scope and impact to the one introduced in the Renaissance: an aesthetic reflection on the transition from anthropocentrism to polycentrism.

Toward an Epistemology of Polycentrism

One way of approaching twentieth-century art is to look at it from its societal preconditions. How can those social conditions be characterized that art aims to reflect through the particular twentieth-century (avant-garde) artistic form decisions as a new optics for observation, and what is the relationship between the art system and the social system?

The starting point is that art is a closed, differentiated system whose criteria for observation of the environment can be found in art itself. That art is functionally differentiated and consequently has to find its criteria for observation in itself was a fact already established in the Italian Renaissance, as we have seen. However, that the system of art is socially differentiated does not exclude the possibility that it is conditioned. On the contrary, the art of Renaissance, and more generally speaking art from the Renaissance until the beginning of the twentieth century, has been conditioned in the sense that it has observed its environment on behalf of the human being. That "one beauty" in which all parts of the work of art must correspond is the beauty of universal humanity.

This is expressed in the linear perspective of the visual arts, the implicit utterance being that art speaks on behalf of the human, i.e., that the world is seen from within the perspective of the universal human observer. In its organization of the components of the painting, linear perspective installs a latent observer, whose position the audience or absent artist can occupy. This is also seen in more general considerations on the judgment of taste, which imply that beauty does not exist in the thing in itself, but in the observer of the thing.

The classical argument for this position can be found in Immanuel Kant's *Kritik der Urteilskraft,* his *Critique of Judgment* (1790), e.g., where he defines and discusses the aesthetic judgment. The aesthetic judgment has the form "X is beautiful." But what is the semantic structure of this judgment, or, rather, the structure of the optical form of the aesthetic observation? The starting point for the aesthetic observation is that a specific object awakens what Kant calls a *Wohlgefallen—a* delight—in the observer. But where is the source of delight? Kant starts from the observation that the form of delight, as aesthetic judgment, is

common to all humans. We often pronounce identical aesthetic judgments: What is considered beautiful by one person is also considered beautiful by another person. And even though sometimes disagreeing about our aesthetic judgment, according to the argument of Kant, we do at least share the same aesthetic criteria. Otherwise we would not be able to discuss aesthetic experiences. The observation of art would become a private matter that could not be communicated.

Following the argument of Kant, one should think that the pleasure of observing beauty was dependent upon the qualities in the observed object. So, beauty, as argued by Alberti, should be a quality in the work of art or in the object under observation. Not only I, but also you and others experience a similar delight. One should think that beauty is a quality of the thing. But no, says Kant: This is a delusion of objectivity. Although beautiful things have common qualities, they have them only according to a specific observational form. Thus, beauty is not a quality of the thing being observed, but exists in the form of aesthetic judgments based on the existence of a common sense—the sense of beauty—possessed by observers.

> Hence he must regard it as resting on what he may also presuppose in every other person; and therefore he must believe that he has reason for demanding a similar delight from every one. Accordingly he will speak of the beautiful as if beauty were a quality of the object and the judgement logical (forming a cognition of the Object by concepts of it); although it is only aesthetic, and contains merely a reference of the representation of the object to the Subject (...). The result is that the judgement of taste, with its attendant consciousness of detachment from all interest, must involve a claim to validity for all men, and must do so apart from universality attached to Objects, i.e. there must be coupled with it a claim to subjective universality. (Kant 1991, p. 51)

However, the judgment of taste is different from other judgments, such as the pure and the practical, since it cannot be derived from universal concepts, but from "subjective universality." But where does this subjective universality come from? The answer is summarised by Kant in the heading to §20 of *Kritik der Urteilskraft:* "The condition of the necessity advanced by a judgement of taste is the idea of a common sense" (ibid., p. 123, German original; p. 82, English translation). According to Kant, one might immediately think that beauty as supposed by Alberti exists in the work of art, or in the object as internal correspondences. But in reality, the category of universal delight is motivated by subjective universality, i.e., by the judgment of taste performed by the transcendental subject. Accordingly, in Kant's argument

in *Kritik der Urteilskraft* the anthropocentric intention is clear. Beauty or delight is not a quality of the thing, but a quality of the transcendental subject's universal optical form through which human beings observe art objects.

Hence we have moved from the standpoint from which Alberti liberated himself to the fulfillment of the standpoint he introduced. As articulated by Alberti, art emancipated itself from its theocentric motivation, in which it had been a mirror image of the divinely beautiful, and the artist nothing but the voice of divinity. This idea was rejected by Alberti, for even though art possesses a "truly divine power," this power has been taken over by the artist and objectified in the work of art. As we read in the previous section, according to Alberti, the masters of art, seeing that their works of art are being admired, feel almost identical to the creator (Alberti §§25 and 26). While Alberti concluded that pure delight can be found in the object, Kant fulfilled the secular conceptualization of art: from God via the art object to the transcendental—universal human—subject. The argument was that although delight is universal and seems to be inherent in the object, this is only a superficial representation of the fact that the judgment of taste lies in the subjective universality of the observer, i.e., as a quality of the transcendental subject. From the theocentric position we have reached an anthropocentric position, according to which artistic delight is an expression of human delight.

Thus, the differentiation from a religiously centered hierarchy of judgments to a subjectively centered hierarchy of judgments is completed. But art has not been *deconditioned*. On the contrary, the criteria of art are determined by the universal human. The next step in the development of contemporary art is that the judgment of taste is emancipated from the universal human. Here, differentiation is followed by a deconditioning, which brings us closer to the reality of contemporary art.

The alternative to the anthropocentric judgment of taste, an alternative that has been identified by Niklas Luhmann, is that the judgment of taste is the outcome of social evolution, i.e., an always provisional result of the development of the self-referential art system.[7] Here, the artistic utterance has the character of a decision on form. However, the artistic observation cannot be identified on the basis of the difference between the beautiful and the nonbeautiful. Art is not defined by reference to the universally divine or universally human characteristics; it is defined by self-reference. Artistic observation occurs as a copying of form into form, i.e., it is a decision on form referring to artistic form.

This implies that the function of art is the unfolding of a universe from a form principle. Art becomes world art, with the artist as a kind of motor of universe creation. Such a conception of art both resembles and differs from the traditional view on art.

To some extent, this view of art represents continuity. It is indebted to Alberti's idea that principles for internal correspondences should be unfolded in the artistic process of creation, the result of which is the work of art, which—if it is successful—incarnates these correspondences. They are to be recognized by the art audience, who through the work of art gains access to the sublime. These ideas of a rule-governed artistic or philosophical universe developing and grounded in immanent principles can be found, as David Roberts has pointed out, in the whole of the history of European art and ideas, from Spinoza's "more geometrico" to Bach's *Kunst der Fuge* to Leibniz's binary world formula: "Omnibus ex nihilo ducendis sufficit UNUM" (Roberts 1999, p. 30).

On the other hand, this view of art also represents a fundamental break, as artistic form creation is not observed in reference to an ontological or transcendental standard. Consequently, art is "de-orthodoxified." It is liberated both from its obligations to a religious project, being devotional, and from its anthropocentric project of being informative on behalf of the universally human. Instead of assuming a normative responsibility, the artistic form of creation takes *difference* as its starting point. Luhmann has noted this with reference to the English mathematician George Spencer Brown's dictum that form is taken out of form by drawing a distinction (Brown 1971, p. 3).[8] In becoming a form decision based on the constitution of a distinction, art leaves its normative position in favor of a paradoxical position. With Luhmann's own example, this is expressed by the grand narrative of postmodernity, which states that all grand narratives are dead. For some, this utterance has immediately been identified as a mark of stupidity. For Luhmann, who observes postmodern thought from a sociological standpoint and refuses to sign up for any kind of postmodern project, it exemplifies the way in which contemporary art theory has to go one step further. The self-neutralizing ontological statement of the utterance is not enough; it has to be used autologically, i.e., to be reentered into itself. The consequence is then that "die Einheit der Gesellschaft oder, von ihr aus gesehen, der Welt nicht als Prinzip, sondern nur noch als Paradox behauptet werden kann. (...) Die Paradoxie ist die Orthodoxie unserer Zeit" (Luhmann 1997, p. 1144) [The unity of society or of the world cannot be assumed as principle, but only as paradox (...) "Paradoxy" is the orthodoxy of our times] (my translation).

Figure 7 Hotel Pro Forma: *The House of the Double Axe*. 1998. © Photo: Roberto Fortuna

The starting point for the artistic creation of form is the making of a difference: to cleave the substance into form and ground, and to reenter this form into itself in order to produce complex form creations. This approach may be called the principle of differentiation, and when differentiations are entered into themselves, the result is complex patterns of interferences. In theater, this change has been reflected by a development from nineteenth-century theater's anthropocentric naturalism to abstract theater in the late twentieth century, for instance the theater performance group Hotel Pro Forma's realization of an interferential aesthetics in *The House of the Double Axe / XX* and other performances (cf. Dehlholm, Qvortrup, and Theil 2003). In music the heritage of "natural

harmony" has been replaced by interferential tonality and rhythm, as in the early experiments of Gyorgy Ligeti pointing toward the mature realizations of interference as a compositional principle by the Danish composer Per Nørgaard, for instance, his sixth symphony from early 2000.

The structural coupling of art and society, or the social condition reflected by art, implicitly suggests that humans within the context of hypercomplexity have lost their privileged position of observation, and that it is an illusion to offer any universal code through which humans can reach each other, not even through art as the medium of articulation for Kant's subjective universality. How does art respond under such conditions?

One reaction is to paradoxically articulate a lack of communicability, such that humans are made aware that they cannot reach each other through communication. James Joyce wrote his books in a "private language," a "stream of consciousness" that is never fully understandable, as one psychological system cannot bridge the communication gap and reach the psychological system of another. Samuel Beckett let his figures "communicate" in acts of nonsense, demonstrating the limits of language. Arnold Schönberg drew his conclusions from the fact that late Romantic music had driven the principle of tonality and harmony to extremes, and he chose to present experiments in atonality. Throughout the twentieth century, music developed into collages of noise, which transgressed conventional principles of interpretation. Here the echo of "negative dialectics," as expressed by Adorno, can be heard, at its most significant level in Alban Berg's concerto for violin, which is a kind of absent music, "in memory of an angel," as Berg's own notes to the concerto say.

In art that celebrates "the aesthetics of interference," loss however is no longer commemorated. This kind of art has realized that beauty should not be brought to light from the bowels of the earth, or from the heart of the human. Beauty does not arise in spite of the banality of the world, but on the contrary by starting a game of banalities and clichés and letting them form new patterns. That we do not understand each other is not then seen as a tragic barrier: the greater the differences, the higher the level of curiosity with which we observe each other, each from our own world. In such games, technological artifacts may participate as co-acting social agents on an equal footing with human actors, who—according to tradition—previously had a monopoly on the creation of form. In the words of Bruno Latour, patterns of networks stabilize, in which small actors, artificial and human, establish provisional couplings that because of their complexity create a certain stability:

"Strength (order) does not come from concentration, purity and unity, but from extension, heterogeneity and by carefully weaving weak patterns" (Latour 1996, p. 49).

The point of departure for this direction in art, which I have tried to characterize through artistic reflection, seems to be that the world since the twentieth century has become so complex that it cannot be observed in its totality from a single grand position or principle. The world can be grasped only by letting it grasp itself, from below so to speak. Consequently, order is not created from above, whether the principle be divine or human, religious or rational. On the contrary, order is created through self-organization. The hypercomplex system creates order through its own, self-generated principles for pattern creation. A significant example is that an information system, such as the Internet, develops according to self-generated principles, thus creating an observation system, which is not realized by a divine or powerful outsider, but by internal mechanisms, and through which the world observes itself according to principles that each individual observer constructs at each of the indefinitely many levels and points of observation. In this way, an in itself unlikely autopoiesis of a communication system becomes possible, as Luhmann says about the function of language as a communication medium (Luhmann 1997, p. 212). It is exactly this principle that artists have aimed at appropriating by using the Internet as a medium for polycentric form generation, as in Espen Aarseth's analysis of cybertext as what he calls a digital realization of ergodic literature (Aarseth 1997).

This transformation can be called a transformation from an art practice motivated by metaphysics to an art practice motivated by the principle of interference. Metaphysics represented an order that seemed to exist prior to the world. This was an order—e.g., the old European ideal of beauty—that art was supposed to reconstruct. The artist looked back, up, or into himself in order to find the authentically or universally beautiful. Compared with this, the aesthetics of interference constitutes an order that exists as a *result* of the dynamics of the world. Here, order emerges as an outcome of the development of the world, e.g., in the form of patterns created by fluctuations, as in Ilya Prigogine's idea of dissipative structures. Order—understood as pattern creation—is created in art by starting aesthetic games and by discovering those unexpected and unforeseeable patterns that emerge when already known elements constitute the basis of new games. The aesthetic project ceases to be based on principles of in-spection or looking back, and instead draws on the principle of letting things happen: the above-mentioned principle of autology, of letting form reenter itself.

Figure 8 Hotel Pro Forma: *Monkey Business Class.* 1996. © Photo: Roberto Fortuna

As already stated, this has taken place in a number of the stage performances of Hotel Pro Forma, in which one significant idea is the use of artificial optical tools to reflect the polycentrism of our current social conditions. In traditional theatre, the proscenium is normally used in order to establish a linear perspective, with the audience occupying the position of the central observer. In other words, we observe the stage as we observe Masaccio's *La Trinità*, from the position of the universal human subject. This anthropocentric common sense is challenged in Hotel Pro Forma's *Monkey Business Class*, a musical for geisha, cowboy, and sailor. The method applied is that video cameras are placed at the side and on top of the stage, from which alternative positions of observation are displayed on huge monitors above the proscenium, so that the audience is constantly bombarded by the unnaturalness of the so obviously natural central observer. The audience is denied the traditional position of the ideal observer, as the center of the world with its linear perspective. On the contrary, offering a large number of observation positions to the audience challenges this natural observation point. *Monkey Business Class* offers the audience a range of mutually interfering, electronically produced observation positions. The performance culminates when a backstage system of video cameras, huge mirrors, pyramids, and hoist mechanisms change the position of the actors and videofilm the play from a floor position projected into the stage.

Observing Polycentrism

How does art communicate in a hypercomplex society? Increasingly, in the course of the twentieth century it became clear that art could no longer reflect an anthropocentric perspective. It couldn't communicate its observations, as if a privileged perspective of observation (articulated,

for instance, as a homage to beauty or the sublime, i.e., in a reproduction of the naturally or transcendentally beautiful) still existed at the center of the world. This privileged perspective, this tribute to beauty, had to be rejected, and the rejection of artistic beauty shocked the audience. Just think of the dissonances of Stravinsky's or Bartok's music, or the showdown of cubism or collage art at the turn of the twentieth century with so-called good taste.

Similarly, the privileged observation perspective from the center of the world can be expressed referentially in the creation of an art world that resembles the real world. Here, the artist is the possessor of such divine power that he can create paintings that are on a level with God's creations, as in the well-known story of a Renaissance painter whose verisimilitude was so perfectly exact that birds were attracted by the fruit in his *nature morte*. This ideal must also be given up: Reference to a world is distorted in the artificial forms of cubism, or totally rejected in abstract painting.

Finally, linear perspective, the hallmark of anthropocentrism, must be rejected. There is no such thing as a privileged perspective. On the contrary, a variety of observation perspectives are available: For example, in Picasso's portraits, which simultaneously represent the *en face* and profile perspectives, in a manner totally similar to the later theatrical stage techniques of, e.g., Hotel Pro Forma. Just look at Picasso's portrait of Madame Nusch Éluard (1937). The painting shows a young lady with an elegant hat, curly green hair, and a dramatic dress with metallic angels on its lapels. The point is that she is simultaneously observed in front, from the side, and from the bottom up. One cannot localize the ideal point of observation because this point does not exist. The painting refers to Mrs. Éluard; but it is also a self-reference to the disappearance of the anthropocentric transcendental subject. This does not imply that we are thrown back to the world of the divine observer. Instead, we are propelled into the confusing reality of the polycentric observer. A similar point can be made about the aesthetic forms of the painting. We are certainly not viewing the ideal proportions of the noble wild or of natural beauty in the human face. In other words, the person is not placed in a natural context, and the colors of the painting do not demonstrate laws of ideal color.

Behind this painting lies a development of art history starting with Impressionism toward the end of the nineteenth century. Here, it was for the first time realized that pictures are not the result of a natural, or universally given, relationship between subject and object, between the transcendental observer and the world. Like the founder of modern

Figure 9 Pablo Picasso: *Portrait of Nusch Éluard.* 1937. Musée Picasso, Paris. © Photo RMN—Gérard Blot

phenomenology, Edmund Husserl, Impressionism realized that a painting of a work of art is the result of the encounter between a contingent object and a similarly contingent observing subject. As a consequence, the artist does not just observe the world. The artist observes his or her observation of the world, his or her "impressions." After Picasso, this was further developed by the avant-garde of the mid-twentieth century. With his installations of industrial objects in museums, Duchamp demonstrated how objects are transformed into works of art when contextualized within society's art system. Thus, while the Impressionists observed and communicated the individual artist's art observations, the avant-gardists communicated and demonstrated society's art observations.

Already today, the revolution of the early twentieth century has become trivial: Just think of the icon of Mac OS, which I see every morning when opening my computer. Here, we have an abstract portrait, drawn by exactly the same principles as Picasso's, i.e., observing a person *en face* and in profile. Polycentrism has become part of our everyday routine.

The Case of Interactive Multimedia Art

Until now I have identified some general epistemological conditions for art in our current society. Although giving examples from the use of "augmented reality" in the installations of Hotel Pro Forma, and thus exemplifying how interactive multimedia can support these reflections, in this section I will more systematically explore the question of whether computer art or digital art has a particular potential for realizing the idea of a polycentric epistemology. Does it make a difference that art is articulated in a digital and not an analogue medium? My answer is that digital media seem to offer a number of potentials for articulation, and they are particularly promising for realizing an aesthetics of interference, partly because the principle of reentering form into itself is the basic condition of the computer as medium, partly because the computer creates the possibility of establishing a new relationship between artist and audience.

Identifying the particular characteristics of the digital medium, according to which it differs from ordinary media, is however a question of poetics. For me, "poetics" is an analytical, not necessarily prescriptive, description of the way in which artists articulate an artistic idea

or aim in a chosen matter: words, clay, stone, musical notes, oil and canvas, stage elements—or digits. This does not mean that the artistic idea or aim exists in advance. On the contrary, typically it is only realized through the intense molding of matter. Thus, one should not confuse poetics and aesthetics. Aesthetics is about the artistic idea: what in a certain era is considered beautiful, artistically desirable, or sublime. Poetics is about the artistic work: how an artist shapes his or her material in order to give form to the artistic idea; how the process of poetical composition can be described.

I will look in particular at three important issues concerning "digital poetics": projection, immersion, and interaction. Although we think that we know what projection, immersion, and interaction mean, we haven't fully realized their implications for digital art, in the sense of their potential for articulating artistically desirable aims. Thus, my aim is to identify the poetic potentials of projection, immersion, and interaction.

From Being to Projection

Traditionally, artworks have been conceptualized as matter with a form: oil painted on canvas, words combined into texts in a book, persons acting on the stage. Within this tradition one can talk about the artwork in categories of "being." The painting "is" in front of the viewer, the play "happens" on the stage. Of course, in many cases techniques of projection are used: front projection in the cinema, back projection through television sets, virtual reality systems, etc. However, in most cases projection is treated as a simple tool and, where possible, disguised and removed from vision. One focuses on projection itself only when some kind of disruption occurs, as when a roll of film breaks or the television set does not work properly.

With digital art and design the configuration is often different. Here, the work of art includes the relationship of projection. Some source, a projector, throws images onto a surface, and the resulting art work depends as much upon the projecting source and the quality and shape of the surface, as upon the internal relationships between objects in the text or visual and auditive image. Thus, the artwork to be observed by the audience is not just the resultant image or projection, but the relationship between the projection source and the material base of the projection. It is not, then, a simple cause and effect relationship, but a complex system of material interferences and of textual interreferences.

We know this from the simple form of shadow plays, and we know it from the effect of sunlight cast through colored glasses in baroque churches, where the dust in the church plays an important role in seeing the colored column of light in the interior of the church, often interpreted as a manifestation of the auratic force of God. In the shadow play the source of fascination is not simply the moving shadows, but the fact that a person with simple finger and hand gestures can create very convincing moving images.

In digital art, one is presented with an increasing number of similar experiments. Let me just mention Japanese artist Makoto Sei Watanabe's *Fibre Wave II*, which was installed in the InterCommunication Center in Opera City Tower, Tokyo, in autumn 1999. The heart of the installation was a computer, which continuously registered wind speeds and wind direction in cities that included Paris, Buffalo, and Moscow and on planets such as Jupiter and Mars. While different wind conditions were depicted on huge displays in the installation hall depending upon which location the public selected on the computer screen, the computer also transmitted wind data to two great jet engines, each wall-mounted in the hall. From these, a Mars storm or Moscow breeze was then passed through a field of three-meter high optical fibre tubes, which glowed fluorescent green as they shifted. The public was thus walking around in a field of fibre optics, rippled by a "universal" wind.

Here, what is challenged is the medium, or rather our preconceived ideas of what an interface consists of. An interface is not necessarily a computer terminal emitting text, images, and sound; it might easily be plastic media: rippling optical fibre fields, physical installations that dance, walls that seem to breathe as they contract and expand. The contribution of the artist is primarily to establish fascinating relations between different sources that *in toto* constitute the art installation. Projectors—not only projecting light but also wind—are directed by real world phenomena, while the shape and quality of projection materials influence the resulting dynamics. And furthermore, the audience is able to influence the connectedness of the projectors with the real world and observe the interplay between the different elements and sources of the art installation.

Consider another installation, also from the InterCommunication Center in Tokyo, in which one puts sensors on one's body and sits in a chair in a soundproof room. The sensors transmit the sounds of the body—the heartbeat, the pulse of the blood, the workings of the lungs—in amplified, distorted, and retransmitted form into the room,

exposing the person to a wonderful, not out-of-body, but into-body experience—literally, an introvertive experience. Here, the initial projection source is not the external world but—in a very literal sense—the internal body world; and in similar artworks the body may act as well as the projection surface, as is known from body art.

Although these examples of digital art represent an innovation, the basic mechanisms are well known from art history. In all art, there is a double relationship: the internal narrative relationship in the story being told or the painting being shown, and the external relationship between the agents or actors in the story or the painting and the storyteller. With the initial "Once upon a time. . ." the storyteller directs himself explicitly to the audience, but soon he disappears behind the story. This double relationship is repeated within projection art installations, with the projector as a technical representative of the narrator. Sometimes actors in the play can break the narrative illusion and direct themselves to the audience, a strategy highlighted by Bertolt Brecht's *Verfremdung* technique, which again is rooted in traditional Greek theatre.

However, in projection-based digital art and design, subtle ways of using such multiplications of relations can be found. One extraordinary refined and complex example of the use of projection techniques is provided by Jeffrey Shaw's *The Golden Calf*, which was created for the Ars Electronica festival in Linz, Austria, 1994.[9] In *The Golden Calf*, the viewer holds a color monitor screen in his or her hands and by moving it around a bare pedestal, one can see a virtual golden calf standing on the pedestal. The monitor is a large flat LCD screen with a spatial tracking system attached to it so that the computer graphics system displays the appropriate view of the golden calf, depending upon the viewer holding the monitor and his or her actual position in relation to the pedestal. In addition to the relationship constituted between the physical exhibition room, the viewer, and the projection image, there are references established between the room and the image. The virtual golden calf has a shiny, mirrorlike skin, and the viewer can see the actual room of the exhibition reflected in the skin of the calf. Technically speaking, this is achieved by first having photographed the exhibition hall with a fish-eye camera, then using the photographs to create a virtual panorama around the golden calf. This panorama has then been reflection-mapped onto the calf so that the installation room is real-time reflected by the calf, depending upon the position of the screen.

This digital installation has been analyzed by Anne-Marie Duguet, who calls it a "virtual site-specific art-work." Duguet notes that *The*

Golden Calf "weaves a set of subtle paradoxes into a web of virtualization and actualization" (Duguet 1997, p. 46). She describes it as a kind of interaction space in which the user, in order to observe the calf in the virtual/real room, has to dance around the pedestal with the golden calf. The viewer is forced to enter the narrative world of the artwork, and simultaneously the artwork exists in and refers to the exhibition world of the viewer.

Actually, this constitutes an examination of simulacra in which Shaw, according to Anne-Marie Duguet (ibid.), draws on the notion of the "infra-mince" (i.e., "infra-thin") separation developed by Marcel Duchamp in 46 notes made between 1912 and 1968. While in some of the notes Duchamp focuses on the relationship between the "identical" and the separate, that is, the "infra-thin separative difference," in his final note he emphasizes that the "infra-thin" separation not only acts as a separator, but also as a conductor, a passage between different dimensions:

> Infrathin. Reflections of light on diff. surfaces more or less polished—Matt reflections giving an effect or reflection—mirror in depth could serve as an optical illustration of the idea of the infra-thin as "conductor" from the 2nd to the 3rd dimension. (Duchamp, quoted from Duguet 1997 p. 46)

Adding to the issue concerning the projection image, Duguet has identified a number of other aspects: the "link-image," referring to the fact that images are interlinked in webs of images; the "sizeable image," referring to the fact that through projection the scaling relationship between image and reality is challenged, as has been the case with experiments in land-art installations; and the "interface image," in which an important aspect is the combination of separation and contact. The viewer is of course separated from the narrative worlds in front of him or her, but simultaneously he or she can observe a subtle contact: If one raises a hand, the person in the image does something similar. If one moves close to the image, the fictive person in the image moves back in what looks like fear. Such relations have been exploited in the works of Gary Hill, e.g., *Tall Ships*.

From Interpretation to Interaction

Traditionally, the relationship between audience and artwork has been analyzed as an active one, characterized by "interpretation." Accordingly, interpretation is seen as changing the artwork, e.g., the reader "acquires" the text, thus changing its meaning into something different.

This understanding of the relationship between artwork and audience is rooted in the analysis of the difference between science and art made in the late eighteenth century by the German philosopher Friedrich Schleiermacher. He argued that natural science registers that which is the case, while the arts perform "sign interpretation." While the relationship between the scientific observer and the natural object according to Shleiermacher's concepts is "dialectic," the relationship between the audience and the artwork is "hermeneutic." Thus, "hermeneutics" was Schleiermacher's designation for a theory concerning the particular form of the observational relationship between an audience and the sign object, in which the interpretative observation changes the meaning of the sign object. Here, we find the origin of the notion of a circular process constituted by artwork and observer, the "hermeneutic circle."

Computer art has taken this spiritual and idealistic notion of the audience-art relationship and made it concrete. The artwork does something to the audience, or, more appropriately, to the user, who also does something to the artwork. This is reminiscent of the old Marxist slogan: So far we have interpreted the work, from now on we want to change it. In computer art, interpretation is replaced by interaction. Furthermore, this mutual process of change propagates its environment, which is being included in the interaction. A complex network of communication and observation is being established.

An illustrative example of this mechanism is provided by the Danish artists Morten Schjødt, Theis Barenkopf Dinesen, Anne Dorte Christiansen, and Peter Thillemann of the digital art group Oncotype and their interactive installation *Rekyl* (in English: "Recoil"). That this work is interactive is already apparent in the title, for when the artwork is modified by the actions of the user, it recoils back into his or her mind.

But what is *Recoil*? It is an interactive installation consisting of a computer, a projector, a screen, and a microphone, which are installed in a 3 meters high, 3 meters wide, 8 meters long room. The user enters the room from one end. The other end is covered by the screen, on which text-based statistical information is rolling (concerning living conditions, consumption of alcohol, health conditions, traffic accidents, etc.). In the middle of the room there is a microphone. As a user, one starts by observing the elements of the installation: One reads the rolling text (and of course tries to interpret it, as we have learned to apply meaning to everything that we see in an art museum), looks at the computer and the projector, and attempts to understand the sophisticated significance of

the microphone standing in the middle of the room. However, sooner or later one has to experiment with the microphone. And then something happens. If the user shouts into the microphone, the rolling statistical text is replaced by a bluish video film showing the face of a person who presents his or her personal history. In total approximately 14 stories can be activated, each one taking between 30 seconds and 2–3 minutes. The person on the video tells an episode from his or her life, with indirect references to the statistical text. As soon as the user stops shouting, the video film disappears and the statistical information begins to roll again.

Points of general significance for interactive artworks can be drawn from this installation. The first and most obvious point is that veneration for the untouchable artwork is replaced by an active and playful relationship to the work. "Don't touch" is being replaced by a command to interact. In this respect interactive, digital works are related to the kinetic artworks of the twentieth century: Tinguely's mechanical figures, Calder's mobiles, Moholy-Nagy's modulators, Takis's magnetic ballets, Duchamp's perpetual installations.

Following from this, the traditional thoughtful interpretation—the attribution of meaning in art environments—is replaced by practical action. One important question is how to keep on making sound in order to prevent the image from disappearing and the story from being interrupted. This again implies that the attention is being moved from the artwork as such to the relationship between oneself as observer and the work of art. For instance one obviously notices the dilemma between shouting and listening. In order to maintain contact, one has to shout. But at the same time, in shouting it is not possible to hear the person on the screen.

Finally, this implies that the environment is involved. What happens when an unknown member of the audience enters the room while you are yelling to an artwork? The answer is that many different things may happen. When *Recoil* was exhibited in Denmark in late 2000, the result was often a sense of embarrassment. The user lowered his voice in order not to "exhibit" himself, that is, become part of the art installation. This situation totally changed when *Recoil* was exhibited in Paris two months later. Here, the actual user normally began to play with the installation, whisper, shout, sing in rhythmic phrases, creating interferential patterns of text information and video clips. Here, he or she clearly "performed," made herself an active part of the dynamic installation, the other part being the computer. But whatever the reaction, the area reached by the installation expands, so that everybody in the installation hall becomes involved in artistic observations

and actions. Here, the performance-art tradition is obvious: Whether or not by choice, we are involved in the realization of the artwork.

In recent years, we have begun to see a plethora of digital artworks such as *Recoil*. In computer games we interact with autonomous agents, or we are represented in the world of fiction by avatars. In advanced 3D artworks, such as Jeffrey Shaw's *Configuring the Cave*, one enters the virtual world through digital interfaces or motion-capturing devices, making it possible to move around, investigate and manipulate the virtual world. In another of Jeffrey Shaw's digital installations, *The Legible City* (Zentrum für Kunst und Medientechnologie [ZKM], Karlsruhe, 1989–1991), one moves around in a virtual city constructed by letters and words on a motion bike. In an Italian digital artwork, one is forced to walk on a transparent floor, under which one can see naked bodies of people in their graves moving in pain when one tramples on them.

It is an important consequence of the way in which interactive artwork functions that one has to reinterpret the interpretation process. We are used to observing the relationship between the artwork and audience as a transmission relationship: The aura from God or from the art genius is transmitted to the viewer. Yet, in front of digital and interactive artwork, no such auratic transmission occurs. It simply does not work to present a spiritual and receptive attitude: The spirit fails to appear. Here, as a member of the audience, it is necessary to contribute to the artistic form creation, almost on level with the artist. The difference is related primarily to the order of succession. The artist makes the first form creation, building a dynamic world of potentialities, an art world. But only the second form decision realizes the artwork as work, and this form realization occurs only when the audience interacts with the artwork.

What, then, are the aspects of such an audience-based form of realization? In digital interactive artworks it is not enough just to push a button making a mechanical figure move or to gently touch a mobile, which begins to move. On the contrary, the relationship between audience and artwork is potentially much more sophisticated. Through the interface, one enters a digital world of signs that are mutually interrelated. This is a sign universe with which and in which one acts.

As argued by Wibroe, Nygaaard, and Bøgh Andersen (2001), one can interact at several levels. The first level is the kinetic level: Using the mouse, a joystick, or a motion-capturing device, one can make digital signs—images, icons, text elements, etc.—and move them. The second level is the plot level: here one can control what information is presented

at what time, so that the narrative sequence is modified. This is well known from computer games in which one can decide about the sequence of places to visit or tasks to solve. The third, and highest, level is the story or artwork level. Here, the user can influence the meaning or morality of the artwork, the intentions of the main figure, and thus the basic structure of the narrative.

From Subject-Object Relationship to Immersion

Finally, the points above imply that the very concept of the artwork is being modified. An artwork is not an autonomous object, which can be observed at a distance, from the outside according to the tradition of thoughtful interpretation. Rather, the artwork appears to be a world of potentialities that must be realized by the user. However, what seems to be a leveling of artist and audience may in reality become the opposite: that the artist acts as a producer of art worlds, i.e., as a world creator. These are the worlds that we as users can enter and make into realities, whether hells or paradises. The reason is that the digital medium is immersive, i.e., all-pervading. One example is Maurice Benayoun's installation from the early 1990s, *Le tunnel sous l'Atlantique*. This is a virtual tunnel under the Atlantic Ocean connecting Paris and Montreal. At each end, a user looks down into the mouthpiece of a tunnel in which a screen and a loudspeaker represent the "underworld." With a joystick the user digs his way through virtual caves and galleries led by sounds and music that are cocreated (or "actuated") by the movements of the joystick. If one is lucky, one may meet the other, digging from the other end of the tunnel, represented by a transparent picture at the other end of a corridor. The technique involves both users being connected to a computer in whose multimedia database the virtual subterranean world is represented as a large number of image and sound combinations, which are activated with the joystick. Each single representation is connected to others as links in a hypertext, and new textual fragments are activated by the movements of the joystick, giving an illusion of a three-dimensional multimedia search procedure. While "digging," a digital camera projects the user's face into the actual position in the database so that one can be "found" by the other. What is created is not an illusion of "reality." The work of art represents a construction of virtual worlds, which are an alternative to the so-called real world. The sub-Atlantic world is not a world representation, but a world construction.

At the surface level, if this is an appropriate word for a sub-Atlantic

tunnel, a number of strong metaphors are articulated. For instance it is clear that "light" plays a central role: The tunnel is a lighted tunnel in the sense that light beams from the mouthpieces. Also, light plays a double role: It is both heaven and hell; heaven in the sense that it is the other's aura, which can be found by digging through the tunnel; hell in the sense of fires coming from the underworld.

Also, a number of narrative conventions are activated, for instance, the combination of affection and perception images (Deleuze 1983 and 1985). The dominating narrative situation is that of the affection images, which in the film is the image representing the main character (the audience being put into the perspective of the actor), and which in the tunnel is the user digging his/her way through the underworld. Now and then the affection image is replaced by the perception image, which in the film is the image representing the whole situation, and which in the tunnel is a map of the current position. This again has become a basic convention in many computer games, demonstrating the fact that in computer art, many art forms are combined, such as painting, film, computer games, gardening, music, sculpture, and dramaturgy.

However, at a deeper level it is obvious that the tunnel is not just a recycling of already known and conventionalized metaphors and narratives. On the contrary, the tunnel demonstrates that these new works of art—computer art—radicalize the communication of art, a process that has gradually developed since the beginning of this century.

First, it is demonstrated that there is not one but many perspectives. Or, in a more radical sense, interactive multimedia works of art demonstrate that their particular world construction is seen and constructed from within themselves. The perspective is not given *ex ante*, but is created by the specific work of art. The context articulated is an "internal context."

Furthermore, the tunnel signifies that artistic reality is the joint product of those who communicate through art. The artist acts as a facilitator, making the first decision on form, but the work of art is actuated only through the intervention of the so-called audience, making the second form decision.

Finally, this specific work of art—but indeed also many other interactive multimedia artworks—demonstrate the role of art in providing a utopian mediation for observers who are separated. Here, the tunnel demonstrates the utopian aim of art as it communicates what cannot otherwise be communicated. It is my assumption that in these respects the tunnel is not an exception, but represents a general trend of

contemporary interactive multimedia art. This shows that so-called computer art is not something external to the general art world—a product of technology being introduced from the outside[10]—but that it grows out of already existing art trends, representing an integrated phase within the development of art in the twentieth century, where interactive, digital media are a new and appropriate means of articulation.

Here the old debate about the relationship between the original and its copy is consigned to the conceptual scrapheap. For where exactly is the original? It is present in the simultaneous realization of the artist's digital sphere of potentiality, i.e., there where the public is. Benayoun's vision of the Atlantic tunnel is a broadband-based Internet version, which from all the world's computers we hack into and undermine the surface of the world.

However, this does not imply that the "digitalization of art" does not make a difference. On the contrary, digital media have a communication potential that is particularly adequate for making observations of a polycontextural society. I see information technology not as a tool, but as a medium; as a kind of artificial eye and ear. Thus, just as technology in general can be defined as an artificial extension of the body, information technology may be defined as an artificial extension of our sensation faculties, i.e., as artificial senses. The relevant issue concerning interactive digital media is how to focus on phenomena that have previously been difficult to see. As Gregory Bateson said, the function of the eye is not to let the world into the mind, but to keep it out (Bateson 1991, p. 182). Similarly, the function of the senses is not to sense everything, but to make a selection. We see by excluding information, and the reason for being able to see is that we select, i.e., we reduce complexity, we focus on something and not something else. In this sense, interactive digital media represents an observation selection mechanism, allowing us to see things that until now have been beyond observation. The communicative articulations of a polycentric society, which have existed in embryonic versions, in cubism or abstract art for example, are fully enfolded in digital art.

Conclusion

In this chapter, the following three assumptions have been presented and discussed: (1) With roots in the Renaissance, theocentric forms of art reflecting the conditions of traditional society have gradually been

replaced by anthropocentric art forms reflecting the conditions of modern society. (2) By comparison, starting with Impressionism, we are currently experiencing an aesthetic transgression from the anthropocentric art forms of modern society to the polycentric art forms of the emerging hypercomplex society. (3) Under current postnormative conditions, aesthetics is a result of interferences between complex systems, rather than the realization of normative categories such as "the beautiful" or "the sublime."

The implicit idea behind the first and the second assumption is that we are moving toward a society that is radically different from so-called modern society. It has been described as "functionally differentiated" (Luhmann 1997), "polycontextural" (Günther 1979) or "hypercomplex" (Qvortrup 1998), emphasizing that it does not offer one single point of observation, but a number of mutually competing observation points, each with its own social context. This does not "create" new art forms in any causal sense, but it creates a need for observing the world differently.

This of course is a challenge to art and to the development of new art forms, and as a matter of fact the change from modern society's anthropocentrism into present society's polycentrism has been reflected by new art forms since the beginning of the twentieth century. In particular, this change has been taken up by so-called digital art, which in a noteworthy manner has articulated the conditions of hypercomplexity. However, digital art is not a product of society, but a form that can be chosen in order to observe new societal trends. Moreover, in the present context, digital art is not a product of technology, but new digital media offer us new ways of observing society: and instead of analyzing digital art within a technological context, it should be analyzed within an art-historical context.

The third assumption, that under the current postnormative conditions aesthetics is a result of interferences between complex systems, rather than the realization of normative categories, such as "the beautiful" or "the sublime," is actually a combination of the first two theses. In a society characterized by mutually competing observation centers, aesthetics cannot defend normative ideas of transcendental aesthetic categories of beauty or the sublime. However, this does not imply that aesthetic forms cannot be specified. But instead of realizing something "beneath" the surface (the hidden ideal of beauty, etc.), aesthetics remains on the surface, as the result of interferences between a plurality of subject centers, each representing its own aesthetic ideal and constituting its own contextuality. This paves the way for digital

The Aesthetic Self-Observation 87

media because they can articulate the hypercomplex result of complex systems' mutual interference.

Theocentric Art Forms

In a theocentric society, a dominating view is that God or the divine constitutes the universal, transcendental principle of society. Consequently, "God" also constitutes the universal observation and communication format. The divine is a basic code for our observations and for the communication of society. God is the nonobservable observer. Thus, one cannot and should not make pictures of God, but only pictures on behalf of or "through" the divine codification.

This is reflected by the art system in the following ways:

1. Art is based on the ideal of the divine principle. The artist reconstructs God's universal order, that is, the way in which the world is constructed according to the principles presented in the gospels. The function of art is to "transmit" the "auratic power" of God.
2. Artistic beauty represents an ideal for the reconstruction of the beauty of God or his creations, and this can be done by repeatedly painting the same holy creations: One does not aim at originality in art, but at reconstructing the ideal form through endless repetitions.
3. Thus, the modern ideal of originality is not recognized—or simply, it is not known. The artist does not create art in order to express his or her individual abilities, but in order to establish a link between the transcendental and the immanent. God speaks through the artist, whose signature is insignificant.
4. Similarly, mimetic desire is not recognized or known. The artist has not—and should not have—ambitions of constructing anything as good as God's creations. On the contrary, this would lead to a state of hubris.

Anthropocentric Art Forms

The anthropocentric—or "modern"–society, which was first articulated in the Italian Renaissance and which reached its peak in the nineteenth century, was based on the idea of the *human subject* as the universal transcendental principle (the transcendental subject). Consequently,

the human constituted the universal observation and communication format. For example, the world is observable through the observational (or epistemological) categories of the transcendental subject (Kant 1966 [1787]).

This is reflected by the art system in the following ways:

1. The ideal of linear perspective is developed because linear perspective represents the point of view according to which the human subject is the observation center. Similarly, linearity becomes a guiding narrative principle.
2. Beauty/the sublime are categories of the transcendental subject that can be reconstructed by art.
3. The mimetic desire represents the potential ability of the observer to construct a world that simulates the "real world." One example is the Faustian ideal of omnipotence, i.e., of duplicating the work of the creator.
4. Originality becomes a basic issue because it reflects the status of the divine artist offering his or her observations to the (passive) audience. This again explains the constitution of a causal relationship between the artist and the audience/spectators; for instance, as the artist creates mental effects (emotions, etc.) in the audience.
5. The same idea is found in the relationship between human beings and technology. The human being is the potential master of the universe, and technology is perceived as the passive tool of the omnipotent human being.

The Crisis of Anthropocentric Art Forms

The general message of modern, anthropocentric art is that the human individual is the center of the world: that the environment is seen through the so-called central—i.e., anthropocentric—perspective, and that the aesthetic norm, the "beauty" of art, is defined through the human subject's aesthetic judgment. Little by little, however, modern art undermines itself, as the belief in the transcendental subject is challenged. Take the example of Impressionism as it rocked the foundations of the established art world at the end of the nineteenth century. What Impressionist painters did was in reality nothing more than take the principle of anthropocentric art seriously, that the world must be

observed through the eye of the individual human being. However, in doing this they demonstrated that the eyes of one observer view the world differently from the eyes of another observer, i.e., that in opposition to Kant's aesthetic theory there is a conflict between individuality and universality. In realizing this, the Impressionists were in fact on line with the contemporary philosophical discussion of transcendental subjectivity represented by Edmund Husserl, which led to the establishment of phenomenology and so-called transcendental *inter*-subjectivity.

What is the general message of Impressionist painting? On the surface, it is that nature—or the environment—does not exist *an sich,* as such, but only when observed through a particular temperament. In this way, its message can be compared to that of Husserl's phenomenology, i.e., that the phenomenon is a result of the meeting of object and consciousness. However, I think that the analysis can be radicalized. Impressionist painting does not communicate an external object (nature, environment, etc.)—it communicates its own observation of an external object. As an audience, we do not observe actual water lilies painted by Monet, but we observe Monet's observations of water lilies. Analyzed in this way, Impressionism does not mark the end of an artistic epoch, but the beginning of a new epoch, oriented toward self-reflection as the basic tenet of art.

In particular, this implies that the "natural attitude" becomes problematic for art. Consequently, art must repeatedly challenge its own artistic conventions, because convention leads to new "natural attitudes," i.e., it leads to an acceptance of the existence of a universal aesthetic language. Art is therefore forced into a state of permanent revolution.

Polycentric Art Forms

The anthropocentric self-description of modern society was first challenged at the turn of the nineteenth century in the code of art and science. Gradually the idea developed that the world was so complex that it couldn't be represented by a single principle, be it God or the human subject. While the tradition of modernity "recognizes only one single universal subject as the carrier of logical operations," in a polycentric society one must "take into account the fact that subjectivity is ontologically distributed over a plurality of subject-centres" (Günther 1979 p. 122). Consequently, the idea of transcendentality must be given up: There is no single issue (God, the human being) that can be raised to a universally constitutional status.

If this is true, observations of the world (including observations of ourselves) cannot be fully communicated, because there is no universal code (or communication format) through which we can fully understand each other. On the contrary, world observations are communicated through a multiplicity of codes, which cannot be reduced to each other (they are mutually incompatible).

This is reflected by the art system in the following ways:

1. Art develops from linear text (or linear perspective) to cybertext, as a machine for the production of a variety of expressions or narratives (e.g., from unicursal topology to multicursal topology; cf. Aarseth 1997).
2. The ideal is not to reconstruct beauty and the sublime, but to overcome the gap between consciousness and communication: to communicate those observations that cannot otherwise be communicated, i.e., to give access to a noncommunicative world. Beauty and the sublime are not transcendentally preexisting facts, which art must reconstruct; on the contrary, they are the potential outcome of artistic experiments, e.g., a result of interferential patterns.
3. The cybersystem is not an imitation of the world (although it is a common illusion concerning multimedia that their special ability lies in their imitational force; in this way multimedia can be included in the program of *traditional* modern art, i.e., to imitate the environment). Rather, the cybersystem consists of differences that are reintroduced into themselves (the principle of reentry), and differences that are reintroduced into themselves create complexity, for instance by creating an illusion of parallel (mutually interfering) worlds.
4. As originality is given up, the idea of the role of the artist develops from the artist as the divine and indisputable creator (the primary cause) and the audience as the "impotent voyeur" to the artist and the art audience as cocreators or "coinvestors" in a shared hypercomplex system. The role of the artist becomes the creation of potential worlds through which "users" can create their own world realizations, or make their own paths.
5. Regarding the relationship between the human being and technology, the ideal of modernity as a master-slave relationship is challenged. Instead, technology is perceived as an agent in itself, and the human-technology relationship is understood as a subject-subject

relationship, in which the human being not only forms the technological agent, but the technological agent also forms the human being. Furthermore, this latter process of formation is reintroduced into the former. One example is provided by digital media, which form the way in which human beings observe the world, including their observation of technology. This gives rise to a new understanding of art as a creative process: Technology is not the passive instrument of the artistic creator; rather, the interference between the human subject and the technological subject constitute a creative process.

FOUR

The Pure Self-Observation of the Hypercomplex Society: The Emerging Orthodoxy of Paradoxicality

Die Paradoxie ist die Orthodoxie unserer Zeit.
—Niklas Luhmann,
Die Gesellschaft der Gesellschaft, p. 1144

Introduction

In chapters 2 and 3, I have presented some changes in society's self-observation through two social transformations, from tradition to modernity and from modernity to hypercomplexity. The journey has therefore followed three orthodoxies, from the orthodoxy of religious determination via the orthodoxy of human rationality to the currently emerging orthodoxy of paradoxicality. Until now I have presented two frames of self-observation: the perspectives of practical and aesthetic reason. In this chapter I will present a third—or, according to Kantian orthodoxy, *the* third—frame: the perspective of pure reason.

The general paradigm is however the same: that the social system of society develops toward new and different levels of complexity, and that society's semantics change accordingly. In order to explicate this paradigm, it is necessary to specify what I mean by the "complexity of society" and by "society's semantics," and it is necessary to specify the character of the relationship between social system and semantics.

With Niklas Luhmann, I define society as the totality of all social

communications. We are "in society" with others insofar as their actions are communicatively accessible. Consequently, with the development of communication media—from language via writing and printing to electronic and digital media—society has developed toward a world society. Distant actions—"distant" both in time and in space—are currently accessible through the historical memory of the print medium, through the speed of the digital medium, and through the reach of the broadcast medium.

This implies that society cannot maintain itself—and thus cannot be understood—as an interaction system. Interaction systems as social systems that emerge among those who are present to one another are only "episodes of societal process" (Luhmann 1995 p. 406). Today's society is a complex system of functionally differentiated subsystems, which again are interconnected and subdivided by organizations and organizational procedures.

However, this also implies that the semantics of society must change. What are the "semantics of a society"? According to Luhmann, within a sociological context semantics are the provisions of concepts in a society. They consist of concepts and ideas, worldviews, theories, opinions, orthodoxies, etc., both at a commonsense level, that is, as common knowledge, and at an elaborated level, that is, in the form of texts, historical and cultural materials, sociological theories, etc. I will however take the definition one step further and define a society's semantics as the systematized form of social self-description (Luhmann 1997, p. 1109). In chapter 5 of *Die Gesellschaft der Gesellschaft* Luhmann presents a number of historical self-descriptions, and I understand these self-descriptions as systematized paradigms, that is, as social "epistemes," which function as grand narratives with implicit claims to internal coherence. Such societal narratives function as important sources of complexity reduction. Thus, if one thing happens, by consulting the semantics of a society one can deduce that others will occur, or which reactions are appropriate. With the episteme as the provider of a causal structure, one can interconnect social phenomena.

Luhmann assumes that when a society's level of complexity changes, those semantic elements and structures that guide social actions must adapt to this change. "Complexity is (. . .) an intervening variable—and apparently the most influential—that establishes a relationship between evolutionary released structural changes and transformations of semantics" (Luhmann 1980, p. 22, my translation). This has been the subject of the two preceding chapters and it will be the subject of the present chapter, namely, to exemplify and analyze relations between

structural changes of society and transformations of social semantics, with the intention to suggest—and this suggestion can of course only be empirically tested—that three mutually overlapping trends can be identified: the trend of tradition, relating to the social semantics of theocentrism; the trend of modernity, relating to the social semantics of anthropocentrism; and the trend of hypercomplexity, relating to the social semantics of polycentrism. As it has been emphasized in chapters 1–3, there is no mechanical or simple causal relationship between social structure and society's semantics. Particularly, it should be recalled that any name for structural changes in a society will always be an outcome of a society's semantics.

The Epistemological Transformation from Tradition to Modernity

We have already seen that the early modern artist displaced God as the indisputable observer, and we have seen how the construction of the world changed accordingly. However, this development took place not only in art, but also in science and technology.

To find the roots of the discussion of science and technology in the Renaissance it might be appropriate to go back to the Greek astronomer Ptolemy. According to the English historian of science James Gingerich (1993), Ptolemy's *Algamest* (Arabic for "the greatest"), written in Alexandria around A.D. 150, is the greatest surviving astronomical work from antiquity. What Ptolemy in *Algamest* did was—for the first time in history, as far as we know—convert precise observational data into the numerical parameters of planetary models (Gingerich 1993, p. 4f). This was revolutionary because "more than any other book, it demonstrated that natural phenomena, complex in their appearance, could be described by relatively simple underlying regularities in a mathematical fashion that allowed for specific quantitative predictions" (Gingerich, p. 5; cf. also p. 74). In fact Ptolemy was on the point of anticipating the scientific revolution that replaced the traditional geocentric cosmology with a modern heliocentric cosmology, a revolution that was triggered only about 1,400 years later, when Copernicus published his *De revolutionibus* in 1543. Ptolemy realized in the second century that according to his observations it would be simpler if we assumed that the earth turned about its own axis once a day than it would be to have all the heavenly bodies turning round the earth; but he abandoned the idea because it would contradict Aristotelian physics.

If the earth revolved on its own axis, "animals and other weights would be left hanging in the air, and the Earth would very quickly fall out of the heavens. Merely to conceive such things makes them appear ridiculous" (quoted from Gingerich, p. 5). So even though the new metaphor was in some ways attractive, in other ways it could not be reconciled with the conservatism of our imagination, and it was therefore rejected in the end.

However, Ptolemy's most important contribution to science is not the results he achieved, but his methodological innovations, which consisted of the conviction that man, through his observations and reasoning, could reduce the complexity of the surrounding world, and that the designation for the consequent construction of the world should be "scientific truth." This, the concept of scientific truth, has undoubtedly been a basic source of the development of knowledge ever since.

It also means that theories based on systematic observation and theories of observation (theories of the way human beings observe the world) are two equally important and related scientific activities. Not only was it obvious that astronomy was based on observation; it was just as evident that the scientific results could not simply be derived from an "objectively existing external world," but were also affected by the way in which humankind sees. For example, astronomy always reflects both the properties and movements of the observed objects and the properties, conditions, and movements of the observer: the position and movement of the earth, the atmospheric reasons for the apparent size, shape, and color of the observed objects, etc. As a consequence, optics, with its theories of the internal and external conditions of the human way of seeing, was complementary to theories of the external world, e.g. astronomy. It is therefore also quite logical that the other well-known work by Ptolemy is his *Optics*, a treatise on human vision from about A.D. 175. Although the original Greek version was lost, the book survived in an Arabic translation, and in 1158–1160 the Arabic version was translated into Latin by Admiral Eugenius of Sicily (Ptolemy 1989, p. 132).

According to Albert Lejeune, Ptolemy's *Algamest* was translated from Greek to Latin at about the same time, i.e., around 1160 (Lejeune in Ptolemy 1989, p. 9), but the complete text was not available in printed form until 1515. For the same reason there is no direct connection between Ptolemy and Copernicus, for example, in the sense that one book "generated" the other. Copernicus is more likely to have been influenced by his stay in northern Italy at the beginning of the 16th century, in a period when worldviews were undergoing crucial changes.

Some 30 years were still to pass until Copernicus in 1543 published *De revolutionibus*, in which he proposed a heliocentric cosmology,[1] a conclusion that was already latent in Ptolemy's work (Gingerich, p. 180). In chapter 10 of *De revolutionibus* Copernicus proclaimed: "In the center of all rests the Sun (...) as if on a kingly throne, governing the family of stars that wheel around" (quoted in Gingerich, p. 34; see also p. 180).

It is evident that the connection between Ptolemy and the scientific revolution of the fifteenth century is only indirect, and an important link here is Arabic astronomy. The Ptolemaic-Aristotelian cosmology clearly fascinated Arabic astronomers around A.D. 1000, and they adopted it as their own worldview. However, in the eleventh century the seeds of criticism of Ptolemy were sown by the works of the most influential Arab astronomer, Ibn al-Haytham (965-c. 1040). Among the things he discusses in his detailed commentary on Ptolemy's *Algamest* (al-Haytham 1989, p. xxxiv) are the optical problems of astronomy. A more radical critique was offered in the following century by the astronomer and philosopher Averroës (1126–1198), who wrote: "The astronomical science of our days surely offers nothing from which one can derive an existing reality. The model that has been developed in the times in which we live accords with the computations, not with existence" (Gingerich, p. 140).[2]

The Scientific and Technological Influence on Culture

After his critical commentaries on Ptolemy's *Algamest*, in the period 1028–1038,[3] Ibn al-Haytham wrote his principal work, the five-volume *Optics*, or *Kitab al-Manazir* (Sabra, in al-Haytham, p. lxxxi), which was translated from Arabic to Latin around 1200 (ibid., p. lxxiv) under the (in this context) significant title *Perspectiva* or *De aspectibus*. At that time "perspective" was still a phenomenon closely related to optics, i.e., to the question of how human observation works; it was not, as it is normally understood today, a phenomenon of the external, "objective" world. Perspective was a matter of human observation, rather than a property of external reality.[4]

Ibn al-Haytham begins his book by presenting two apparently contradictory approaches. In his search for a theory of optics by means of which he can make his empirical astronomical observations computable, he is inhibited by the fact that the very nature of human vision is controversial: Does vision come from without or does it come from the eye?[5] When we see an apple, does the picture of the apple—or, to better understand the dilemma, the concept of the apple—come from

outside us or from within? Ibn al-Haytham's scientific contemporaries claimed that "vision is effected by a form which comes from the visible object to the eye" (al-Haytham, p. 4). This is a theory that accords with Ibn al-Haytham's own approach, but does not give him any instrument for making optical or astronomical calculations. The mathematicians for their part "agree that vision is effected by a ray which issues from the eye to the visible object and by means of which sight perceives the object; (and) that this ray extends in straight lines whose extremities meet at the centre of the eye" (al-Haytham, p. 4). Using this approach Ibn al-Haytham can make computations for equilateral pyramids etc., but as a theory of vision—the sense of vision—it contradicts his own view. The problem is that on the one hand Ibn al-Haytham's optic theory can be based only on the idea of rays radiating in straight lines with the eye as the center, while on the other hand he cannot accept the idea that vision—rays of light—radiates from the human eye. After long discussions and an empirical study of the structure of the eye, Ibn al-Haytham concludes however that the two approaches—the centripetal theory of the scientists and the mathematicians' theory of straight, but centrifugal lines—can in fact be combined: "The eye does not perceive any of the forms reaching it except through the straight lines which are imagined to extend between the visible object and the centre of the eye" (al-Haytham, p. 82).

Although the book was not printed before 1572, a number of copies circulated in Europe, and according to Sabra it was Ibn al-Haytham—not Ptolemy—who was the primary source of inspiration for the optical writings that were produced in the 1260s and 1270s by Roger Bacon, John Pecham, and Witelo (al-Haytham, p. lxxiii). It is thus clearly evident that the cultural, scientific, and artistic "revolution" of the Renaissance was not a sudden event, as is often thought, but that there was a long line of development from the so-called Dark Ages to the Renaissance. In addition the sources of inspiration were not exclusively Greek; the Arab world played a significant role.

As I have argued, the theory of the way we see—the theory of optics—is an important scientific and philosophical subject, but so too is the development of instruments that can increase our ability to observe and reason. In the development of a scientifically based astronomy, the issues of how to increase the ability to see and how to reduce the complexity of what one sees became matters of the utmost importance.

A famous example of how the theories of optics and the diffusion of light were applied to practical tools is found in the achievements of the Italian Renaissance architect Brunelleschi. Not only did he exploit the

optical theories to improve his own architectural instructions; between 1401 and 1409[6] he also, according to his contemporary biographer, Antonio Manetti, painted two pictures of buildings in Florence in accordance with the principle of vision resulting from straight rays of light, which form visual pyramids with the center of the eye as the apex. Indeed, he is said to have even arranged the pictures such that they could be seen through a small hole in a wall, thus creating the perfect illusion of a three-dimensional construction.

In 1435 Leon Battista Alberti (see chapter 3), according to most art historians, converted Brunelleschi's experiments into a practical guide for painters (White 1967, pp. 121–126; Kubovy 1986, pp. 10–20, and Kemp 1990, pp. 21–25).[7] In Alberti's instructions in *Della Pittura* the reader is furnished with "a full-grown, mathematically based theory of vision applied to artistic representation," a theory "which is founded on a simplified theory of vision, in which rays of light travelling in straight lines convey information from surfaces of objects to the eye" (cf. Cecil Grayson's preface to Alberti 1972, p. 11).

It has however been questioned whether the idea of linear perspective did in fact develop directly from optical science through applied architecture to painting.[8] It is at any rate a fact that Masaccio's famous *La Trinità*, the first known fully developed picture painted according to the principles of linear perspective, was created independently of Alberti's book, since it was painted ten years before the book was published. As a consequence it is probably more correct to say that the use of linear perspective in painting was an expression of and a result of the scientific and cultural development of the age in the broad sense, where the optical principles were combined with the belief in man as a rational observer, who is able to report what he sees and has confidence that what he sees is "truth." All these tendencies are summed up in Albrecht Dürer's famous words, "'Perspective' is a Latin word, meaning 'looking through'" (quoted in Elkins 1992, p. 209), and it was operationalized in the construction of innumerable methods of projection, stereometric diagrams, measurement techniques, perspective machines, observation networks, and so on (Kemp 1990).

The Cultural Influence on Science

As pointed out above, science and technology influenced cultural development and in particular the cultural articulation of the anthropocentric principle. The relationship between science and culture works both ways, however. As we have seen, there is a long, winding, yet

clearly traceable path from Ptolemy to Renaissance painting, just as there is a similar connection between Ptolemy and Renaissance science (cf. Copernicus's scientific results). However this line of development cannot explain why Copernicus chose a heliocentric model, and as I have tried to show, there is no reason to believe that the scientific world alone, through more and more accurate observations, would have come ever closer to the "objective truth" that lies hidden behind the surface of the external world. In this sense Thomas S. Kuhn is right when he writes: "Copernicus's radical cosmology came forth not from new observations but from insight. It was, like Einstein's revolution four centuries later, motivated by the passionate search for symmetries and an aesthetic structure of the universe. Only afterward the fact, and even the crisis, are marshalled in support of the new world view" (Kuhn 1962, p. 67f).

But Kuhn's argument is inadequate. Although we must to a certain extent resort to guesswork, the reason Copernicus proposed a heliocentric model, according to Gingerich, seems to be what we would today call irrational. It appears that his observations of the movements of the planets conflicted with his belief in the existence of material, crystalline planetary spheres or spherical shells. If Copernicus had not carried out his revolutionary restructuring of the planetary model, he would have had to abandon the theory of crystalline planetary spheres for the simple reason that one sphere, according to his observations, would collide with and crush the other. As we know, the Danish astronomer Tycho Brahe chose a geocentric—or rather a geo-heliocentric—model. Viewed from our perspective, Tycho Brahe seems to be the conservative astronomer, while Copernicus was the forward-looking revolutionary scientist; but in reality there was no great difference in how radical they were. Copernicus persisted in the notion of material spheres, while he radically accepted a heliocentric model. Tycho Brahe persisted with the geocentric model, while he radically abandoned the idea of crystalline spheres. So once again, it was less a matter of science, with its observations, coming ever close to a materially existing truth, than of a weighing of the advantages and disadvantages of choosing from different metaphors. The dilemma in which Copernicus and Tycho Brahe found themselves was solved only by Isaac Newton's theory of mass attraction.[9]

Why then did Copernicus choose the heliocentric model? I think Gingerich is right in saying that the introduction of a revolutionary new astronomical paradigm in the sixteenth century was more an expression of the sociocultural context in which Copernicus lived than a

solution to a scientific crisis within the narrow confines of the area of research Copernicus worked in, as Thomas B. Kuhn claims (cf. the above quotation).[10] Although he was born in and later returned to Poland, Copernicus acquired his scientific training in the northern Italian intellectual world, which was dominated by Renaissance culture, and where there was a fervent desire to view phenomena in an anthropocentric perspective. Put simply, the observer was more important than the observed, the "cogito" more important than the "sum," the organization of the world in accordance with the individual's rationally based sensing of the world more important than the world *an sich,* innovation more attractive than tradition. As mentioned above, observation tools—perspective-enhancing spyholes, observation frames, mathematical theories of linear perspective—played an increasing role in painting as instruments that strengthened the observing artist's position in relation to the status of the observed object. As an example the main figure in Leonardo's *Last Supper,* as we saw in an earlier chapter, was the artistic observer, and the whole aesthetic arrangement of the painting is not only constructed from the observer's point of view, but also in order to challenge the observer to see things in a new and different way. In fact, the latent impact of the painting—and of many contemporary pictures—is through the observation of the picture, to make the observer observe himself as the center of the universe. This unlimited faith in the individual's ability to construct the world in accordance with his sense and intellect, even at the expense of a time-honored world picture, formed the cultural context in which Copernicus was trained and, supposedly, was a fundamental reason for his scientific results.[11]

The Epistemological Transformation from Modernity to Hypercomplexity

Introduction

As we have seen, the epistemological agenda of the transition from tradition to modernity was to construct the universal human being as the central observer of the world. Particularly, the development of astronomy during the European Renaissance represented this transition from theocentrism to anthropocentrism as the new social episteme, and thus as a basic paradigm of astronomy.

Similarly, in the scientific observation of the world in the twentieth

century, one can witness a transition from anthropocentrism to an increasing focus on observations of observations. The background is that the naturalness of anthropocentrism, i.e., of the transcendental ego as the natural optics for observing the world, is being challenged. Increasingly it becomes obvious that there is no such thing as a universal observation format and observation position, but that many conflicting observation formats and positions are available. This implies that the observation format and position in itself must be observed and analyzed, and this is an expression of the transition from complexity (a complex observer's observations of a complex world) to hypercomplexity (a complex observer's observations of the complexity of his own observations).

The Search for the Answer to the Enigma of Complexity's Complexity

One of the researchers who at an early point in time showed an interest in the emerging hypercomplex society—or the "post-industrial society," as he called it—was Daniel Bell, not least in his epoch-breaking book from 1973, *The Coming of Post-Industrial Society.* Although Bell chose the rather backward-oriented label "post-industrial society," the important thing was that he was fully aware of the complexity problem and that the point around which his analysis revolved was the transition from a society based on the game against nature and fabricated nature to a society based on the game against social complexity. Ironically enough, it is his relatively banal division of phases that has been inherited by his followers (indeed, I have also been inspired by it), while his most important insight—the understanding of the central significance of the issue of complexity—has been overshadowed and almost forgotten.

According to Bell, the transition from industrial to postindustrial society was precisely a question of complexity, or more precisely a question of the change from one kind of complexity to a qualitatively different kind. Drawing upon the inspiration of the information researcher Warren Weaver,[12] Bell asserts that where industrial society was based on what he calls "complex simplicity," the post-industrial society is based on so-called "organized complexity" (Bell 1973, 28f; cf. Weaver 1947). "Complex simplicity" for Warren Weaver refers to, for example, mechanical systems, such as a car, where there is indeed complexity, but each of the individual elements functions according to simple principles. One can have in mind a traditional organization, such as the Ford Motor Company from the beginning of the twentieth century or

large public bureaucracies. Here one has—or had—an incredible complexity that is managed by breaking down all the complex elements into their smallest units: Time studies of the individual are carried out and systematized into a rule-governed standard determining how the individual worker is to work, and how his or her efforts are to be coordinated with the similarly described work of others. In this manner, a mechanical organization system is constructed, where the lowest level is coordinated horizontally, and the next level makes sure that the lowest level functions according to the stipulated regulations—i.e., such that the higher level controls the work carried out by the lower level, and layer upon layer leads to a higher degree of complexity, until the highest level is reached, which has indirect insight and control over the whole complicated organizational machine. The advantage gained by such an organization is control and a feeling of certainty, order, predictability, and fairness. But the disadvantage is a rigidity that is impossible to overcome: If a single detail goes wrong, such a system has limited ability to bring about self-regulation. One doesn't organize oneself; instead one is organized. One awaits instructions. This principle was suitable for systems of a certain size, but when the system became too complicated, as a way of managing complexity it would break down. The lesson learned was that only to a certain level can the growth of external complexity be matched by a similar growth of internal complexity. When this level is passed, a qualitatively new type of internal complexity must be constructed: not bureaucratic but self-organizing and self-regulating complexity.

For this reason, in the 1930s and 1940s, an increasing interest was shown in the steering principles of complex systems. One person who put this question on the agenda was the American mathematician Norbert Wiener, who founded the scientific discipline of cybernetics. *Kybernetes* is the Greek word for "steersman," and the discipline deals with the science of steering and navigation. Wiener didn't himself fully develop the new cybernetic paradigm in accordance with its implicit assumptions. He realized indeed that steering couldn't base itself on control from the top down, but that it to a large extent had to do with feedback, i.e., self-control, but he never managed to grasp the question or more directly its implications: namely, who or what steers this feedback? A thermostat adjusts a radiator and is indeed based on feedback: It manages the temperature in the room and regulates the level of heat accordingly. But who regulates a self-regulating system's self-regulation? Wiener never asked this question. It was first posed with the so-called second order cybernetics, e.g., with the German

American mathematician Heinz von Foerster. Born in 1911 he published a series of revolutionary papers in the 1960s and 1970s about self-organizing systems and the problem of "eigenvalue" (how does a self-organized system establish its own zero-state?) and of systems observation (an observer observing a system is also a self-organized system), in which he brought the cybernetic principle of feedback from the level of connecting single elements to the level of the system. These articles, of which the most important were collected in the book *Observing Systems* (von Foerster 1984), have been the source of inspiration for second-order cybernetics in biology (e.g. Chilean biologists Maturana and Varela), in social theory (Niklas Luhmann), and in many other fields.

Let me for a moment return to Warren Weaver. Being a member of the group of 1930s and 1940s complex theoreticians around Norbert Wiener, Claude E. Shannon, and others, he proposed the concept of "organized complexity" as an alternative to the concept of simple complexity. By "organized complexity" Weaver meant a complex interaction of especially complex elements, e.g., in a large organization that exists on the basis of an interaction between subsystems just as complex. Perhaps the best example of such an organized complexity can be found in contemporary society. It was clear to Weaver that the problems that arose were of a different character than the problems found with traditional forms of complexity. He exemplified the question as follows: The starting point is problems concerning systems with two variables, e.g., one billiard ball colliding with another. This example of simple causality is then followed by an example concerning complex problems, i.e., problems where not two or three, but myriads of billiard balls move around the table. Still, however, nothing new is under the sun, but the demands made upon the ability to make calculations increase. The answer to such complex questions is to use probability calculations, i.e., statistical techniques. One cannot say how each single atom in a body moves, or which person among an insurance company's 2 million clients will be the first to experience an accident, but it is possible to calculate the body's temperature as an expression of average tendencies, and one can calculate the frequency of accidents among clients. On the basis of this, the insurance company can determine the premiums charged for its coverage, such that after all payments have been made, it makes a profit.

But how will an organization, i.e., a group of people, behave? Why will two football matches with exactly the same teams not end in exactly the same way? According to Weaver, there are a long series of problems in

biology, medicine, psychology, economics, and political science that cannot be approached with traditional methods, neither the causal nor the more complex and statistical. They belong to a completely new class of problems, which Weaver calls problems concerning organized complexity. The problem with such systems is that individual elements behave differently than we are accustomed to with the game of billiards: When the individual ball is hit, it asks itself how it should react. The billiard ball registers the blow. It observes the game. It observes its own way of reacting, and thereafter decides where to roll.

With respect to the last mentioned type of system, where the whole question deals with how this kind of system is to be understood, Weaver doesn't supply a real explanation. He says that they belong to a new type of complexity—organized complexity—and he presents it as a challenge for science. But as to exactly how this challenge should be met, we are told little.

In one of his last, post-humous, publications, Luhmann characterized this type of "non-trivial" or "self-referential" machines. "They operate by means of a self-contained reflection loop that decides about all input-output transformations at the actual position of the machine; or, to be more precise: at the historical state at which the machine has put itself. As this changes with each operation, such machines command a practically unlimited, at least incalculable repertory of potential reactions" (Luhmann 2002, p. 77. My translation).

An initial scientific reaction to this emerging understanding of complexity is to reconsider the concept of rationality. If the fundamental challenge is represented by organized complexity, then the twentieth century's megalomaniac belief in unlimited rationality must be replaced by the concept of "bounded rationality," the American theoretician Herbert A. Simon in the 1940s suggested. The concept was publicly presented in 1945 (Simon 1997) in a book about administrative behavior, where Simon suggested that it should oppose organization theory's then dominant belief in "scientific management."

The view that Simon reacted against was that decisions in organizations could be made on the background of scientific insight into the organization and its surrounding world, and that they could be true and unambiguous. When all the possibilities had been examined, then it was the leader's task to make a "decision" on his or her own. Simon drew attention to the fact that the decision wasn't necessarily correct in a strict scientific sense, it was only one way of excluding other possibilities. When made, it is not "correct," but simply a fact of life. This means that the decision's real effect is that it reduces complexity be-

cause it, at least momentarily, excludes other possibilities. But each decision therefore includes a necessary risk, namely the risk that any decision represents the exclusion of other potential decisions. The characteristic reaction to a decision therefore involves carrying out a risk analysis, i.e., examining the possibility of arriving at other decisions. If decisions belong to the category of organized complexity, i.e., if they also include the criterion for decision making, then decisions necessarily must respect the laws of bounded rationality. Thus, bounded rationality is not just the outcome of not knowing enough, but it is the outcome of the condition that decisions are not made *ex ante*, but are themselves part of the decisional system. Any decision is both about deciding something and about deciding the decision.

Societies, organizations and individuals in the twenty-first century face a situation such that there can never be obtained sufficiently adequate information to reach unambiguous, correct decisions. This means that it is a mistake to believe that it is only necessary to acquire even more information than at present. The problem is not that we have access to too few inputs, but to too many. The point is not to have your mobile telephone with you at all times, but to know when to switch it off.

The Answer: Polycontexturality and Self-Reflection

Summing up, as we have seen, in the postwar period, the complexity problem came into focus. The immediate answer was the theory of first-order cybernetics, that is, a theory of the functioning of complex systems, partly based on local feedback mechanisms, partly based on the assumption that there is a general external steering subject.

However, this assumption was soon challenged by the initially rather vague observation that some systems operated according to another type of complexity than did mechanical systems. For these latter systems, feedback plus external steering was not enough. This was supported by the concept of bounded rationality, which is another way of saying that the assumption of the existence of a rational steering subject—a system's director—for the production of homeostasis was wrong. One has to apply the principle of feedback to the system as such: There is nothing outside the system, neither a God, nor a human director. The system must not only regulate itself, it must also observe itself based on its own regulation and observation criteria. This was the understanding first presented by Heinz von Foerster in the early 1960s, when he worked at the Department of Electrical Engineering at the

University of Illinois. We have to take the important step from first-order cybernetics, which is the cybernetics of regulated and observed systems, to second-order cybernetics, which is the cybernetics of self-regulating and self-observing systems.

Simultaneously with Heinz von Foerster, the German American mathematician Gotthard Günther, who was born in 1900 and was educated and worked as a researcher in Germany, South Africa, and the U.S.A., held a position at the same Department of Electrical Engineering at the University of Illinois, where he worked on computer-logic problems. Gotthard Günther's field was logic—he called his life project the development of a trans-Aristotelian logic—but his project was far too advanced to be generally accepted or understood outside the narrow circles of the department. As a pensioner he returned to Germany, where at the end of the 1970s he collected 35 of his most important scientific articles and published them in three volumes under the title *Beiträge zur Grundlegung einer operationsfähigen Dialektik* (Günther 1976, 1979, and 1980).

Gotthard Günther recognized the fact of bounded rationality, but he concluded that it was not only explained by the limitations of the steering or observing capacity of the subject. It may also be explained by the absence of a universal observation position, that is, by the problem that we do not have a naturally given universal medium for observing the world.

Kant had assumed that there was a universal pure reason, which was a result of the natural position of the transcendental subject in the center of the world. But toward the end of the nineteenth century and throughout the twentieth century, doubt was raised about this dominant view: Durkheim already in 1895 questioned the anthropocentric postulate in sociology. Georg Simmel accounted for this doubt in society's differentiation: Indeed, a society with more than one center cannot be based on a postulate of anthropocentrism, i.e., a single logic or a single set of values. It cannot, following Weaver's and Daniel Bell's conceptions, be based on complex simplicity, but must be governed in accordance with a different and higher order of complexity. In the field of philosophy, Edmund Husserl criticized the Kantian assumption of a transcendental subject, as a consequence searching—courageously, but in vain—for an intersubjectivistic solution, i.e., the solution that scientific truth can be established as an agreement among observers reached through open interaction, a solution that later on was further developed by Jürgen Habermas. Transformed into sociological terms, the basic

question was: How can we defend a conception of a common world if reality is based on social differentiation?

It is this arena that Günther entered. His ambition was to develop a "transclassical rationality," as he called it, i.e., a rationality that is valid for a world that doesn't have only one, but a number of centers of reflection, i.e., a world that isn't governed alone by many different principles, but that observes itself from many different positions and through many different optics. What can be done? Warren Weaver asked this question, but didn't answer it. Edmund Husserl could see the abyss, but he tried to build a bridge over it. Most others regarded such thoughts as meaningless and—passively or actively—ignored or undermined the activity.

In confronting this problem, Gotthard Günther was radical. It is not only a question of how to determine what is substance and form, such as one decides the criterion for making a distinction between red and green or soft and hard. No, in his paper "The Tradition of Logic and the Concept of a Trans-Classical Rationality" Günther contended that one couldn't maintain the universal distinction between what is form and what is substance. According to Günther, such a once-and-for-all distinction is an expression of the belief that the universe is governed by universal laws or observed through a universal medium.

Thus, we cannot take our starting point in an ontological or a transcendental certainty. Instead, we must begin with the concept of self-reflection: He or that which observes does so always under specific conditions, and since it can no longer be assumed that conditions are universal, i.e., common for all, they must themselves become the object of observation. One can no longer just say: "I see that and that," but must always add: "under such and such conditions." A transclassical rationality involves observing the observation of one's own observations.

> With the alternative: is this true or false, we miss the whole point of the problem. Because as soon as we begin to talk about self-reflection we have ceased to refer to the original classic situation where a thinking subject naively (= without reference to itself) faces a universe of (thought) objects. Instead, we want to know: what laws of reflection govern the opposition between Subject and Object? (Günther 1979, p. 119)

Another way of putting this is to say that the world consists of a mass of different subsystems, which are the source of different worlds. Günther calls this polycontexturality, i.e., each subsystem creates its own world, or, in the terminology of Günther, its own context. In an article from 1973, "Life as Poly-Contexturality," Günther makes the

distinction between classical and transclassical science. "What classical science has investigated is a subjectless Universe; and a subjectless Universe presents us with a rigorously mono-contextural structure" (Günther 1979, p. 304). However, already assuming that there is a distinction between spirit and matter is to accept that the universe is discontextural, which is reflected by religion's distinction between the secular and the transcendental world. But if one studies, e.g., the human body, one learns that the discontexturality is enormous. Thus, while one may—up to a point, as Günther says—consider the material substratum of the world as monocontextural, the living organisms must be considered as "poly-contextural structures" (Ibid.).

The same is the case if one wants to study a modern society. In a society governed by tradition, things are given beforehand in the form of habits. In a modern society, things are taken less and less for given. This means that more knowledge is required to make the "right" decisions. But as there are limits to what a single individual can remember or a simple interaction system can accomplish, society differentiates into smaller systems, which each specialize in the management of its set of limited tasks. Doctors have knowledge of the difference between the healthy and the sick, jurists know the lawful from the unlawful, politicians understand the parliamentary or power and what is and isn't possible politically, researchers know the difference between the true and the false, etc. Put differently, one can say that different actors find themselves in different contexts. The politician's spectacles focus sharply on the differences between a majority and a minority and how to create them, and therefore his world consists of alliances, tactics, compromises, power, precision, and the like. The doctor's world, on the other hand, consists of sick and healthy people; the kind of alliances and the kind of power possessed by these people is not a relevant distinction. And when the scientist describes her world, she is concerned with describing it as precisely as possible: not in rhetorical and appealing terms to secure political support, but through a clear application of the assumptions under which the description takes place, in order to say that the specific observation is carried out under a set of preconditions that are determined by the observing or acting system's own specific functional position in society. Thus, these functionally differentiated systems constitute a polycontextural social system, and the functioning of this social system exemplifies—and necessitates—a theory of a transclassical rationality such as Gotthard Günther has suggested.

Substance and Form

As already recognized by Günther, a fundamental distinction, which was challenged during the epistemological discussions in the twentieth century, is between substance and form, i.e., between pure quantity or matter and the form of matter. We have made this distinction for thousands of years. But, what exactly *is* "substance" and how does it gain form? Normally, we imagine something like the craftsperson working in clay who makes a pot. The clay "assumes a form" in the hands of the turner.

But there are a number of problems connected with the image of a relationship between substance and form. One problem is that clay also has a form, otherwise we wouldn't be able to call it clay. The question is thus whether substance ontologically speaking is substance, and form always form, or whether this distinction is a matter of observation. For one observer, "clay" is form, while according to the turner clay is matter. Gregory Bateson, another contemporary (1904–1980) who was involved in the discussion groups concerning information theory and cybernetics, suggested that form is the result of a double distinction: the observed distinction and the observing distinction. What about a tree, for example, or a forest in the distance? We haven't formed them, and yet they have form—the form of the tree. One can say that we distinguish the distinction, i.e., transform form into "information." Bateson summarized this idea in his famous dictum that information is "a difference which makes a difference" (cf. Bateson 2000 p. 459, cf. also 271f and 315).

Thus, a related question is whether the relationship between substance and form is the same as the relationship between content and expression. One might immediately believe that the meaning of a thing, e.g., a vase, lies in the thing itself—in the clay so to speak—and is expressed only through its name or its form. But this is not apparently the case. Another suggestion was elaborated by one of the last century's great language philosophers, the Danish linguist Louis Hjelmslev, who lived at almost the same time as Gotthard Günther, namely from 1899 to 1965. For him the distinction between substance and form is not equal to a distinction between the real and the conceptual world. On the contrary, the distinction between substance and form exists both in reality and in the conceptual world such as it is expressed in language. Normally one assumes that there are an infinite number of "content things," which gain a form on the basis of signs.

The sign is in other words a "name" for "the thing," i.e., a form for the substance. This distinction is not recognized by Hjelmslev. Firstly, he argues, this creates the problem of presupposing a natural connection between content and expression. Secondly, it presupposes—and this is also problematic—that there exist "things" (trees, cars, natural concepts) before they gain their form or become signified.

In order to tackle this problem Hjelmslev made a distinction between, on the one hand, the content's substance and the content's form and, on the other hand, the expression's substance and the expression's form. The content's substance is what is called "meaning," i.e., the content that is common to all languages. The content's form is the form that meaning gains in a specific national language. One says goodbye all over the world, but it is done differently and therefore gains different forms of content: "Farvel" [have a nice trip] is the basic way in Danish of saying "goodbye" or "auf Wiedersehen" or "au revoir." Thus, although it has the same meaning (substance of content), it is a different expression (form of content). Of course in Danish one can also say "på gensyn" [see you again], but then one has not "really" said goodbye. In other words, there is a difference between substance and form of contents. In a corresponding manner, there exists an expression's substance—the many different sounds—that come to expression in the expression's forms, for example, in a particular language's limited number of phonetic forms. The parallel between Hjelmslev and Bateson is evident: that information is a double distinction. In the conceptual system developed by Hjelmslev, this would be a distinction in expression form that makes a distinction in content form.

Medium, Form, and Meaning

As the preceding shows, in the course of the twentieth century the distinction between substance and form was discussed from an increasing number of perspectives. Apparently, substance is not unambiguously substance, just as form is not always form, and as a result it is no longer possible to talk about substance or form "as such." The conclusion is that one cannot talk about the *what*-question (what is substance, what is form?) without raising the *how*-question (how, that is according to which criteria, is the distinction between substance and form made?).

But what then are we to do? How are we to define the categories of "substance" and "form," at the same time as we make it clear that they don't have universal status and are instead more dependent upon their

mutual relation? Niklas Luhmann has suggested that one should distinguish between structures with relatively loose connections and structures with relatively strongly connected elements. The first—the structure that is characterized by loosely coupled elements—can be called the "medium" (as an alternative to the term "substance," with its more universal associations). The second—the structure that is characterized by more strongly coupled elements—can be called "form." We see something—a form—through a medium, but the medium itself cannot be seen when we are looking through it. For example: We see an object through the light as its medium, we hear a sound through the air as its medium, we communicate through language as a medium. What we characterize as a sound (a tone, for example) is a strong coupling of the loosely coupled elements of air. Correspondingly, the trace of a footprint in damp sand is a fixing of previously loose sand. Different sounds are formed into words, which are the medium for poems, and so on.

Instead of "substance and form," we talk of "medium and form," and one of the advantages is that there isn't something that "in itself" is the medium or the form. We emancipate the concepts from their ontological burden. The medium is always the medium in relation to the form for which it is the medium, and correspondingly the form is always the form in relation to the medium on the basis of which it is form. The "medium" is therefore a general term for what we normally call substance. By giving the concept a different name, we avoid the concept of substance's ontological character (i.e., that "substance is substance" in a universal sense).

As I have suggested above, we see something—a form—through a medium. Sand for example is the medium for the footprint. This distinction can be transferred to psychic and social systems, i.e., to the way in which we think and communicate. When we think and when we communicate, we do so through meaning. Consequently, using the concepts developed above, meaning is a common medium for society and the psyche. It is through meaning and through selection that we can create social and psychic forms. Or put differently: We communicate and we think through meaning as medium.

But at the same time, meaning is of course—as with all things—itself a form, and meaning's form is the separation between the actual and the potential, i.e., on the one hand what exists, what is possible, what lies within the actual horizon, and on the other hand what is not possible or visible, i.e., that which lies beyond the actual horizon. Meaning is, Luhmann says with an abstract concept, "the world's form."

But how does meaning come about? Where does it come from? Traditionally, many would use religious terms ("what is the meaning of life," one could ask, and Luhmann would translate the same question as, "what is the world's form?"). If one wanted to translate the religious language into the medium-form terminology, one would say that God is the medium, and the form God "makes possible" is meaning. This form is the distinction between the transcendental and the secular. Perhaps one can also envisage how it is possible to account for the function of religion in a hypercomplex society. It is not a universal point around which everything revolves, nor is it a universal cause. It is to have relationship to—to find concepts for—the relationship: with meaning as form, there exists something without a marking, something beyond meaning. It is this with which religion is concerned, often with paradoxical concepts such as life after death, or the meaningless meaning (Luhmann 1996). If one chooses a less religious form of expression, one might say that meaning is a result of the evolution of society and the psyche. Meaning is, so to speak, what we can imagine, and to imagine something is precisely to bring firmly together what was loosely connected. Thus, meaning is both medium (the precondition for thinking and communicating) and form (our world horizon).

George Spencer Brown and the "Laws of Form"

Another mathematician from the twentieth century who aimed at developing a trans-Aristotelian logic was George Spencer Brown. He was born in 1923, and as a four-year-old, as he has later recounted, he read Euclid's *Elements*, which his father gave him. Thereafter he wasted, to use his own words, 16 years in the education system. In 1959, he initiated that research project—supported and encouraged by Bertrand Russell among others—that resulted in his main work, the 140-page long (including appendices) *Laws of Form*. Published in England in 1969, it represented nothing less than an alternative to classical logic, which had in the opinion of some reached its pinnacle with Whitehead and Russell's *Principia mathematica*, published in three volumes in the years 1910–13. According to Spencer Brown, *Principia* was the last anxious attempt to save mathematics from its self-appointed enemy: the paradox. Some years after the publication of his work, Spencer Brown finished his university career and established the Sentinel Trust for Creative Education.

Laws of Form, translated into a number of languages (into German in a version in 1997 with a number of new introductions and appendices),

has had a strange destiny. It had an obscure existence until the mid-1980s, when it was discovered by Niklas Luhmann, who gave it the status of the theoretical basis for systems theory. Since then it has left its mark on Luhmann's work and has also been the object of discussion and interpretation by others in the systems theory milieu, not least Luhmann's pupil Dirk Baecker, who in 1993 edited two volumes of articles with the titles *Kalkül der Form* and *Probleme der Form* (Baecker 1993a and 1993b).

The starting point in *Laws of Form* is that a universe arises when a space is created, i.e., a distinction is made. This is well known in narratives of creation: According to the scriptures, God created the heaven and the earth by making a difference between light and dark, and no sooner had he done this than he made his next distinction, when he separated the primordial ocean into heaven and sea, and again clove the sea into land and ocean. Not only is this the narrative of creation. It is also the suggestion for an epistemology that cannot start with an ontologically given thing (the atom or the commodity) or in a given transcendental ego, but must start in that which precedes form: distinction. Similarly, the story of creation is one long narrative of the application of distinction's logic, such that something arises when a distinction is drawn and a space is shaped by its opposing parts and when the categories that have arisen are again divided into new forms.

The basic implicit assertion in Spencer Brown's *Laws of Form* is that if we cannot take our starting point in the existence of something—for example, a common world—with ontological certainty, then we must start from what founds a world, namely that a distinction is drawn. Therefore the Bible's story of creation, i.e., the narrative of the world before the world, is introduced by making a difference: therefore, a theory of a society, which cannot be based on fixed assumptions, is introduced with the statement "Draw a distinction" (Brown 1971, p. 3). With this opening distinction, a difference is made between an inner side and an outer side, a marked state and an unmarked state. Something is indicated by separating it from something that it is not. The traditional difference between whole and part is replaced by the distinction between system and environment, a distinction that can be repeated endlessly by system differentiations, in which the whole system uses itself in forming its own subsystems, thus "more rigorously filtering an ultimately uncontrollable environment" (Luhmann 1995, p. 7). The practical outcome is a social reduction of risk by increasing internal complexity. The theoretical outcome is a theory of social systems as closed, that is, autopoietic, systems.

Of course, after the first distinction, one could remain in the inner side of the form. One can remain with the familiar, in the security that what one doesn't know isn't worth knowing. The distinction is narrowed into itself, it is "condensed," as Spencer Brown puts it, and the surrounding world is perceived as "the other," i.e. as the simple negation of "my" or "our" world. This represents the traditional society's image of the world: The world is confronted with what lies beyond it—civilization with the primitive, order with disorder, culture with nonculture. Upon such a foundation it is possible to construct something known as "our civilization," and to canonize it as given and collect it in normative schemes or as the single, true reason: the Western rationality, for example. Irrespective of whether the foundation is religious/normative or rationalist, it represents a monocentric world picture.

But in a world that has become polycentric, it is not enough to remain in form's inner side. In a polycentric world, the same thing happens as for anthropologists when they in their studies of the "primitive" realized that if one sat in the position of "the other," it was not difficult to imagine that these others felt confronted by a corresponding primitiveness, an otherness that was just as radical. Western culture can in other words be observed from the outside, as a foreign world, as an inverted primitiveness, and it can observe itself as such.

Instead of standing in one's own world as if it were the only world, one is thus forced to realize it as a marked space, and to cross the boundary between the marked and the unmarked space, between system and environment. Of course one cannot simply move, as we saw with the anthropologists, into the unmarked environment. One doesn't just shift standpoint or optic—what is called in anthropological fieldwork "to go bush," to become oneself "primitive"—but one is forced to observe one's own observation. In the theory of form, this is expressed in the manner that one doesn't just cross the boundary, but observes the form as the unity of the distinction between the marked and the unmarked state. By crossing the boundary of the known and recollecting the earlier condition, looking backward, one partakes of a second-order observation. One observes one's own observation. One recognizes that the certain knowledge, the familiar order—civilization, culture, the taken for granted—are not ontologically given, but could themselves also have been different.

It is first at this point, strictly speaking, that a world or a form is created: not just a difference between something and its negation, but a unity of difference. Indeed form is, as Spencer Brown has said, the unity of the distinction and its marked and unmarked sides. God created not

just the earth, but heaven *and* earth; as Augustine already saw, God was interested not in the one or the other, but in the distinction.

Lastly, one can also take as the starting point the second-order observation. Thus the topic is the form of the unity of the marked and the unmarked. A second-order's observation also implies that there is another side: the second-order's observation's outer side. This outer side is comparable to the horizon of phenomenologists. It is the precondition for the formation of form. We have thus returned to our starting point, namely that no distinction can be made without, as Spencer Brown calls it, a preceding "motive": There must be a world before a world is first constituted. The known world, which is the result of an endless number of differentiations, of the crossing of boundaries and of the resulting self-observations, inscribes itself in itself, just as fractals do. That the world as such is thus inscribed in itself is thus the hypercomplex society's answer to the traditional world's reliance upon God or destiny, or to modern society's reliance upon rationality and progress. In the Bible it is God who draws a distinction. In the hypercomplex society's self-description, it is the inscription itself that makes a difference. God is replaced by the paradox, which reactualizes religion; not, however, as a potential for security, but rather a potential for insecurity (Luhmann 1992, p. 91, English translation, Luhmann 1998, p. 43), that is, as a semantics of the paradox. In a world where rationality was the monocentric answer to religious monocentrism, God appeared to be of no consequence, as a hypothesis of which we have no use in our rational account of the world, as Laplace put it. In the world, where paradox is the fundamental condition, paradox semantics, i.e., religion as reservoir of schemes for paradoxical interpretations, is of fundamental significance.

But shouldn't paradoxes be avoided? This was the view of classical logic, which Whitehead and Russell attempted to save, as already mentioned, with the argument that paradoxes are the result of category mistakes. To this it is Spencer Brown's assertion that the paradox is a condition for recognition, and that the answer of paradoxes is "deparadoxicalization," for instance in the form of time. Things take time, just as the creation of the world took seven days, and it is this that makes it possible to cope with paradoxes. Not because "time" is an ontological precondition, but because "before" and "after" cannot be freely reversed. The marked and the unmarked state are different. It is thus only in a world without time, i.e., in the natural science of the classical world, that paradoxes couldn't be dealt with, because all natural processes per definition were reversible (Prigogine and Stengers 1979).

Paradoxicality, Interference, and Polylogy

By calling our contemporary society hypercomplex, one is asserting not merely that it contains more possibilities for connections than one as observer is capable of making, but that it is necessary to accommodate the contingency of one's own descriptions of the surrounding world. The challenge is not just the uncertainty of the world, but the uncertainty of one's own uncertainty.

From its earliest phases, society has increased its own complexity. "Language creates," as Luhmann has said, "the possibility of negating and concealing: the possibility of lying, deception, and the misleading use of symbols. Means of dissemination like writing and printing switch off the repression of conflict typical in interaction systems" (Luhmann 1984, p. 513; English translation, Luhmann 1995, p. 376). When man declares himself free, i.e., has made himself free of society and defined himself as society's environment, this is indeed a source of conflict and leads to an increase in complexity.

This increase in complexity accelerates with the differentiation of media-based functional systems. When being together is based on money as the common medium for observation and communication, the effect is not only an increase in tempo, but an increase in the number of possibilities. With money, which is a medium of universalization, each person in principle can buy and do anything. When intimacy is located in the code of romantic love and not in paternal decisions or the will of God, then uncertainty is heightened because this code requires "that one admits the other entirely and without negation, so that any conflict symbolizes an end to love" (Luhmann 1984 p. 513; English translation, Luhmann 1995, p. 377). In the world of science, the problem is the opposite: "Every communication depends on criticism, thus on rejection and conflict, because here the code bases validity on universal acceptance (. . .): the rule that truth must be universally accepted forces all communication on the operative level into the form of contradiction" (Luhmann 1984, p. 513; English translation Luhmann 1995, p. 377). This condition works against scientists agreeing to celebrate the already known, and therefore screws up the scientific world's rate of change and complexity.

Differentiation paves the way for an increase in complexity. However, when communication becomes attentive to its own contingency—that things could take place upon a different foundation, i.e., that the value of communication isn't something that can be taken universally for granted—then complexity becomes hypercomplexity.

The communicating system looks toward its own complexity and thus intensifies its level of complexity. Anthropologists discovered that it is not enough to observe the other, which is complicated enough in itself, but that they at the same time had to observe their own observations, because they were clearly never neutral, i.e. could always be different. The scientist recognizes that his truth criteria aren't naturally valid. Consequently, the intense observation of the scientific object must be supplemented by a just as intense self-observation. The artist's concept of beauty is questioned, and when "beauty" is no longer taken for granted, the artist is forced continuously to make his own and society's concept of art an issue. The lover admits that love is not merely love, but could be something else, i.e., could be based on other criteria, and is thus forced to make love itself a topic.

The Self-Description of Hypercomplex Society

Society described as a system that recreates and modifies itself on the basis of observations of the other and of itself, and thus builds up its inner complexity with the help of functional differentiation, is not a society that finds itself on a higher level, is "better" or of greater value than the traditional society. "The thesis is," writes Luhmann, "that the transition to this form of differentiation makes society's irritability increase, i.e., increases its ability to quickly react to changes in the environment. However, the price to pay is that a comprehensive co-ordination of these forms of irritation must be given up. With the lack of co-ordination of irritation forms, society can only react in an irritated fashion. It is unable to use a centrally controlled solution to the problem of over-irritation" (Luhmann 1997, p. 789).[13]

The "hypercomplex" society is not then a name for a better or more highly developed society, it is solely a proposal for another way of describing society than the one with which we are traditionally familiar. Precisely because this description is *different,* it cannot be used in a better/worse scheme. The assertion is therefore not that the hypercomplex society is worse or better than other societies, but simply that it is different and thus presupposes other descriptive categories. The decisive task is to perceive this society as a society, i.e., to observe it as a sociological and historical phenomenon and not as the final point of history or its measure. The task is to use adequate concepts, which at the same time allow us to recognize society in its own right and to hold it at such a distance that it can be described and analyzed, and doesn't just appear as a natural or universal phenomenon, as the final station of history.

The Paradox of Time

What is the answer to the problem of society being hypercomplex, i.e., that it continuously reproduces its own foundation? On the technological level, one of the answers is information and communication technology, as long as the computer's intention is the management of complexity, and as long as the intention with the digital network is the development of a communication system that on the basis of its self-organizing structure is in itself so complex and flexible that it can match the growing societal complexity. The Internet doesn't forget, but guides new data to those systems that already exist. It doesn't hide, but makes itself visible for itself on the basis of its infinite number of connections, i.e., internal self-references. The result is not however a solution to social complexity, but rather a transformation of it. The growing outer social complexity is matched by a corresponding inner technological complexity, so that what to begin with appears to be the management of outer complexity shows itself to be a transformation of the problem from its social into its technological form. Thus, the Internet tackles the problem by transforming it into a new mode of existence. Only insofar as other means of complexity reduction can be implemented with the Internet (search engines, filtering mechanisms, link structures), insofar as communicative couplings can be more easily managed on the Net than in society (concerning both speed and distance) or insofar as complexity is less harmful in its technological than in its social form does the Internet represent a solution.

On the organizational level, the answer is decision making, since decisions, if they have no other effect, at least for a time make sure that other possibilities are held at bay. But with decisions' removal of other possibilities, the level of risk shoots upward, i.e., one becomes nervous that another decision would have been more appropriate. As already mentioned, this version of complexity management as a matter of transforming the complexity problem from society into a decision system based on bounded—and not unlimited—rationality was first expressed by H. A. Simon in 1945 (Simon 1997). Again, the complexity problem is tackled by a transformation, this time from its social into its organizational form. Consequently, reorganization that seems to become an independent ideal, because it signals an extremely high tempo of decisionmaking and thus glorifies the leader, in reality is a mirror of the social complexity problem. As with the Internet case, the transformation from social into organizational complexity may provide a solution, partly because organizations function as complexity containers,

thus removing complexity from society and making it invisible for the citizens; partly because organizations actually are decision machines (which society is not); and finally because broad complexity problems can be divided into specialized complexity issues, each of which is tackled by its own organization.

On the human level, the shifting answer seems sometimes to be the speeding up of the tempo, at other times to be the opposite, i.e. simplification. We work harder and at higher speed, while celebrating the ideal of slow meals and a simple life. The point of departure is that the human being is not a part of society, but exists as its environment and must therefore choose between following his social environment or following his self. Since Kant, this phenomenon has been generally known as the dilemma between necessity and freedom (Dahrendorf 1968). Is one to follow one's social environment—this is the option called "necessity"—or should one follow one's self and call it "freedom"? Each time a choice is made, it is clear that it is not a case of absolutes, but outer poles in a paradox: If one chooses to follow the demands of the social world, the result is a loss of freedom that leads into social freedom ("necessity's freedom," as it has been called by all, from Calvinists to Marxists), while choosing to follow one's self results in the swift recognition that free opportunities are reduced ("freedom's necessity," existentialists have coined this opportunity).

On the one hand, one uses time as a means to manage complexity, for example by using it as a medium for division: "Differentiation substitutes two limited and therefore scarce quantities of time for the endless temporal horizon bounded only by an uncertain (and always possible) death," Luhmann says (Luhmann 1984, p. 527; English translation, Luhmann 1995, p. 386). Time is split up: By dividing the day into hours and the hours into minutes, it becomes possible to increase the number of meetings. In this way the calendar—and careful and detailed planning—becomes an instrument in the management of complexity.

Or, on the other hand, one sets time out to drift—temporarily—letting it pass, taking a vacation and realizing oneself. The effect is, as the Romantics already experienced, that sensibility increases, and attention to details can be improved. But with a modern consciousness it is difficult to ignore how this setting of the clocks to zero becomes a contradiction in terms. For the world doesn't cease to change in the meantime. The result is that the timeless condition loses its taken-for-granted character and transforms itself into an eigenvalue, to which one cannot avoid paying intensive attention. It thus loses its tacit character and becomes in itself a stress factor. An increased level of

sensibility also leads to an increased level of irritability. Vacation, yes—but only until tomorrow.

Time in the hypercomplex society, in other words, becomes an incarnation of the self-contradictions of complexity management: "A society that constructs greater complexity must (. . .) find forms for creating and tolerating structural insecurity. It must guarantee its own autopoiesis over and beyond its own structures, and this requires not least a greater inclusion of the temporal dimension in the creation and working out of contradictions. Time multiplies contradictions. But at the same time it mitigates and dissolves them. On the one hand, when one brings broader temporal horizons into consideration, more intentions contradict one another. On the other, a lot can occur in succession that could not occur all at once. Thus time clearly has a contradictory relationship with contradictions: it both increases and decreases them" (Luhmann 1984, p. 514f; English translation, Luhmann 1995, p. 378).

Paradoxicality and Deparadoxicalization

Why is it that what was once a dilemma has now become a paradox in our society? Earlier it was possible to choose either one or the other, while today it seems that when the first is chosen, the second is actualized. The reason is that dilemmas can no longer be resolved by some outer authority, whether this be metaphysical or transcendental. This explains why the dilemmas of yesterday have become today's paradoxes.

The traditional expectation was that paradoxes could be dealt with by referring to God as the creator of order, able to provide a guarantee of meaning in the meaningless, e.g., a life after death. The modern expectation was that paradoxes could be dismantled in a rational manner, i.e., by referring to the human being as the source of order: Why do we need a conception of life after death when medical science can be a source of security? Why do we need a reservoir of religious meanings when we have created the best imaginable, rational society?

But today neither metaphysics nor rationality is capable of providing absolute solutions. God is dead, and scientific reasoning has experienced a similar fate. "The modern must," as Jürgen Habermas has written in his book *Der philosophische Diskurs der Moderne*, "create its own norms" (Habermas 1985).

From Theology and Anthropology to Polylogy

Today the answer rests with neither the theological nor anthropological, but with the polylogical. The answer for our times cannot stand

outside of the issue itself, but must enter it. The strategy is not one of dissolving paradoxes, but of deparadoxicalization. One is to search for the thing's minimal difference from itself, as Duchamp put it: neither *above* the physical or social matter, i.e., in metaphysics, nor *under* the surface of matter, i.e., in rationality, but in patterns in the thing itself, revealed in the play of its elements against each other.

It was Spencer Brown who underlined that if the possibility one has is to make a distinction, then the only possible next action is to reenter this distinction into the already established form. The result of this repetitive reentry of a distinction into its own form is that patterns are formed: We find this in Johann Sebastian Bach's music, where ingenious patterns of patterns develop a *new* polyphonic pattern. The interference of the many small, mutually developing patterns creates a meta-pattern. We are familiar with this from the experience of throwing not one, but two or more pebbles into a completely still pond, so that the rings in the water interfere with each other, or when we walk along the paths of a Japanese garden, amongst its meticulously cultivated flower beds. Similarly, social systems stabilize themselves by reentering distinctions in forms, i.e., by letting the social system be the environment of a new functional differentiation, thus creating an immensely complex, asymmetrical and thus irreversible system of systems. "In this manner, namely through the re-entry of the form in the form, meaning becomes a self-regenerating medium for the ongoing selection of specific forms" (Luhmann 1997, p. 58). This is the vision of a hypercomplex society as a learning society: A society that deals with complexity by building up complexity. A society that recreates itself in new versions, on the basis of what it has already learned.

III

Media of Self-Observation

FIVE

Communication, Media, and Public Opinion of the Hypercomplex Society

According to the American media researcher James Carey, two alternative conceptions of communication have influenced the public view of mass media and the theory of this phenomenon: One is called the "transmission view" and is by far the most common in Western culture. In contrast to the transmission view stands the "ritual" view. According to the transmission view, media are transmission channels that transport information from one place to another. Something happens in Jakarta, and through the media this is transported to readers or viewers in the United States. According to this perspective, the newspaper and the television channel are vehicles for the dissemination of news and knowledge. It is assumed that there is a correspondence between reality and its mediated representation, and as a consequence readers and viewers, at least in principle, can compare what the media say with what has happened in reality. Furthermore, this leads to a cause-and-effect conception of the media. Thus, information, knowledge, and worldviews are disseminated through the media and transported into the minds of the receivers. If we watch violent television series, we become violent ourselves.

The alternative conception of communication is the ritual view. According to this theory, the basic function of the media is to construct a common world. "Here," says Carey, "communication is linked to terms such as 'sharing,' 'participation,' 'association,' 'fellowship,' and the 'possession of a common faith.' This definition exploits the ancient identity and common roots of the terms 'commonness,' 'communion,' 'community,' and 'communication'" (Carey 1989, p. 18). An illustrative example is presented by Eve Stryker Mumson and Catherine A. Warren in their introduction to Carey: Millions of Americans set their

clock radios so that they can wake to the news. This is not primarily to receive information, but to facilitate the daily transformation from the private universe of sleeping to the public world of presidents, wars, government decisions, local events, and sunshine and showers. According to this view, journalists are not primarily information providers, but rather dramatists, who build public stages and people them with actors performing their well-known routines. As a matter of fact, these persons often act according to the ritual rules of this mediated world: When in the television studio, one must act according to its rules, and when the world has been transformed into a studio, the world behaves accordingly. This implies that the question as to whether the media mirror the world or vice versa is wrongly posed. According to Carey they co-operate. Similarly, the French sociologist Bruno Latour has suggested that technology and people should be observed as actants, who establish actant networks of mutual mediation (Latour 1994).

The media thus function as did gossip in the traditional local community: They increase the probability of successful communication in society by increasing its redundancy. The contribution of gossip to communication is to limit the variety of potential communicative selections, and similarly the mass media reduce complex issues to simple social schemata: standardized narrative structures, agendas, etc. This is the precondition for ensuring and confirming the stable existence of the social world, although today "my world" is not limited to the boundaries of the village, but includes world society, as in the definition suggested by Luhmann, that "society" is the totality of communicatively accessible actions. Thus, mass media's "simplifying" of complex issues, their "standardizing" of agendas, and so on, standard issues of criticism from intellectuals, should basically be understood as the condition *sine qua non* for making societal communication possible. Furthermore, the mass media's common world is not constructed "by" the media and then imposed on recipients. It is formatted in a network of public actors, media technologies, media institutions, and audiences, in which all parties contribute actively to the formatting of what Luhmann calls the "transcendental illusion" (Luhmann 1996, p. 14; English translation, 2000, p. 4) of society as a global community.

Communication as Transmission

The theory of communication, which says that communication can be observed as the transport or transmission of meaning between people,

has dominated media and communication science since the Second World War. This is not so strange: On the contrary, most people would immediately say that communication is the transport of information from one person to another via a communication medium, just as a pipeline functions to disseminate water or oil, and the train transports commodities from town to town. We are all familiar with the model where "something" called information, via a stipulated connecting line, leaves the speaking mouth of a person and enters the listening ear, and it is precisely this model that seems to be confirmed when a person talks into a telephone, while the listener is at the other end of the line with his or her ear pressed to the telephone handset. This has been expressed theoretically by Warren Weaver, one of the fathers of communication theory, in what is actually a mis-popularization of Shannon's mathematical communication theory. He has suggested the following illustration: When I talk to you, my brain is the source of information, yours is my goal; my voice is the sender, your ear and its connecting nerve is the receiver.

The transport model has a long history. It has shown itself to be resilient and also influential, most likely because of its simplicity and because it intuitively mirrors what apparently takes place when we communicate. In versions of differing complexity, it can be found in numerous introductory textbooks of communication and media theory.[1]

From Warren Weaver in the 1930s until our present day, a shift has taken place in communication theory's transport paradigm, from a focus on the sender to a focus on the receiver. This can be summarized in four phases:

- The effect model
- The two-step and multistep models
- The "usage and gratification" model
- The reception model

In the effect model, attention is first devoted almost exclusively to the sender, and the effects of communication are considered to be the result of the sender's actions. The dominant model looks like Figure 5.1.

In analysis of the communication process the sender and his/her intentions are taken as the starting point. Thereafter, investigation turns to the channel supporting the communication: How strong is it, how large is the public reached by the sender, and in what manner does the channel color the content of the message (e.g., more text can

128 MEDIA OF SELF-OBSERVATION

Figure 10

be communicated via the newspaper than via television; the structure of the text is linear on radio/television, but has a complex structure in the written media)? Then the transmission of the message as a certain signal is studied, e.g., with technical or semantic code systems. After this, the technical and semantic sources of noise are reduced: competing media, technical disturbances on the telephone line, and so on. And then analysis moves to the relationship of the receiver: a retransmission or recoding by the receiver based on his or her technical and semantic-cultural background. Only having reached so far in the analysis of the process is it possible to evaluate the effects of the media. The American media researcher Harold D. Laswell has drawn all these aspects together in five well-known questions: Who? Says what? In which channel? To whom? With what effect? (Laswell 1948).

The two-step model (and its successor, the multistep model) was a development of the effect model.[2] Here attention is directed toward occasions, far from rare, when there is no direct linkage between the sender and the receiver. On the contrary, the message reaches the receiver after first having passed a number of in-between stations: Newspapers and other media organizations were in-between stations for the communication of politicians to their voters. Opinion leaders stand between media and citizens in social communication. And, in inter- and intra-organizational communication, there are many gatekeepers, who filter, control, and serve as steps in the communication cycle.

The usage and gratification model shifts the focus for the first time from the sender to the receiver. Instead of regarding the public as a passive mass, in terms of how communication effects can be modified by the in-between stations, which the message must pass through on its way to its final goal (cf. the two-step and multistep models), it is asserted that the public are active (and besides, quite differentiated) in their use of the media.[3] The recoding and interpretation of the message,

which is carried out by the receiver, is among other things dependent upon the needs of the receiver: The message is used in a particular manner and therefore has an effect that is far from the one intended by the sender.

This tendency reaches its preliminary high point with the reception model. Here the receiver becomes the main object of analysis. Special emphasis is placed on how there is no pre-given meaning in a given media text (published or electronic), it is instead produced in the encounter between the text and public, and this interaction is influenced among other things by the discourses that unfold in connection with the public's application of the media,[4] e.g., normally watching television is an interpretational activity whether carried out on one's own, or together with family or friends. And with respect to communication in organizations it is important to analyze the organization's culture, through which the message is interpreted, and the often complicated internal channels of communication in the organization, through which the message must pass.

In other words, there have been a lot of large changes in communication theory between the first simple effect models of the 1930s and 1940s and today's sophisticated theories. At the same time, it must be emphasized that many of the aspects of communication taken up by these models are useful in an analysis and evaluation of both social and organizational communication.

Theoretically, the most interesting thing is nonetheless the change in the overall understanding of communication as transport points toward a theoretical break: a break with the fundamental view that communication is the transport of meaning from one person or institution to another, and a movement toward the alternative view, that communication is a case of double contingency. A psychological system is disturbed by happenings in its environment, and in reference to itself it partly chooses to observe these disturbances as another system's communicative selections of information and utterance, and it partly—again referring to itself—selects an understanding.

Before turning to examine some of these alternative theories, I shall look a little more closely at the theoretical implications of the transport model.

The Transport Model's Implicit Assumptions

What are the drawbacks in a communication theory based on the transport or transmission paradigm? One fundamental problem is that the

theory is out of touch with contemporary philosophical and knowledge-theoretical discussions. The second problem is that the transport metaphor appears to be empirically deceptive. In Warren Weaver's plausible literal "translation" of the metaphor "my brain is the information source, yours the destination," he expresses extremely well what it is that definitely *doesn't* take place: It is not the case that thoughts are moved from my brain to your brain, unless we imagine that what is taking place is thought transference.

For the moment I will restrict my attention to one further simple implication of the theory: It builds upon an ideal or assumption that media communication occurs in a transparent manner. For Weaver and his colleague, Claude E. Shannon, the theoretical task involved determining how sensitive the electronic transmission of information was in the presence of noise, and even though Shannon asserted that his theory was not to be considered a semantic theory, Weaver made the opposite assertion and talked respectively of *semantic* transport and noise (Weaver in Shannon and Weaver 1948).[5]

Another relevant issue—in agreement with the theory and its fundamental metaphor, but in opposition to the social context in which the media-mediated communication takes place—is that communication deals with the actual establishment of a society with others. "Communication comes from the Latin *communis,* common," underlined the American media researcher Wilbur Schramm: "When we communicate we are trying to establish a 'common-ness' with someone" (Schramm 1954).

This conception has deep roots in the history of European thought. One of the ways in which it was imagined that this dream could be realized was through the construction of the completely transparent language: the perfect language. This dream has gained the attention of Umberto Eco in a 385-page witty, historical account, *The Search for the Perfect Language* (Eco 1995). For centuries humans have sought the perfect language. According to Eco, this can be traced back to the building of the Tower of Babel, and much later the same dream came to expression in the Pentecostal mystery, where the apostles in the New Testament account gained the ability to express themselves in an exact language, which all could understand as if it were their own mother language.

Since then, hundreds of artificial languages have been created with the rationalistic aim of overcoming the translation problems caused by the existence of innumerable natural languages.

In the seventeenth and eighteenth centuries, when the social division

of labor into different functional domains—the modern Babel—began to exert a serious influence, a new but corresponding dream developed: the dream of a modern publicity, in which the most different private people could meet as citizens and, on the basis of rational argument, establish a shared, transparent communication forum, so that they could act in a united manner, as in the French *le public* and in the German *Publikum*. In this forum it was, as the English philosopher Hobbes expressed it, truth and not authority that formed the basis of laws: "Veritas non auctoritas facit legem" (Habermas 1962). Today, this dream goes under the name of the lifeworld, i.e., an asserted particular realm of society where communicative action takes place in an understanding-oriented discourse.

Recently, an arguably more naïve and more technocratic, but still in certain respects corresponding, dream has been proposed, the dream of the "information society" in opposition to the earlier industrial society. In this current version the dream is based neither on some kind of perfect language nor on the citizen's ability to argue in a rational manner. Today's dream is a technological dream. e.g., marketed under the rubric of "information highways." The idea seems to be that with digital high-capacity communication channels, the old society with its barriers to information and communication will be replaced by a society where everybody has complete access to information about everything, and where all without exception are able to speak. The person who hasn't merely earned the most money by it but also believes he has done the most to bring about its realization, namely Microsoft's director Bill Gates, has called this society "frictionless capitalism" (Gates 1995, especially pp. 157–183). This represents one of the actual reasons for doing something with the transport- or transmission-based communication theory. If it is taken literally, then Bill Gates's view is that we are entering the utopia that has been described for so many centuries: digital channels broad enough and without disturbing noise.

Objections to the Transport Model

This model of communication and its supporting theory can, as noted, be called the transport model. It appears at first sight to be immediately true, but if one examines it a little more closely, it is seen to be based on a doubtful assumption. The transport model implicitly assumes that the two communicating parts live in a common world. The world that you see is the same as the world that I see, and we can therefore without problems communicate with each other about our surrounding

world. Furthermore the transport model implicitly assumes that we communicate via a common code system, and the common code represents the assumption not only that we see our surrounding world in the same manner and therefore understand in a similar way the words and concepts we use, but also that we have immediate communicative access to each other.

It is easy enough to understand that these assumptions were earlier regarded as unproblematic. A theocentric society is based on the implicit assumption that all of humanity and the whole of the world are the work of God. Put differently, all people are seen to live in a common world. This means that communication isn't in principle a problem.

In an anthropocentric society the assumption is that all people are created according to a common format: the transcendental subject. Of course, we are all different from each in one way or another, but basically we are the same because we are equipped with identical cognitive categories. Even if we aren't necessarily created with the same abilities or inhabit a common universe, we still communicate via a common code system.

It is therefore easy to understand how these assumptions are drawn into doubt when we enter the hypercomplex society. This society is polycentric, i.e., a society of many centers, many contexts, and many different basic assumptions and blind spots. Consequently, it can no longer be immediately assumed that we are equipped with the same abilities or created by the same creator. The assumption that communication is an unproblematic affair was at the beginning of the twentieth century questioned by those who looked critically at human cognition.

Communication as Double Contingency

Communication According to Watzlawick

Among twentieth century researchers, Paul Watzlawick in particular, an American linguist and pragmatist, has endeavored to reveal the theoretical shortcomings of the transmission model of communication. In 1967, along with his colleagues J. H. Beavin and D. D. Jackson, he published the pioneering book *Pragmatics of Human Communication* (Watzlawick, Beavin, and Jackson 1967). Here they exemplified and argued for a number of "basic communication premises," of which the following three are worth further consideration:

1. One cannot not communicate.
2. All communication is both communication and communication about communication.
3. The message sent is not necessarily identical with the message received.

One cannot not communicate. Not only intended communication is communication, but "noncommunication," i.e. action not intended as communication, or action intended as noncommunication, is also communication, in the sense of mutual observation of the other's noncommunication. A good example is taking the elevator: On an elevator a great deal of energy is used partly to non-communicate, partly to observe the other people's noncommunication. One communicates that one isn't communicating, for instance by adopting a blank expression, and one observes that the others aren't communicating, for instance by noting their empty gaze.

The essence of communication in an elevator is that it communicates about intended noncommunication. Moreover, actions that were not meant as communication can also be interpreted as such. One scratches one's neck, and immediately it is taken as a secret message. One opens the newspaper on an airplane, and the person sitting next to you takes it as an expression of discourtesy. Or one does not open the newspaper and is immediately interpreted as importunate.

That communication can take place as communication and as noncommunication has inspired the American researcher of interaction Erving Goffman to distinguish between two forms of interaction: blind and focused interaction (Goffman 1971; see also the excellent introduction to the work of Goffman by Tom Burns 1992). Blind interaction is based on the observation of nonobservation, what Goffman calls "dead-eyeing," to "non-observe" the other (Goffman, p. 71). Focused interaction, in opposition to this, is the observation of observation, i.e. participants demonstrate their observation of the other for the other: One exhibits one's interest in the other party. Often it is the case that the nonverbal action supports the focused interaction: eye contact, body contact, and the like. As a consequence, it is evident that one of the fundamental problems facing interaction through media (e.g., interaction in electronically mediated interaction groups) is the maintenance of focused interaction when precisely nonverbal mechanisms of interaction, such as eye contact, body contact, and so on, lack support. Focused communication could also be called tightly coupled interaction,

because coupling media are used in addition to the purely verbal medium. When these forms are deficient in electronically mediated interaction systems, a consequence can be an unwillingness to maintain more intimate interaction.

All communication is both communication and communication about communication. This premise for communication follows from what has already been said about noncommunication, namely that in all communication two parallel processes can be identified: the explicit communication—communication about "something"—and the implicit communication, where the goal is to establish, maintain, and/or regulate the communication process, e.g., by fixing or changing the power relationship in the communication. To sit at the head of the table, to be equipped with the conductor's baton, or to preside in the pulpit of the preacher, all are different forms of communication about communication. One way of putting this is to say that all communication looks both outward and to itself. Communication maintains and corrects itself in a continuous, ongoing manner. With further reference to Erving Goffman, one can say that communication on the basis of its autocommunicative character maintains itself in communicative patterns or rituals—indeed, one could go so far as to say that communication communicates, and that the people who take part in the communication are "intruders," disturbing its already existing fundamental patterns.

The message sent is not necessarily identical with the message received. Communication takes place between mutually closed psychic systems, each based on its own meaning horizon. The American sociologist Talcott Parsons labeled this as "double contingency," i.e., mutual uncertainty. One party observes the communicative selections made by the other, and attempts to construct his or her own understanding, while the other does the same.

This means that it isn't "A" who communicates with "B," but "A" communicates with "B's" communication and vice versa. Behavior "has an effect as communication," say Watzlawick and Beavin (1967). This implies that "A" doesn't receive information or "a meaning" from "B." Instead "A" reads "B's" behavior as communication, i.e., coded selections, which "A" selects in accordance with his or her own codes.

Communication According to Kierkegaard

As has already been indicated with the references to James Carey, Watzlawick, Parsons, and others, there is an alternative to the transmission view of communication. As suggested by James Carey, communication

should not be observed as a transmission process between a sender and a receiver, but as a ritual construction of a social system.

Since classical times, "communication," with its root in the Latin word *communicatio,* has been used to denote the establishment or participation in a community. To "have communication," with the devil for example, meant to cultivate the company of the devil. In our context, *communicatio* means community: community in a medium—or under certain particular conditions—that can remove physical or mental distance. *Communicatio in sacri* meant to take part in a religious ceremony in such a manner or with the result that one became a part of the community because worshipping God constituted a "medium" capable of removing the barrier, i.e., making community possible. Thus, one might say that one "shares a commonality with Jesus Christ."

But is such a community possible? A general religious argument is that it isn't, with however one notable exception, namely, in faith. In faith one surrenders oneself to the other, the object of faith. In such circumstances one achieves the immediacy of community.

Kierkegaard, perhaps the most eminent modern existential and religious philosopher, distanced himself from this conception. In Kierkegaard's example, the lover can in a most intimate manner reassure the loved one and in his actions demonstrate his love and thereafter ask. "Do you now believe I love you?" But this question doesn't give any community of belief. Quite the contrary, the lover in this manner pulls himself toward the loved one and "forces" a declaration of faith—and a forced declaration is no faith declaration.

Immediacy doesn't in other words necessarily lead to communicatio. If the desire is to create *communicatio,* then the assumption paradoxically enough appears to be what seems to be the opposite: distance. To illustrate this, Kierkegaard repeats his example, but now based on an inverted strategy. The lover could for example test his loved one by for a while appearing indifferent and uninterested, then in an uninterested mode asking, "Do you believe I love you—do you believe me?" He could act indifferent, or be ironical, e.g., pretend, thus creating confusion. Only in this situation would the other's declaration of faith become a truthful declaration. As Kierkegaard puts it: "[I]t is positively certain that the latter method is a far more basic way in which to require faith. The purpose of the latter method is to make the beloved disclose herself in a choice; that is, out of this duplexity she must choose which character she believes is the true one" (Kierkegaard 1962, p. 137; English translation, 1991, p. 142).

It is only with this last "method" that it is possible for the result to

be true faith understood as immediacy, i.e. in *communicatio*, and its precondition is the opposite of immediacy, namely distance.

To illustrate the point, Kierkegaard transfers the above example to religious communication. According to Kierkegaard, what the example shows is that Jesus Christ is not an immediacy, but—as he says—a "sign." For "a sign is the denied immediacy or the second being that is different from the first being" (Kierkegaard 1962 p. 122, Kierkegaard 1991 p. 124). A marker in the sea is evidently a sign, Kierkegaard exemplifies. For at first it seems to be just a thing—a post or a light—but that it is a sign implies that it is something other than what it is immediately: not a post or a light, but a sign of, e.g., a reef. If faith in Jesus Christ were given immediately, then faith would function according to the transfer model of communication. Faith as a thing—or somebody's faith—is transferred into my mind. But faith is—in the modern sense—a matter of selection. It is to accept that something is an act of communication, and furthermore to select an understanding resulting in faith. Thus, faith is a matter of choosing, it is something one takes upon oneself. And therefore Jesus Christ is not just a sign, but a sign of "contradiction," namely "between being God and being an individual human being" (Kierkegaard 1962, p. 123; English translation, Kierkegaard 1991, p. 125). "In addition to being what one is immediately, to be a sign is to be something else also. To be a sign of contradiction is to be a something else that stands in contrast to what one immediately is" (Kierkegaard 1962, p. 123; English translation, Kierkegaard 1991, p. 125f).

But what then is a miracle, asks Kierkegaard? Is it not the "proof" of the validity of faith? Is it not through the miracle that Jesus Christ makes himself visible in his immediacy? Is a miracle not communication from God in the sense of a transfer of meaning from a sender to a receiver? No, to need a miracle in order to have faith is itself mistaken faith. Therefore the miracle is precisely not the expression of immediacy, but is merely that which directs *attention* to the sign of opposition. It directs attention toward what we must have faith in thereafter. For faith is—to use less philosophical jargon—a selection that the receiver makes, and the miracle is most clearly a disturbance (and not a meaning transfer), which creates the opportunity for such a selection. A miracle is in other words only communication's first selection, while faith is the selection of the receiver, which completes communication as its final selection.

Thus, communication is not transfer—of information, meaning, faith, etc.—but communication is a series of selections. The first selection is that something isn't just a coincidence, but a difference, which

should be observed as an intended, i.e., communicative, difference. If we observed everything as intended utterances, one would say that we suffered from paranoia, because we would interpret every human action as an utterance to or about us, and because every external phenomenon—the silent movement of the leaves of a tree, the black cat crossing the street—would be understood as a message from somebody else. However, if we observed nothing as utterances, we would suffer from autism, i.e., we would focus our observations only on ourselves. Thus, the first selection of communication is the selection of a phenomenon as an utterance. The second selection is to choose an understanding: that another person's movement of the arm means that I should stop. That the light in the sea means that I should beware of a reef. That a miracle is a sign of a transcendental existence.

Communication Theory's Communicatio

I believe that one can use the examples from Kierkegaard—the passionate communication of lovers and the faithful communication of believers—as illustrations of what communication is. Niklas Luhmann has with a corresponding, but more profane, example said that honesty cannot be communicated. To add "honestly said" to a statement is to dispute its honesty. It can't be said, "I love you—honestly." Indeed, for me the opposite is the case, that I unconditionally mistrust those who find it necessary to add a verbal or nonverbal "declaration of honesty" to their statements. Those who explicitly declare their openness or revelation, or who make an explicit claim for honest eye contact implicitly demonstrate that they expect the opposite and thus reveal their mistrust. How should one reply to such people? Should one take up the challenge of honesty by making a corresponding declaration of honesty and thereby return the mistrust, creating mutual mistrust based on unceasing revelations? Or should one—in possession of a friendly character—desire to avoid playing with words and omit this "double bind," as Bateson would have called it? At any rate, in choosing to adopt the stance of friendliness, one has already imagined and thereby confirmed the existence of an underlying suspicion of dishonesty. One might prefer instead the other possibility, namely to verbally or non-verbally—for example through irony—make this relationship apparent, i.e., the impossibility of a communicative immediacy, and as a consequence cause the anger and irritation of others. In choosing this as the only possibility for nonintrusive honesty, one is charged with being cold and from the outset demonstrating a distance from others.

My conclusion is that communication—in the strict sense of the term—is not transfer of meaning from one person to another. Instead, it is partly the making of a series of selections, partly a situation of double contingency, because "A" does not have access to "B's" selections and vice versa.

One party makes a selection by saying or doing something. The other party makes a selection by choosing to interpret the action as communication, and by choosing to understand what is said in a particular manner. When using the word "selection" and not "choice," I emphasize that these selective actions are not necessarily consciously controlled choices, but normally depend upon a long list of factors. When using "selection" and not "construction" of understanding, I emphasize that it is not a free meaning construction, but a selection of possible understandings within a psychological and/or social horizon of meaning.

Communication in the usual sense of the term is not immediate or straightforward—even if this might be reassuring. Instead, it always involves a risk that cannot be eliminated: the risk that the other understands something other than what is intended, or that she answers honesty with dishonesty. I can run this risk or choose not to run it, but there exists no totally safe insurance policy against it. Only with time and through the many acts of communication is it possible to create a foundation that can be called borderline honesty, and this is the closest one comes to honesty, and therefore trust.

Moreover, in a second respect there exists a parallel between Kierkegaard's meditations on Christian faith and communication theory. When he says that "the whole of modern philosophy has done everything to delude us into thinking that faith is an immediate qualification, that it is the immediate" (Kierkegaard 1962, p. 136; English translation, Kierkegaard 1991, p. 141), then this also applies to a significant part of modern communication theory in its attempt to make us believe that communication is based on a similar choice of immediacy. Communication is the transport of meaning from one person to another, the common definition goes, which implicitly assumes immediacy and openness. Or, according to a second definition, true (in opposition to imagined) communication presupposes a community, where all the communicating parties freely take part, without preconceptions and with mutual understanding as their shared intention.

According to Luhmann—and to Kierkegaard—such communication does not exist, not even as a borderline ideal. Every communication is

based on double contingency. "A" cannot—even through the most intensive inspection—observe or control the communicative choices of "B" and vice versa. Moreover, a situation of mutual understanding in the strict sense would not be desirable, because it would mean the end of further communication. Any communication presupposes a difference or a state of insecurity. If this were not the case, there would be nothing to talk about.

Communication

Basically, if communication isn't transformation of information or meaning from one person to another, what is it then? According to Luhmann, who was inspired by Watzlawick, Bateson and others, communication is a process of selection. It focuses on something and leaves other things out (Luhmann 1984, p. 226f; English translation, p. 164f). Although the following is heavily informed by Luhmann, its perspective is different. Luhmann analyzed communication as a phenomenon of social systems, emphasizing that only social systems can communicate, while psychic systems can think. I analyze communication as a phenomenon of structural coupling between psychic systems. Thus, I agree that psychic systems cannot communicate in the strong sense of establishing a *communio*. However, they can irritate each other in the systems theoretical meaning of irritation that a system can observe its environment and in reference to its meaning horizon—its reservoir of possible selections—can select an understanding.

The relationship in a communicative situation is a relation between an ego and another ego. However, for any ego, any other ego is inaccessible. It is the ego's environment. Thus, communication is a relationship between a system and its environment. This relationship is characterized by contingency. The basic communicative relation is a relation between two mutually contingent systems: Luhmann, drawing inspiration from Talcott Parsons, calls this reciprocal contingency "double contingency." "B" is undetermined in relation to "A," and vice versa. What "A" says, the way he says it, and his intention in saying it are incomprehensible to "B," just as "B"'s answer, the way she answers, and her intention are incomprehensible to "A." The basic interaction is therefore a reciprocal reduction of complexity: "A" speaks, i.e., does not hit; "B" answers, i.e., does not run away; "A" talks about the weather, i.e., not about love, etc. Still, however, one can never be sure: Couldn't "A"'s first remark be a slap in the face? couldn't

"B"'s answer be a running away? couldn't the talk about the weather—or about nothing in particular—be the first gambit in a seduction? Communication is thus at bottom improbable, while at the same time it is constantly attempting to eliminate its own improbability.

Meaning

Like all other systems, psychic and social systems are confronted with a complex environment. They cannot connect with all possible states in their environment. The way in which a system can cope with this problem is by being "conditioned," i.e., by not allowing every potential coupling with an external state. Not everything is possible. This results in a stabilization, but it also creates a state of risk, because the decouplings may be the wrong ones. Luhmann suggests that for social and psychic systems, this conditioning factor can be called meaning (in German *Sinn*). Thus, meaning is the way in which social and psychic systems reduce complexity, because meaning makes something possible—e.g. "understandable"—while others are outside mental or communicative reach. Meaning is a particular way of establishing connections: that something means "A" implies a connection with it and thus not with something else (cf. Luhmann 1984, the chapter on *Sinn*, pp. 92–147; English translation, Luhmann 1995, pp. 59–102). However, meaning is not intentionally chosen by a psychic or social system, but is the outcome of all preceding communications. Through communication a meaning horizon is created, and all later communications are partly based on, partly modifying this meaning horizon.

The connection through meaning is however always the system's connection with something through the system's reference to itself. The reference to something outside is thus made through self-reference. All that has meaning belongs to "the world," i.e., is produced by the system as meaning. That which does not have meaning is what the system has not itself produced: It is what Kant called the *Ding an sich*, the thing as such. It can be described only negatively, as the absence of meaning.

The Asymmetry of Communication

As already confirmed by Watzlawick and Beavin, any kind of communication involves double contingency. This actualizes the question of how a social system can be built through communication.

At first, communication seems to be chaotic. If communication implies double contingency, one should think that the implication was

unpredictability. In reaction, others would state that communication occurs within a common meaning horizon, that is, as an activity within an already established community. This is for instance the implication of Jürgen Habermas's concept of communicative action as that particular intersubjective action, which creates mutual understanding. But if communication could not transgress already established borders of meaning, it would be totally predictable. This would imply that communication constitutes a stable system, a system that cannot change.

The point is that a communicative system is neither chaotic nor stable, but represents that type of system that is based on the principle of self-organized criticality (cf. Bak 1996). But how does communication result in a self-organized critical system, i.e., in a system that has identity, yet continuously changes itself?

The answer is found in asymmetry, i.e., communication results in the building of asymmetrical structures. The point is that communication as well as any other kind of form-based distinction includes a differentiation between the form's inner and outer sides, and this gives rise to an asymmetry. That which is differentiated cannot be substituted: The inner side can never be the outer side; before can never be after; ego is never alter ego, or to use Spencer Brown's formulation, "a distinction is drawn by arranging a boundary with separate sides so that a point on one side cannot reach the other side without crossing the boundary" (Brown 1971, p. 1). The formation of asymmetry occurs along three dimensions. Along the spatial dimension as a distinction between the form's inner and outer side, i.e., between system and surrounding world; along the time dimension as a distinction between before and after, i.e., between past and future; lastly, along the social dimension as a distinction between ego and alter ego, i.e., the party who understands a communication and the party who is the intended recipient of the communication. Consequently, society arises as an output of communication that is asymmetrical. Although not everything is possible, at the same time the communicative process is impossible to predict. This implies that society as the totality of communications is a self-changing and unpredictable, yet identifiable system.

Luhmann has described in an abstract and precise manner how this asymmetry occurs in communication. The presentation is found in an introduction to a book that he published with Peter Fuchs in 1989, *Reden und Schweigen*.

> Eine Kommunikation teilt die Welt nicht mit, sie teilt sie ein. Wie jede Operation, wie auch eine solche des Lebensvollzugs oder des Denkens, bewirkt die Kommunikation eine Zäsur. Sie sagt, was sie sagt; sie sagt nicht, was sie nicht sagt. Sie differenziert.Wenn weitere Kommunikationen anschliessen, bilden sich auf diese Weise Systemgrenzen, die den Schnitt stabilisieren. Keine Operation findet den Weg zurück zu dem, was vor ihr war—zu dem unmarked space. (Fuchs and Luhmann 1989, p. 7)

In a free translation it can read: "A communication does not transport the world, it in-forms the world. As in any other operation, communication results in a distinction. It says what it says; it does not say what it doesn't say. When further communications are coupled to the first, borders between systems are created, thus stabilizing the distinction. Thus, no operation finds its way back to that which existed prior to the operation—to the unmarked space."

Communication as Selection[6]

Even though communication in its most abstract conception can be observed as a differentiation of form, in its repetition it creates a stabilization, so that communication appears as a structural coupling of psychic systems. Psychic systems cannot communicate. They can only observe their environment and act accordingly. One psychic system observes another's selection as communication and makes selections in accordance with this observation. This process of mutual observations and individual selections is what we normally call communication.

Let me take the simplest communication: Communication between two actors, "A" and "B."

The first selection is made by "A": From an excess of possibilities "A" chooses a specific information and not all the others. Besides, "A" chooses a specific form of communication, i.e., utterance, rather than another. She says "hello," and not "goodbye," and she does it with a friendly nod of the head, not verbally.

That there is talk of communication presupposes a *distinction* between two selections, i.e., between information and the form of communication: The nod *means* something, either intentionally (i.e., as an expression for "A"'s actions) or in terms of interpretation (i.e., as an expression of "B"'s interpretation). "A" can nod in a friendly manner, even though "B"—for example, myself, when I watch television with my mother-in-law—believes that "A" is about to fall asleep. Conversely, "A"'s nonintentional movement—for example, a birch tree swinging with the wind—can be interpreted by a person of a poetic disposition as

the birch tree's "friendly nod." But as said: To be able to talk of communication, the fundamental condition is that a distinction can be made between the act and its content, i.e., between the utterance and the associated information. If this isn't the case, the action will not be one of communication, but a functional act: somebody using a hammer or falling asleep. First when the distinction is established, the action "means" something: The action becomes a sign, i.e., with the words of Peirce, it stands for something in a certain respect. With the words of Spencer Brown (Brown 1971 p. 1), which I would prefer, a form is made that is cloven by the distinction between information and utterance.

Back to the case under discussion, where "A" has made two selections: The selection of information and the selection of utterance. "B" then makes a third selection: the selection of understanding. He makes a re-entry of the form into a form, i.e., he enters the supposed distinction between information and utterance into a new distinction between information and utterance, which implies, partly that he takes the act as communication, and partly that he understands something and not something else. This understanding is—which is an important point—based on his own criteria for selection. It is not, in other words, a result of a transfer of meaning from "A" to "B." This is precisely why, as suggested by Watzlawick, what is sent is different from what is received. The "sent" (the first two selections) is based on one instance of selection, while the "received" (the third selection) is based on a second instance of selection.

With these three selections a communication is carried out. Communication does not include—as some, e.g., Jürgen Habermas, have asserted—"agreement" as the fourth selection. On the contrary, one could say that "agreement" *(Verständigung* is the word used by Habermas, which is hard to translate, even as the concept of "consensus") would mean that communication ceased because there wouldn't any longer be talk of an excess of complexity, necessary for new communicative selections. Communication thus consists of three selections: selection of information, selection of utterance, and selection of understanding. One party chooses to say something in a particular manner. And the other party chooses a specific understanding, which is tested in the following course of events. But the communication then reaches its conclusion. Søren Kierkegaard has fittingly put it in one of his countless unpublished notes: "that two are in real disagreement is no misunderstanding; they are indeed really in disagreement because they understand each other" (Kierkegaard, p. 300).

As a result of the selection of understanding, there may however be a

fourth selection, which isn't agreement, but a choice about action. "B" can do something as a result of his selection of understanding (depart, buy the ware for sale, beat up "A"), and this action may in fact be (for "B" and/or "A") a new act of communication if "A" distinguishes between information and communication, i.e., observes "B"'s actions as a communicative selection. At any rate, communication continues in the sense that a new round of communication is instigated. "B"'s action is a selection of information and of utterance, either as a result of "B"'s intention or as a result of "A"'s interpretation: "B" says something with his action, and/or "A" differentiates the action into information and utterance. As a consequence, noncommunication (actions without communicated intentions) can be communication. "What did you mean with that wink?" "A" can ask, even though "B" only had something in his eye. To make a distinction between the medium—facial movements—and form, namely the significance of the wink of the eye and the resultant perception, is to assume that the action is communication, even though "B" reacted physiologically to an irritation, i.e., didn't make such a distinction.

Communication Media

Normally, "communication media" is regarded as the concept for a transport channel: Information or meaning is transferred from one person to another through a medium, or meaning is distributed from the sender to a large number of receivers through media.

But if communication is not understood as transfer, but as a process of selections, then the concept of "media" cannot serve as a tool or instrument of transfer. Irrespectively, media are an aspect in the differentiation of communication such that the medium is the undifferentiated difference, while form—or "idea" or "information"—in the words of Gregory Bateson, is the difference that makes a difference (Bateson 2000, pp. 272, 315, 459).

Communication's fundamental differentiation is between medial substrate and form or, in Luhmann's abbreviation, between medium and form. Light is a medium, and when it passes through the stained glass window of the church, it gains a form. Sound is a medium, i.e., of innumerable differences that can be further differentiated into phonemes, and these can be a medium for words and for sentences. The medium is subjected to selection so that it assumes a form, and it can then be a medium for further forms. Sand on the beach with its infinite

number of grains can be a medium for the creation of forms, e.g., the person strolling along the beach leaving his footprints, i.e., signs. Society's most general medium is meaning, because meaning is the necessary precondition for the creation of significance. The relationship between medium and form is relative in the sense that form can be a medium for creations of form.

In his theory of communication media, Luhmann makes a distinction between two types of media: dissemination media (in German, *Verbreitungsmedien*) and effect media (in German, *Erfolgsmedien*). The function of dissemination media—books, newspapers, broadcast media—is to increase the potential for communicative couplings, i.e., to increase the likelihood that somebody observes a given sender's communicative choices. The disadvantage is of course that too many observe these choices, and—from the position of the communicator—it is impossible to confirm whether his or her own communicative suggestions have been chosen as the premise for further communication or action.

By comparison, the function of the effect media is to reduce the number of potential communicative couplings. Typical examples of effect media are found in symbolically generalized communication media (cf. chapter 3 above) like money, power, truth, morality, love, etc. These media reduce the number of possible communications within a certain functional subsystem of society, thus increasing the probability that actually occurring communications are accepted (Luhmann 1997, p. 204).

Symbolically Generalized Media[7]

As we have seen, social systems establish a certain stabilization over time. Complexity is reduced according to types of conditionalization, e.g. "meaning" as society's general conditionalizing factor reaches a self-organized critical state. More specifically, codes of generalized symbols are being produced, which control the passing on of the work of selection (Luhmann 1988, p. 7). Luhmann calls such a code of generalized symbols a symbolically generalized medium. These symbolically generalized media are thus a functional response to the problem of the improbability of communication, and according to Luhmann they can be called semantic constructs. In this connection semantics should be understood as a cultural expression, in so far as culture can be defined as a reservoir of themes for communicative processes.

According to Luhmann, it is the function of the symbolically generalized media to render probable the communication that, due to the

double contingency of communication, is improbable, bordering on the impossible. Just as money—the symbolically generalized medium par excellence—makes it possible to compare otherwise incommensurable products, there are many other symbolically generalized media ('power' in politics, "truth" in science, "love" in intimate relations, "faith" in religion, etc.), which all make their contribution through the work of selection and thus the reduction of complexity to the otherwise unlikely communication among differentiated social systems. The work of selection is expressed for all the symbolically differentiated media in a binary coding: power/not-power, truth/not-truth, love/not-love, etc.

To give an example: Political parties can operate with widely different constructions of the social world, just as they can have widely differing value criteria. And yet political communication normally does not break down. The explanation is that it can take place through the symbolically generalized medium of "power": The parties do not necessarily understand one another in the everyday sense of the word, and they do not share opinions about what is good or bad, but they understand and acknowledge that the issue in political discourse is power versus not-power, government versus opposition, majority versus minority, etc.; in this symbolic generalization their communication can take place. A similar example is the way scientific schools can communicate, even though they have incompatible views of the world. As the American sociologist of knowledge Thomas S. Kuhn has demonstrated, their various paradigms exclude one another. Yet the various schools can communicate in the discourse of truth versus not-truth.

To be more specific, how do symbolically generalized media function? Luhmann in his many analyses and presentations of this has developed and specified the following subconcepts:

Code. At the basis of any symbolically generalized medium lies a binary code that is partly a division of the contingent, but also partly a division of an area-delimiting applicability. To the functional system of politics' symbolically generalized medium of power belongs the binary code power/not-power, in a democratic society translated into majority/minority. The contingent field from omnipotence to powerlessness is thus divided into two parts (gaining a binary structure), while phenomena outside power's area of applicability are not articulated. Similarly, to the functional system of the economy's symbolically generalized medium of money belongs the binary code profits/losses, for example in the form of accounts.

Program. "Program" is a name for the conditions under which the positive, as opposed to the negative, value of a certain code can be assigned

to a factual situation. In the symbolic generalization of political power, "program" may therefore be a political program stating how power, if gained, is to be used—that is, how "power" (a code) is to be assigned to the society (a factual situation) to which power is to be applied. In education, the program is, for example, syllabuses, which state how good/better grades (or just progress) are to be achieved and poor grades (regression) avoided. The main programs can be supplemented with secondary programs, which help to bridge the gaps between the code and the factual world. Hidden syllabuses might for example constitute such a secondary program.

Secondary codes. Secondary codes are codes that can supplement the dominant code, for example if the gap between the main code and the program is too wide, or if the main code is suspended. To the symbolically generalized medium of science belongs the basic code "truth," while "reputation" is a frequently used secondary code. Thus, one need not examine all scientific arguments every time, but can often shorten the discussion by referring to already widely accepted views in the scientific world; or one can, instead of reviewing a given standpoint from A to Z, refer to the general scientific reputation of whomever has presented the standpoint. Why some things become basic codes while others become secondary codes is determined by what has gained the most legitimacy. It thus naturally follows that seeking support through reputation cannot in the long run provide scientific legitimacy. In politics, the binary code progressive/conservative is, according to Luhmann, a secondary code, which supplements and concretizes the code power/not-power.

Symbiotic mechanisms. Symbiotic mechanisms are mechanisms that root the abstract symbolically generalized media in the individual human being as an "organic substrate," as Luhmann puts it, i.e. as flesh and blood. In politics, i.e., in relation to the symbolically generalized medium "power," the lust for power (or just the almost physical joy of having it in one's possession) is a symbiotic mechanism, while in education it may be the urge to study, i.e., the almost physical joy of learning and understanding something new.

Contingency formulae. Contingency formulae are symbols or groups of symbols that serve to transform an undetermined contingency into a determinable contingency. If one excludes one solution to a problem, this should increase the likelihood of another. In the medium "money," for example, scarcity is such a contingency formula.

Dogmatizations. In most symbolically generalized media, dogmas gradually develop. In the medium "power" there are a number of apparently ingrained, indisputable formulae concerned with legitimation,

while in the medium "education" there are several "nature given" dogmas about the development of children.

Forms of resonance. The concept of "forms of resonance" refers to forms in which the relevant symbolically generalized medium is clearly evident, i.e., has resonance. In the case of money it is the market or competition that is the "soundboard," while modern power reverberates in particular through public debate. As for education it often has a low profile in everyday practice, but gains resonance, for example, in curricular discussions, which must necessarily reflect the code, secondary codes, dogmatization, etc., of the medium.

System references. Most symbolically generalized media refer to and are stabilized by a social subsystem, i.e., a special, closed system within the general social system, where a special medium has its place. It is politics, with the political system, in the case of power; science, with its scientific institutions, in the case of truth; the educational system for education, etc.

By virtue of, and corresponding to, the many symbolically generalized media, a number of mutually exclusive social subsystems are thus constituted, representing the gradual differentiation of modern society. Table 2 presents such subsystems with the above-mentioned subconcepts.

When we examine this table, it becomes clear that a crucial problem in a high-complexity modern society is that individual persons and organizations can no longer cope with the growing societal mass of information. There are no longer, as the slightly misleading term puts it, "Renaissance men," only experts. In other words, there is a differentiation of knowledge domains, which in itself involves a reduction in complexity in terms of the relevant domain, but at the same time means that the overall view is lost. We can view differentiation as a maximizing of internal relations combined with a concurrent minimization of external relations.

The result is that modern society gradually has developed into a social system that consists of many mutually differentiated subsystems. One well-known effect of this is the loss of cohesion and overview already mentioned. It is therefore often asked whether there are higher-order—more universal—symbolically generalized media that link groups of subsystems, and the answer is that many different symbolically generalized media have competed over time for the status of the "common medium." This competition to appear as the common medium takes the form of an ongoing struggle in which one candidate is constantly being nominated rather than another, and is then ousted by

Table 2 Functionally Differentiated Systems

Functional System	Symbolically Generalized Medium	Code	Program	Function	Symbiotic Mechanism	Contingency Formula	Dogmatization	Form of Resonance
Economics	Money	+/−payment +/−surplus	Prices Accounting	Reduction of scarcity	Satisfaction of needs	Scarcity	Competitiveness	Market, competition
Politics	Power	+/−power	Government or party program	Creation of collectively binding decisions	Desire for power	Constant sum	Formulae of Legitimacy	Public opinion
Science	Truth	+/−true	Theories and methodologies	Creation of new knowledge	Quest for truth	Inconclusiveness	Laws of nature	Preference for the new
Love relations	Love	+/−loving	Seduction/marriage	Reproduction and socialization	Sexuality	Casual relationships	Biological structures	Literature (the novel)
Religion	Faith	Immanence/Transcendence	Scripture	Management of contingency	Metaphysical experience	God	Religious dogma	Personal crises
Ethics	Morality	+/−respect	Ethics	Inclusion/exclusion	Moralism	Freedom	Generalizations	Social conflicts

continued

Table 2 *(continued)*

Functional System	Symbolically Generalized Medium	Code	Program	Function	Symbiotic Mechanism	Contingency Formula	Dogmatization	Form of Resonance
The arts	Art	+/- beauty +/- sublimity	Aesthetics	Observation of the unobservable	The thrill of beauty	Work	Inherent beauty	Art criticism
The judicial system	Law	+/- justice	Laws, legal norms	Contingency reduction concerning normative expectations	Need for upholding the law	Justice	Natural law	Social conflicts
Mass media	Information	+/- information	News criteria	"Irritation" of society	Sensationalism	Editorial competition	Society's watchdog	Public sphere
The education system	Education	+/- mediable	Teaching and curricula	Career selection	Love of learning	Career structure	Developmental dogma	Debate on syllabuses

Sources (concerning the code of the functionally differentiated systems): Economics: Luhmann 1988, pp. 46f, 64, 243. Politics: Luhmann 2000a, pp. 88ff. Science: Luhmann 1990, pp. 167ff. Love: Luhmann 1982, pp. 51f. Religion: Luhmann 2000b, p. 77. The arts: Luhmann 1995, pp. 309ff. The judicial system: Luhmann 1993, pp. 60, 67ff, 169. Mass media: Luhmann 1996, pp. 36, 41. The education system: Luhmann 2002, pp. 59, 73.

a third, and so on. In the rational epoch in Europe in the late eighteenth century, science was suggested as the common medium, while during Romantic period in the early nineteenth century, art and its distinction between the sublime and the ordinary was another candidate. Politics has been suggested as the common medium, letting the state be the steering center of society, while others have suggested that economics, represented by the market as its form of resonance, should be the central instance of society.

As already mentioned, the function of symbolically generalized media is to increase the probability that actually occurring communications are accepted. When I communicate in a supermarket, for instance by silently putting the commodities in front of the store clerk, it is implicitly expected that the medium is money and that I want to buy the commodities. Thus, the variety of possibilities is limited and the problem of double contingency has been almost eliminated. However, the risk is that accepting one particular symbolically generalized medium and entering a particular functional system means that other possibilities are even more difficult to achieve. That my selection of commodities was meant as a declaration of love to the store clerk will probably not be understood, and more explicit love declarations to her or him will normally either cause confusion or be taken as a case of sexual harassment.

Mass Media

Niklas Luhmann's Theory of Mass Media

Niklas Luhmann presented his theory of mass media in a book from 1996, *Die Realität der Massenmedien.* An English translation was published in 2000 as *The Reality of the Mass Media.* The basic point of Luhmann's theory of mass media is that they constitute a functional subsystem in society, and, like other functional subsystems, they act according to their own code, which again is based on a system of behaviors, organizational structures, etc. As within other functional systems in society, newspapers act according to their own common functional identity (and not according to high or low morals among editors and journalists). They present a reality to their readers based on their specific code of observation, and their function as independent watchdogs is a reflection of their social differentiation in functionally differentiated society.

The mass media's fundamental function is to assist in the stabilizing of society's asymmetry. According to Luhmann, their special contribution is a common production of the modern human's fundamental "transcendental illusion" of a global shared world. Without doubt only a few of us have, with our own eyes, seen Bill Clinton together with Boris Yeltsin (not to speak of Monica Lewinsky), or George W. Bush and his advisers. Nevertheless, these things and much else besides are a part of our social reality: Because of the communicative accessibility of the mass media, we have a sense of a shared reality; something that we refer to and share with others. Our common world is not first and foremost the village or the family, it is the media's common world.

This doesn't imply that the so-called "average person" is "seduced" or "manipulated" by the media. On the contrary, most people have a supposedly distanced relationship to this common world. We know that it is produced by the media. That people should be manipulated or seduced by the media is something that particularly media researchers who follow the transmission theory are keen to believe. For them a reality is transmitted through a channel to the audience, and if this reality is changed during its way from source to receiver, somebody in between—the journalists or the mass media institutions—must have done this. However there isn't such a reality ready to hand. There is a world that is extremely complex and that cannot be "compared" to a resulting mediated world picture. Therefore, to understand the reality of the mass media, one must look at the ways in which mass media function not only as competing organizations but also as a functional subsystem in society.

Nevertheless, even if we aren't seduced by the common world of the media, this doesn't mean that we are indifferent to its character. It is of course of the utmost importance how this world is formatted and in what connections it gains a media presentation. Indeed, it is this world that is ours and that we share with others. It is the basis of our community. This is why Luhmann in an interview on the function of the media has said that the central question is not the truth of the media, i.e., if one statement or another is true (Luhmann 1996b). The central question is how the common world of the media is structured. This question is not answered by looking at the world, but by looking at the media's function. What kinds of mechanisms determine what ends up on the front page, and what is or is not sent? What are the selections served by the media, and what are the priorities and criteria on which they are based? These should be—and increasingly are—central questions for media research.

The Irritating Mass Media

The basic function of the mass media is, as noted, the construction of a common world. Their second function is however to bring about "irritation." Through this, as Luhmann says, they "keep society on its toes" (Luhmann 1996, p. 47. English translation 2000, p. 22).

But why are the media irritating? They don't irritate because they have an almost transcendental mission. Nor are they irritating because they have particularly noble or courageous chief editors, although this character mask is sometimes developed as an expression of the special function of mass media. In the words of Luhmann, they irritate society because they constitute their own functional subsystem in society. Thus, they irritate society because they make communicative choices on the basis of their own criteria. Evidently, the need to sell copies of their newspaper or to have large numbers of subscribers may support this function, but it doesn't create it. The point is that there isn't anybody in particular outside the media who can decide what the media will say: They do it themselves. Precisely through this function they keep society alert. This means in particular that the "good" and the "bad" sides of the media are two sides of the same coin. The mass media's intrusion of so-called good taste—that a newspaper talks of private issues, chooses a "non-serious" perspective, insists on presenting stories although it may be against national interest, and so on—is also what keeps society alert.

But does this mean that the media only say what suits them, or that news is selected according to random principles? No, over time the media system has, from the 1700s, developed its own particular code. As we saw in the preceding section, a code is a form with two sides, which can draw upon something from the horizon of possibilities; something is selected and something is left unselected. The political system's code is power: The world is examined in terms of criteria that can or cannot bring together a majority of people, of how a particular party is able to form a government, of how one can avoid sitting in the opposition. The economic system's code is money or profit: Can he or she pay? Does it look as if the investment will yield a profit?

The mass media function in principle in a similar manner. According to Luhmann, the code of mass media is information, or more correctly: The code is the distinction between information and noninformation.[8] The media grasp the world when they ask whether such and such is information or noninformation. When a dog bites a mail carrier, it is noninformation. The opposite case is information. It is therefore only the last mentioned that is made a topic by the media.

However, to produce newspapers it is not enough just to operate with the code of information vs. noninformation. Just as the political parties have their programs, just as economic actors have budgets and production targets and so on, the media have also developed programs and guidelines, which help them to make selections between information and non-information. What for example is information in sports journalism: Is it the first or the last match in a tennis tournament? What is information in politics? In economics? In science? For all of these activities, programs and routines have been devised, and they can be continually revised in terms of the fundamental code: What kind of communication is currently appropriate? Are older routines to be replaced by more recent ones? Moreover, has the media in question developed the organizational tools necessary to support the communicative selections? One creates, for example, a certain competition among the editorial staff on a paper. The best journalist receives the highest salary. A system of informants is established. Special training is offered, there are self-proclaiming criteria for good journalism, and schools of journalism work scientifically in observing journalism's own criteria of observation, for example in reflections over which news criteria are considered relevant. Thus, these schools are both a reproduction mechanism of the mass media system and the self-reflection mechanism of this system. Sums of money are paid to people who use video equipment to look at the world as "journalists," that is, to adopt the journalistic code rather than that of scientists, artists, or Samaritans.

Following on from these, there are a number of subsidiary, written and unwritten criteria for what results in a + value in the +/- information code, i.e., what counts as a "good" story. An event is judged journalistically good because it is new: solo news are better than common stories. A piece of news is better if it is surprising, e.g., it concerns the breaking of norms. Therefore, unusual traffic accidents are better news than ordinary accidents. Furthermore, a local news item is better than one from far away.

The most important characteristic of the information/noninformation code is found, says Luhmann, in its relationship to time. Information is not open to repetition. Once an event has been made the object of observation, it becomes noninformation. This means that the media system subjects itself to aging and must ensure that it constructs new information the whole time. In other words, there is a continual deactualization and corrosion of information.

All of this can be used to observe the historic constitution of the modern mass media system. All things considered, it is indeed surprising

that newspapers present the same amount of news each day. Of course, special events can change the format, but in general it is apparently the case that the "transcendental illusion," which is created each day, is limited to, say, 48 pages, which are further reserved for specific types of content based on the same repetitive criteria, and that the world viewed on Monday morning is different from the world viewed on Sunday. As Luhmann has put it, it must therefore be the case that the media are subject to an "evolutionary improbability" (Luhmann 1996, p. 53. English translation, 2000, p. 25).

As late as the 1600s newspapers waited until something "happened" and were therefore published somewhat irregularly as flyers. Today, it is, so to speak, the opposite—not in the sense, suggested by Baudrillard, that the "Gulf War has never happened," but in the sense that the world as a horizon of possibilities is realized according to specific, standardized criteria. The world is not "constructed," but "formatted" by the mass media. "Our" world, i.e., the world we accept as our common world as citizens, is not "reality," but the mass media's reality.

The Eye of the Public

What Is Publicity?

"Publicity" is one of society's unclear concepts. What does it mean? Let me start by presenting some examples of the use of the word.

According to the dominant use of the concept, it has something to do with the media and with a certain positioning in social space. If these two aspects are combined, then publicity is a place in society, an arena in which public debate takes place through daily newspapers, weekly magazines, and electronic media. "Will this and that survive the light of publicity" is a question one can raise to an issue that has been concealed in a government office, but is now being made "public." One can imagine someone from the press sneaking into a private office, taking something, and bringing it into the limelight, into public view. The best example in our times is the Watergate case. From a formal perspective, a parallel action—the movement from public into private and then out again—occurs when the same journalists or at the very least their colleagues pry into the private domains of celebrities, taking pictures of them with or without bathing suits. "They are public property," say journalists, or "They are of interest to the public." In such cases an opinion is created: public opinion, it is called.

156 MEDIA OF SELF-OBSERVATION

Already at this point, a number of meanings are hiding. Initially, the "public" and the "private" seem to be regarded as domains: When one is in the private domain, one is protected by its peace, but when one passes beyond the garden gate, the public terrain takes over, where there is no longer any protection. But apparently, this criterion is not sufficient for everybody: Some people seem to be public property even though they are in the private domain. Consequently, a second understanding may be suggested: "public" and "private" are *perspectives*, i.e., specific ways of looking at things. Some things can have "public interest," which means that an unwritten rule is practiced such that it is viewed in a specific manner (in the public eye). These can be persons ("public people" as they are called) or issues (issues of "public interest").

In addition, a regulating mechanism exists in the concept of publicity, a mechanism with a particular character: Whether and when people or issues are deemed "public" property is not entirely related to their status or position, and there appears to be no fixed rules on this. It is something that readers or the market subsequently decides. For example, the legitimacy involved in making a case public might become evident only from the effects of its becoming public. It is therefore readers or the public who themselves regulate the public sphere, which they themselves constitute. The public sphere with its public opinion appears to function in a self-regulatory manner.

The Public Eye: Boundary, Observation Principle and Self-Regulation

Let me proceed with a preliminary summary. The concept of publicity covers at least three significant aspects: boundary, observation principle, and self-regulation. As a boundary, publicity appears to be a concept used to determine what belongs to one domain and what belongs to another, i.e., what is public and private. One goes round one's private garden, but the moment one steps beyond it, one walks on "public" pavement. Within the boundary of one's own property, certain rights apply—e.g., the right not to be photographed by the press—but it is different when one is outside. In this sense, the concept reminds one of the right of access: We have public toilets and parks for all to use, and we have private toilets (and for the wealthier, even private parks), which only the owners and those they invite can use.

As a way of seeing, as an observation principle, publicity appears to be a concept referring to the optic applied to specific people and issues. One can almost sense it physically: If Madonna (or Björk or Crown Prince Frederik of Denmark) passes by, one has the right to stare at

them. On the other hand, the same gaze is not acceptable in looking at Jensen the neighbor, not even when he is walking along the street—unless of course Jensen has done something that gives rise to public attention. Even on the beach—naturally I am talking of "public" beaches—the manner in which one stares is not without significance. When you observe others in their diminutive swimsuits, you should do so in a diffuse and "uninterested" manner. If you gaze in an openly offensive manner, it can have negative consequences, unless of course curiosity can at the same time find a legitimate reason. Normally this reason is that one is looking with the public interest in mind; for example, with the desire to prevent a crime or to later write a letter in a newspaper to the public, for instance about the obscenity of tiny bathing costumes. In such a case, there is no curiosity behind the gaze, but public interest. The observation principle is that of the public eye.

Both as an observation principle and as a boundary criterion, publicity is apparently self-regulating. It is "the public" who themselves decide where the boundary is and what is a permissible gaze. In addition, publicity can function as an instance of appeal: The person who trespassed by entering private property, and thereby broke the law, can himself become the object of public interest and accordingly expect public judgment.

The concept "publicity" therefore covers at least three aspects. This suggests that there is good reason for asking about the history of these strange words: "publicity," "public opinion," and "public sphere."

Jürgen Habermas

One person who has examined these words and concepts is the German sociologist Jürgen Habermas, in particular in his first major work *Strukturwandel der Öffentlichkeit. Untersuchungen zu einer Kategorie der bürgerlichen Gesellschaft*, published in 1962, which received an English translation in 1989, with the title *The Structural Transformation of the Public Sphere*.

In the book's first part, Habermas reconstructs the development of the European bourgeois utopian model during the eighteenth century, where the public sphere was established as the site for the production of rational consensus among free and equal citizens. He demonstrates through comprehensive empirical analysis how this conception was realized: In secret clubs and societies, coffee houses, salons, and so on, bourgeoisie pockets of resistance were created against the premodern state, becoming the foundation for the literary and political public

sphere, and finding their articulation in the philosophies of Kant, Hegel, John Stuart Mill, and de Tocqueville. The main point in his argument was that the bourgeois public sphere was the main place for communicative-based understanding.

According to Habermas, society at that time was divided into a private sphere, where family life and goods and commodity production and exchange took place, and a sphere of public authority, comprising the state and court, where the authorities represented their power. Between these two spheres a new sphere began to grow: a new political and literary public sphere, which represented the private sphere because it stood in opposition to the feudal authorities.

However, the plot in Habermas's book is that this model for the eighteenth-century utopia of the transition to a modern society can be given a normative status for the further development of European society and especially for this society's management of its public functions. It becomes an ideal for today's society. The modern state arises instead of the court and its feudal apparatus of power; parliamentary governance takes root and institutionalizes the place where free citizens can meet and have their discussions; modern commercial and noncommercial media take over the public sphere's functional sphere. This makes the second part of Habermas's book on the public sphere into a narrative of decline. It becomes the history of how modern European society never managed to realize its own utopia from the 1700s. Quite the opposite, it has been betrayed again and again. The public sphere is transformed by opportunistic politicians into a simulacrum of publicity, as power becomes more important than truth. The media look for the largest, rather than most informed, public because for them it is the number of paying subscribers that rules. The idea of a bourgeois public sphere becomes in this manner a utopian model whose scientific validity depends upon its not being confirmed.

The Public Sphere as an Operation of Observation[9]

It is possible that Habermas's description of the growth of the public sphere in the 1700s is correct, even though there is much to confirm the view that there is talk here of a strong idealization (Thompson 1995). I am, however, of the opinion that it is problematic to assert that the public sphere still functions in the same way. It is problematic when one takes a category from the developing anthropocentric society and transfers it normatively to the polycentric society. A consequence of this operation is that the public sphere can at best be used to assert

how things aren't. The question should instead be posed as follows: How should the public sphere be characterized so that this characterization has validity for a polycentric society? Or put differently: If our intention is to carry through the project and defend the theses presented at the beginning of this book, then how should we describe the public sphere?

In a previous section I draw attention to three aspects in the concept of publicity, which it should be possible to identify and accordingly justify: publicity as a principle of observation (which is something other than publicity as a set of rules); publicity as a boundary criterion (which is something other than the public sphere as a restricted domain); and publicity as a self-regulating function (which doesn't just mean that it regulates its guidelines for what must or must not be: The public itself regulates its own principle of observation). How can these three aspects be explained?

It is my view that, to begin with, publicity can be defined as a particular operation of observation. It is a particular way in which society observes itself.

As already noted, society can see and describe itself in many ways, i.e., according to many different codes: It can observe itself with an economic code (on the basis of the distinction of profit/loss), with a political code (can a specific policy proposal gain or fail to gain the support of a majority?), with a moral code (is this suggestion honorable or despicable?), and so on. In comparison, publicity represents a particular operation of observation, with a way of functioning based on the following rationale: Publicity as an operation of observation is characterized first as a boundary in society (to private enterprises, state institutions, associations, political parties, families, organizations, etc); second, it involves a movement across this boundary. Put differently, to begin with, a distinction is established (the distinction of public/private), and thereafter this distinction as a boundary is transgressed. Publicity, in other words, doesn't do away with boundaries (if this were the case, then the operation of observation would make itself obsolete or unnecessary, since how could one, for example, make "public" the actions of Crown Prince Frederik if there were no boundaries between the public and the private?). Publicity as an observation principle sets and transgresses boundaries.

What is happening as the result of this operation of observation? First, the private area, whose boundaries are being crossed, is being "generalized." Prior to the crossing, it was governed by private rules. After the crossing, it is observed according to general public principles.

Second, there is a shift in the topic. This occurs, for example, when the public eye falls on the decisions of private corporations, as in the case of the Brent Spar oil-platform issue in the 1990s and its main actors, BP, Shell Oil, and Greenpeace. Greenpeace set a boundary and transgressed it, and in doing so generalized the issue. Before the action it was the private concern of Shell and BP: By being opened to public observation, their specific business interests became a topic of general concern (it is possible to economically profitably dump an oil-platform in the Atlantic, but is this in the interests of the general public?). Third, there is a redefinition of the observational criterion: What was originally viewed through the lens of an economic code is now viewed through a moral code.

One further point, however, is that publicity as an operation of observation has a rather unusual basis: The public eye is characterized by its "indeterminancy." One cannot be sure beforehand what public opinion will be, not only because it is the result of a manifold of single opinions, but because it always observes itself. When will a swing take place in public opinion such that it declares "now, this is too much," or "all the intrusions into the life of royalty have reached a limit"? What is public opinion about BP and Shell dumping the Brent Spar?—that it will have an effect on the environment, or that it will benefit international production? This cannot be predicted in advance, and it is in this sense that public opinion is a particular opinion: It is the "decision of indeterminacy," as the German sociologist Dirk Baecker has expressed it (Baecker 1996, p. 97).

That the public's opinion has an indeterminate character can be explained by a second aspect of the concept of publicity: The public eye always switches between observing "something" and observing itself. As soon as a new topic has entered the public's gaze, and the public's opinion about it has been formed, the public begins to observe itself: Is this opinion too shallow? Is this the right level? "Next week, I don't purchase the [journal] *Bild Zeitung!*" Not least is this mechanism seen between these different media forms: The electronic media take up a topic, and almost immediately the newspapers comment not only on the topic, but on the manner in which it is treated in the accompanying television coverage. It is this unceasing self-observation—and not just its collective aspect—that gives this public meaning a character of indeterminancy.[10] From this it is clear that the public eye is to a heightened degree a polycentric eye: It is an eye that the whole time is directed toward a topic and against itself, and thereby fixes and changes its own criteria in an ongoing fashion. In this respect one can say that

public opinion constitutes the hypercomplex society's centerless center: a center that unceasingly defines and redefines itself.

Defensive Strategies

This means that the organization or institution that becomes the object of the public's observation possesses a series of defensive strategies, which so to speak are "built into" the way in which the public functions: The most important thing is that public opinion can always be described precisely as "opinion." It doesn't have the character of necessity, it could always also be different. A scientific inquiry might conclude that something was the case—that BP and Shell's actions actually had specific consequences. A juridical examination might conclude that the action involved breaking the law. A political perspective could lead to an intervention or a prohibition. All these forms of observation can lead to a decision with sanctions. But the public's decision is only an *opinion*. If this opinion is to have an effect, it must be taken up by one of the other functional systems, e.g., in the form of a scientific examination, a court trial, or a political intervention. Public opinion works by creating interference in relation to other functional systems, not by having an effect itself. If the latter were the case, the public would function as a "people's court."

A second possibility for defense is to introduce the principles of publicity into the organization under observation. If something distasteful is discovered, for instance about BP, then the company can defend itself against public opinion by making publicity a principle of its own: The director's spokesman might for example remark that precisely this problem, of which the public has gained a glimpse, occupies the interests of BP: "We debate the case and we are—just like the public—unsure about what is and isn't right." Sympathy can be gained by choosing this strategy.

Lastly, one can ask, what is the connection between public opinion and the mass media? The immediate answer is that there is no connection. The mass media—the press and electronic media—don't constitute the public, because the public is defined by its form of observation, and not as a place or set of institutions. Nevertheless there is a connection: Public opinion is indeed first and foremost the result of an optic for a particular form of observation, but this form of observation, however, realizes or materializes itself in different media of dissemination, such as the press and electronic media. It isn't the media of dissemination that account for the public eye but the public eye that determines

the particular form of observation in the press and the electronic media. Here, the mass media do not function according to the journalistic principle of +/– information, but according to the principle of public opinion: In leading articles, readers' letters, feature articles, etc., the dominant code is not the mass media's code, but the code of the public.

SIX

The Communication Medium of the Hypercomplex Society: The Digital Network

The Ecstasy of Communication?

We no longer live in the drama of alienation,
we live in the ecstasy of communication.
—Baudrillard 1987

Unlimited expansion of broadband communications! Computers in all schools and all libraries! Greater efficiency in the provision of state services through electronic networks. E-democracy, e-business, and frictionless capitalism. It was, in the mid-1990s, as if the spirit of utopia—although in a new form—was being allowed to rear its head for the first time since the Wall fell and the old dreams were definitively banished to the byways of history, with the "small" difference that this time utopian hopes were not based on social forces growing out of repression but on technological forces that were born in digital laboratories, nursed by multinational companies and set free by political administrations.

In September 1993, the Clinton administration published the report *National Information Infrastructure: An Agenda for Action*, encouraging private investment and growing competition, but also with policies meant to prevent the growth of a divisive society based on the information-rich and the information-poor. In Singapore in 1993, the government published *A Vision of an Intelligent Island*. In Japan in May 1994, the report *Reforms Towards the Intellectually Creative*

Society of the Twenty-first Century was presented with a detailed plan for the development of an optical fiber broadband network that, no later than the period 2005–2010, would link all households. In Europe, it was the so-called Bangemann report, also from May 1994, *Europe and the global information society* that set the policy agenda. It makes an appeal for the expansion of transnational broadband networks and the favoring of competition and private enterprise. In 1994, the British government submitted the report *Creating the Superhighways of the Future: Developing Broadband Communications in Britain*; in June of the same year, the Norwegian government published the plan *Nasjonalt Informasjonsnettverk* [National Information Network], while the Swedish government's IT Commission at almost the same time used the rather more poetic *Vingar åt Människans förmåga* [Wings for the Abilities of Man] as the title of its national report. The "information society" seemed to be a European, indeed a global, obsession.

The Escapist Dream of Transparency

In its most naïve version, the dream of the electronic network represents an escapism into the free—in the sense of the organizationless—society. As a characteristic example of the dream, consider William R. Johnson, at the time vice president of the computer firm DEC's division for telecommunications and networks, who imagined that "in the 1990s, networking will evolve to the point where, for all practical purposes, people will be able to electronically communicate anything (voice, data, image, video), anytime, anywhere in the world." For the DEC vice president, and for many others, it is only a matter of overcoming the inhibiting social and organizational constraints in order to realize the potential inherent in electronic technologies.

> Networking has the power to allow everyone to participate in a worldwide marketplace—Will we be able to ensure that everyone has equal access to it? Networking makes it feasible for people in organizations to share information freely and frequently—Will we be able to release ourselves from "chain of command" organizational structures to take advantage of this capability? Networking will give people access to vast libraries of historical and up-to-the-minute written, visual, and oral information—Will we be able to develop tools to allow people to chart their own courses of learning and discovery through so much information? Networking has the potential to connect all the world in one global electronic civilization—Will we be able to sustain a diversity of cultures? (Johnson 1991, pp. 150, 168)

What would happen if Johnson's dream came true? We would all probably drown in complexity, for the problem of an electronic network society is not that there is too little, but that there is too much information. The most important function now and in the future is not to obtain information, but to limit the amount of information reaching us. In view of this, organizations are not straitjackets but important, positive mechanisms. Indeed, we could say that organizations are information filters. They arise in response to society's increased complexity and they save us from death by information overload, stifled by infinite quantities of information.

. . . the Schizophrenia of the Network?

Behind the dominating utopian hopes of a transparent society with a frictionless market and a direct democracy lies the old utopian belief in *Gemeinschaft*, a global community. It is the idea of Tönnies's *Gemeinschaft* of people forming a direct, unsophisticated community that fuels the visions, with the Internet as a medium for immediate and transparent interaction, in which countless chat groups, digital communities, and virtual worlds add up to one global village. According to Howard Rheingold, global cyberspace is a huge collection of self-organized cybertribes, while for Michael Dertouzos it is a global flea market with no central authority (Dertouzos 1997, p. 9).

Already in 1985, in his influential study *No Sense of Place*, J. Meyrowitz turned this dream of a global, digital *Gemeinschaft* upside down. Actually, with the Internet we were on our way back to the Middle Ages. Meyrowitz characterizes the so-called information age as follows:

> To the extent that electronic media tend to reunite many formerly distinct spheres of interaction, we may be returning to a world even older than that of the late Middle Ages. Many of the features of our "Information age" make us resemble the most primitive of social and political forms: the hunting and gathering society. As nomadic peoples, hunters and gatherers have no loyal relationship to territory. They, too, have little "sense of place"; specific activities and behaviors are not tightly fixed to specific physical settings. The lack of boundaries both in hunting and gathering and in electronic societies leads to many striking parallels. Of all known societal types before our own, hunting and gathering societies have tended to be the most egalitarian in terms of roles of males and females, children and adults, and leaders and followers. The difficulty of maintaining many "separate places," or distinct social spheres, tends to involve everyone in everyone else's business. (Meyrowitz 1985, p. 315)

This characterization was the result of a study in which the impact of the development of different media on social interaction was analyzed from within a historical framework. The approach was based on the assumption that the relationship between media and society can be analyzed with media as the independent variable, and that in relation to historical "media regimes," corresponding "social regimes" can be identified. While the conclusion was not utopian, but dystopian, the basic assumption was however the same, that the Internet results in total transparency and thus stimulates a less organized, more community-interaction oriented society.

In his essay from 1987, *L'autre par lui-même,* Jean Baudrillard painted the picture of a dystopian network society in even darker colors. Anyone who turns on a computer and links up with the electronic network is familiar with the underlying feeling of fascinated horror: on the one hand, the intimate fascination of having everyone else under your skin, in fact penetrating far into the nooks and crannies of your hard disk, the omnipotent fascination of ubiquity, of not only being yourself, but being on the network; and on the other hand, the schizoid fear of not being able to keep the world at bay, of being engulfed by communications, of being personally invaded by computer viruses, spam mails, and unanswered e-mails.

> With the immanent promiscuity and the infinity of connections among all the networks of communication and information, [we have] arrived at a new form of schizophrenia [. . .] the schizophrenic is open to everything against his will, and he lives in the greatest confusion. He is the obscene victim of the world's obscenity. His characteristic feature is not, as is often said, primarily the loss of reality, but rather the absolute closeness and the total instantaneity of everything, an over-exposure to the transparency of the world. (Baudrillard 1987)

The Internet: A Complexity-Management Medium

For me, both the utopian dream of transparency and the dystopian fear of total instantaneity are illusions. The Internet should not be explained in moral terms. It is neither heaven nor hell. Rather, the indisputable success of the Internet should be understood in sociological terms. There must be certain qualities of the Internet—a structural match—that relate this specific technological system to the current society.

This is an idea suggested by Manuel Castells. In his book *The Internet*

Galaxy he states that "the Internet is the technological basis for the organizational form of the Information Age: the network" (Castells 2001 p. 1). While Castells provides a descriptive explanation to this assumption, it is my ambition to give a theoretical explanation. My hypothesis is that there is a structural match between the current society and the Internet. In the construction of the Internet as a communication medium, particular structural qualities of the hypercomplex society have been transformed into the structure of the Internet. Consequently, the Internet could—for better and for worse—be called the communication medium of the hypercomplex society.

In this chapter I will champion the idea that the Internet represents a communication medium that combines global reach, that is, transparency, with complexity-management mechanisms, that is, filtering functions in that very special sense that the Internet copies the complexity-management functions of society into its own medium structure. My assumption is that if a society that continuously increases its complexity became more and more transparent, it would indeed collapse from overcomplexity, that is, from the fact that so many possibilities became available that they could not be managed. However, while the answer to increasing complexity is not transparency, it is also not closure in any absolute sense. A society with an increasingly complex environment cannot solve its problems only by closing its borders, by rolling down the curtains or by transforming functional multiplicity into social reproduction based on one principle, e.g., "scientific socialism" or "the market." It might survive for a period in splendid isolation or by developing its one-principle government into higher and higher levels of bureaucracy within the narrow limits of this one principle, but it would then suddenly collapse, as demonstrated by former East European countries. Therefore, as a supplement to the development of functional subsystems, institutions, and organizations, i.e., the building of internal social complexity, the emergence of the Internet can be interpreted as the development of a digitally based communication medium that combines the potential for an unseen number of structural couplings with a potential for complexity management. The Internet is such a technologically based communication medium.

Generally speaking, in order to manage its external and internal complexity, society must develop uncertainty-absorption mechanisms, and a basic tool for managing external complexity is to build what Luhmann has called "secondary," or internal, complexity structures. I will demonstrate that the success of the Internet is not based on its simplicity or transparency, but on the fact that the Internet is

the first communication medium that combines a global reach with a higher potential for complexity management than any earlier dissemination medium has possessed. The Internet is both a dissemination medium and an effect medium integrated into one digital communication structure.

Daniel Bell on the Track

The notion of the information society—or at that time the "postindustrial society"—appeared for the first time in 1973 with Daniel Bell's *The Coming of Post-Industrial Society*. For Bell the transition from industrial to postindustrial society was as radical an upheaval as the transition from preindustrial to industrial society. Whereas the industrial society was based on the struggle with an already "processed" nature and used energy-based machine technology as its basic tool, the postindustrial society is based on the games between persons, in which an "intellectual technology" based on information will develop alongside mechanical technology, as Bell predicted more than 20 years ago. In the industrial society, the machine was the dominant metaphor, and both nature and human beings were treated like objects. In the postindustrial society, it is not muscle power or energy that counts, but information. Whereas the industrial society primarily produced goods, postindustrial society is dominated by the production of services, i.e., by a service economy. Whereas the numerically dominant class in industrial society was the working class, with its organizational background in mass production and its correspondingly heavy-industrial occupational interest organizations, postindustrial society's dominant class will, in Bell's term, be the "knowledge class" with a social background in educational institutions, universities, service professions, information activities, research and development enterprises, etc., and consequently with quite different organizational and interest-based ideals. Whereas industrial society with its large, heavy industries was dominated by an "economizing" mind-set, postindustrial society with its service enterprises, its growing education and research system, and a growing health and leisure sector will encourage a rival "sociological" mind-set, i.e., a mind-set where knowledge, not material growth, occupies center stage, claimed Bell. While industrial society at least preserved the dream of the encyclopedic overview, and thus the dream of the rationalist or "scientific" control of details, postindustrial society is a specialized and—in later terminology—functionally differentiated society, where regulation

comes from "within": self-regulation in the ongoing reciprocal adaptation of complex systems without any central observation and control point. While industrial society could be traced to one simple principle—the market and competition as the mechanisms of control—mirrored by socialism with bureaucratic control as the single principle, postindustrial society represents an unprecedented complexity, where many different control principles and instruments must be used.

Bell made all these issues his theme in the early 1970s, but there was a crucial point that he mentioned only in passing: the new information and communication technologies. For Daniel Bell's book was not written from the point of view of any technological determinism. On the contrary, his book was a sociological book about the transformation of modern society, and only six years later, in 1979, did he publish the major article "The Social Framework of the Information Society," in which he analyzed computers and telecommunications systems as the technologies best suited to the technological needs of postindustrial society. Here, Bell focused on the new role of technology in a complex society in which a major intellectual and sociological problem was that of "organized complexity," that is, the management of large-scale organizational and social systems with large numbers of interacting variables. The technological answer to this challenge Bell coined "intellectual technology"; partly because it was a "social technology," that is, a technology that should be compared to organizational systems such as hospitals or an international trade system rather than to traditional machine technologies; partly because its function was "the substitution of algorithms (. . .) for intuitive judgments" (Bell 1973, p. 29).

The Challenge of Digital Complexity

As already said, it is my thesis that the Internet represents a new communication medium, which combines global reach and complexity management. This thesis may be qualified by applying Niklas Luhmann's understanding of communication and communication media[1] to the analysis of the Internet as communication medium.

As pointed out in chapter 5, Luhmann draws upon the inspiration of the American sociologist Talcott Parsons to argue that communication is characterized by double contingency: In the interaction of two subjects the selections of understanding are mutually contingent. However, while neither "A" nor "B" can observe the other's selection of understanding, both parts can observe the other's communicative selection. For instance, the present reader cannot observe what I mean, but only

my selection of words and sentences. From this, based on specific personal and social preconditions, he or she must deduce a certain "meaning," i.e., select an understanding, which I, the writer, cannot get access to. However, if I receive an e-mail from the reader, I can observe the words and sentences of the mail and from this construct my personal understanding of it, and thus, indirectly, construct an assumption concerning my reader's understanding of my communication.

The central issue in analyzing the impact of different distribution media on communication is the mutual relationship of the two fundamental selections of any communication: how is the selection of information in time and space related to the selection of understanding? And how may the selection of understanding indirectly—that is, as a new "turn" of the communicative turn-taking process in which the receiver selects his or her information—be observed by the original sender? Furthermore, it is essential to analyze the size of the potential group of participants in a given communication.

In a society based on oral, linguistic communication, the selection of understanding is closely coupled with the selection of information, both in time and in space. The cost is, however, that all participants in a given communication must be personally present in time and space, within speaking distance, so to say. One cannot reach the other outside of natural speaking distance, and every communication disappears after having been finished. It remains only in the memory of the participants and is reliant upon being repeated again and again.

The type of social differentiation related to this type of communication can, according to Luhmann, and in agreement with the above quoted characterization of Meyrowitz, be called "segmentary differentiation." The world is differentiated in mutually decoupled, interaction-based social segments. Each of these segments is internally integrated through oral communication, while the segments are externally decoupled.

In an age dominated by the printing press, much larger social groups can be established, both in time and in space. A given communication does not disappear, but may be filed in communication files (libraries, archives, etc.), which function as society's memory. In principle, every human being is within communicative reach, depending only upon the transportation of messages (books, newspapers, etc.) and upon the reading and linguistic abilities of people. However, the receiver's selection of understanding is separated from the sender's selection of information, both in time and in space. Also, the observation of the communicative selections is restricted to the written medium. Finally, the possibility of the sender observing the receiver's selection of understanding is very re-

stricted, both in time and in space and through the medium. The writer of a letter must wait for a written reply, and the author of a book normally cannot observe the reactions of the readers.

Here, other forms of social differentiation are made possible, and Luhmann suggests the following three forms: center-periphery differentiation, stratified differentiation, and functional differentiation. However, Luhmann does not imply any mechanical relationship between a specific dominant form of distribution medium and a specific form of social differentiation. Social differentiation is society's answer to the challenge of social complexity, and with the development of new forms of dissemination media and the resulting potential for reaching larger sizes of population, new types of social differentiation are being developed, in order to cope with the resultant growth of social complexity. Thus, according to Luhmann, the development of an increasing number of functionally differentiated subsystems since the fifteenth century's Renaissance is the outcome of society's management of an increasing level of social complexity. Society simply cannot cope with an emerging global communication, which becomes less and less decoupled in time, with a geographical differentiation between only close and far away (center-periphery differentiation), or with a differentiation between different levels of society (stratified differentiation). Consequently, a growing number of functionally defined social systems emerge, such as economics, politics, justice, science, art, ethics, education, and love. The communicative rationality of these functionally differentiated systems means that only a limited number of communicative selections are likely within each subsystem.

Communication within the system of economics is about profit and loss, while communication within the system of ethics normally is about respect and disrespect. Consequently, the likeness of successful communication within such a system can be increased, while these systems do not restrict the geographical or social reach of the communication. Here, functional differentiation is different from center-periphery or stratified differentiation. In a center-periphery differentiated society, communication over the geographical boundaries is unlikely, while communication across social differences is not the same as in a stratified society. Also, individuals are not—as in a stratified society—restricted to only one differentiation form, but may freely "travel" between social codes. Of course, the communicative limitation of a functionally differentiated society is communication between different functional systems: How can artists communicate with politicians, private company managers with scientists, or lovers

with lawyers? The answer is partly the public sphere, which constitutes a sphere for meta-communication across functionally differentiated subsystems (cf. chapter 5); and it is partly "buffer zones" built into organizations, e.g. the fact that a university has an economic department taking care of financial communications with private companies and sponsors and the like.

In the present context, the important fact is that dominant communication media regimes are interrelated with types of societal differentiation, although there are no direct couplings. One cannot deduce a specific media regime from a differentiation form, but a certain differentiation form may emerge as society's evolutionary answer to challenges in complexity in a given communication medium, and vice versa. Here, I shall not go through all the major media regimes, but direct attention only to the following scheme, which deliberately does not include a column for social differentiation forms, emphasizing instead the impact of a given communication medium on the communication couplings: How does a certain communication medium have an effect upon the receiver's observation of the information selections of the sender, and how does it have an effect upon the sender's observation of the receiver's selection of understanding, the so-called understanding control? Also, one can register the effects of a given communication medium on the potential size of the communication group: Is it restricted to the small interaction group of verbal communication, or does the medium potentially include all persons with access to a networked computer? Focusing on the last phase, characterized by a growing influence of the Internet as media regime, it should be noticed that the "only" immediate difference between oral communication and Internet communication is the size of the communication group (as we shall see in the next section, there are other less immediate, but important differences). This explains why so many have suggested that Internet communication represents the return of tribal society on a global scale, as in the notions of "digital tribes," "the global village," etc. As I will demonstrate in a moment, these notions are extremely naïve because they underestimate in particular the complexity of global, synchronous communication.

Within this context, cyberspace may be defined as that special digitally supported communication space in which each individual participant of the communicative act can observe the other actors' communicative selections in all observation media: The observation is not limited to text, but can include three-dimensional images, sounds, and in principle also smells and tactile senses. Thus, cyberspace represents

Table 3

Communication Medium	Observation Medium of a Communicative Act	Relationship of Information vs. Understanding Selections in Time	Relationship of Understanding vs. Understanding Control Selections in Time	Relationship of Communicative Selections in Space	Size of Communication Group
Oral communication	All	Coupled	Coupled	Physically coupled	Within physical reach
Printing press	Text	Decoupled	Decoupled	Physically decoupled	Global
Radio/TV	Image/sound/text	Coupled	Decoupled	Physically decoupled	Global
Telephone	Sound	Coupled	Coupled	Physically decoupled	Global
Internet	(In principle) All	Coupled	Coupled	Physically decoupled	Global

a global communication space (Tække 2002), which in principle is closely related to the small orally based interaction group, with the added implication that the physical decoupling is not experienced as such. As we shall see, only by forgetting about the extreme levels of social complexity in a global communication realm is it possible to regard cyberspace as the digital representation of the village community or the flea market.

In an era increasingly influenced by the Internet as a communication medium, selections of information and utterance as well as selections of understanding and understanding control are coupled in time and space. Consequently, communication based on the Internet is in principle equal to communication based on oral communication, with the only difference being that while the latter potential group of communication is restricted to a small segment of people, the former may include everybody on earth.

This is the reason why Meyrowitz compares the current "information age" with the primitive hunter-gatherer society. As can be seen from the scheme, the quality of the dominant distribution medium is similar to the distribution scheme of the segmentary society, with the

exception that while the former was restricted to the limited size of the verbally based interaction group, in principle the latter is global.

However, while Meyrowitz and many others, e.g., McLuhan and the notion of the "global village" or Dertouzos and that of the "global information marketplace" (Dertouzos 1997), focus on the similarities between global cyberspace and former tribal societies, village communities, flea markets, etc., celebrating the assumed return of Tönnies's *Gemeinschaft* (Jones 1998, p. 21), Luhmann emphasizes the difference. With the potential for global communication between people who are virtually present in time and space, the problems of managing complexity increase accordingly, simply because the complexity-management mechanisms in simple face-to-face communication are relatively limited in scope. It is well known that in the communication of interaction groups there are many functions of inclusion and exclusion, functions of defining explicit and implicit communication roles and patterns, etc. However, while these tools are functional for the structural stabilization of small interaction groups, they will not be very helpful in the stabilization and maintenance of large social groups or systems. Consequently, these media increase the discrepancy between possible and actually occurring communication, out of which arises the problem of communicative selection, which society reacts to with organized and/or individual selection (Luhmann 1997, p. 311). Consequently, the global Internet—and, in particular, cyberspace—will never become anything like a "global community." On the contrary, the Internet has to "reinvent" the complexity-management tools of society, such as organized differentiations (for instance in mutually separated intranet systems) and functionally differentiated subsystems, each with its own symbolically generalized medium. Maybe this is the real revolutionary effect of the Internet: that it copies the structure of society into the medium, providing the Internet with an extraordinary social complexity-management potential compared with any other medium.

According to Luhmann, we are not experiencing a return to a (global) *Gemeinschaft*. On the contrary, in the current global society, already from a conceptual point of view we must "bid farewell to all Gemeinschaft mythologies—more precisely, we relegate them to the level of the self-description of social systems" (Luhmann 1995, p. 220). As a matter of fact, this is the hidden secret of the Internet: It is not the medium of a new global community. The Internet is not a "low-complexity" medium, realizing a global interaction system. On the contrary, the Internet is a "high-complexity" medium, combining

accessibility in time and space with society's most sophisticated complexity-management mechanisms.

The Internet: A Social System or a Self-Organized Dissemination Medium?

The very fact that organization is a means of reducing complexity is something we see exemplified in the now global electronic network, the Internet. The more it spreads, the more small and large subsystems arise in the network: clubs, discussion groups, associations, teaching classes, subcultural systems, virtual worlds organized as "real" societies, and millions of Web sites representing what according to Hegel is the basic building block of society: the home-based family. All this apparently helps to increase the complexity of the Internet, but in reality the opposite is the case. All these organizational formations reduce complexity. For one would have the highest degree of complexity if one logged on to the network and on the screen saw an infinite amount of apparently identical electronic messages, which were not divided into groups, and moreover did not clearly state where they came from, whether they were important or unimportant, etc. In such a situation, one would drown in information, and the only way to save oneself would be to organize incoming information. But, as we know, it is bothersome and difficult to organize one's heaps of information if disorder, i.e., complexity, has taken root in them. The "natural" way to organize information is to ensure that it is produced and distributed by and in organizations, e.g., that the letter before me comes from my project colleague in Italy, this article I have just read has been published by the journal *Telecommunications Policy*, this summary is from the faculty council of the humanities at the University of Southern Denmark, the reminder was sent by my English proofreader, this note belongs to the book I am writing. My collection of information reduces complexity by creating pigeonholes for the subject, sender, deadline, and so on. In other words, the signs of organization are apparent.

But, what in fact is the Internet? Basically, and technically, it is a loosely organized structure of linked computer networks. Access is available to people from all parts of the globe, as long as they have a computer connected to the data network.

The Internet has developed explosively. The first ARPANET with four computers was established in the late 1960s. In the early 1980s, there were under 1,000 networked computers. In 1990, there were

300,000 host computers, and around New Year 1991–1992 more than 4 million users from over 5,000 organizations in more than 50 countries were linked up (Hart, Reed, and Bar 1992, pp. 666–689). The Internet at that time linked a good 700,000 so-called host computers, i.e., computers that each provided access to the Internet. During autumn 1992, 1 million computers were connected. By the beginning of 1996, the number had passed 10 million computers, and in January 2001 the number exceeded 100 million host computers.[2] It is difficult to estimate the number of users per host computer, but it has been suggested that the total number of Internet users worldwide by 1999 was between 150 and 180 million. A report on the economic impact of the Internet published by the United States Department of Commerce expected the number to rise to 1 billion by 2005 (Slevin 2000, p. 40).

The important issue is, however, that the Internet reminds us of Luhmann's definitions of a social system: a global social system of events that can be reached by one another communicatively. Thus, it is relevant to raise the question of whether the Internet constitutes a social system in itself, a parallel world, as suggested by, among others, Philip Zhai, in his claims that the digital virtual world "is ontologically as solid as the actual world" (Zhai 1998, p. 34). Is it, as suggested by Peter Bøgh Andersen, an autopoietic system—or, as he terms it, a "semi-autopoietic system" (Andersen 1998, pp. 35–41)—that is, a system that functions as a social system and therefore is a social system? Or is it, as I would contend, a communication medium, although a communication medium with a qualitatively different structure than other known dissemination media?

Apparently, the basic element in the Internet is countless interaction systems, i.e., temporary social systems that are entirely constituted by reciprocal observation/acknowledgment. I send an enquiry, order an article, or answer a letter, and as a rule receive one or more answers, confirmations, comments, etc. over the next few days, while receiving further letters, invitations, and notifications from others. The system is not unlike walking down the street, saying "hello" to a slight acquaintance, making visual contact with a passerby, buying a book from a bookseller, noticing a headline at a newsstand. Transient interaction systems are constantly being established, but as soon as the interaction ceases, the minisystem in question is again dissolved. The Internet, in other words, seems to be a global society constituted by millions of interactions.

However, a crucial characteristic of the Internet is its organization and its organizations. When I walk down the street, it is decisively important

to me that the thousands of passing interactions can be classified. A book in the bookshop is not a chat with a friend; a girl passing is not a newspaper headline; a meeting at the university is not a train carriage full of strangers; the evening meal at home is not a judgment in the High Court. All the thousands of transient interactions can be classified in relation to the functional subsystems or organizations to which they belong, and this in turn tells me who has access, what obligations are imposed, and what symbolically generalized codes control the interaction. If these spontaneous classifications were not automatically made, if social life were not based on millions of spontaneous decouplings, any individual in a modern society would immediately drown in social complexity.

And so it is with the Internet, which appears to be a kind of prototype of the spontaneous self-organization of the complexity-increasing society. For the Internet develops through self-growth; it is not organized in advance. In principle anyone can join, and everyone does so with thousands of different motives. But, in the wake of this self-growth of organizations, organized procedures for interaction are constantly being formed. The process gives rise to a spontaneously initiated reduction of complexity.

Again, however, this does not necessarily imply that the Internet constitutes a new social system, as many have contended. Rather, I would suggest that the Internet, and in particular, the World Wide Web, is a very special dissemination medium. It is a dissemination medium with a structure that combines global accessibility with self-generated addressability; a reproduction mechanism that is not based on the function of one intentional central agency (the publisher or the organizer), but on the self-generation of functions characterized by recursiveness.

The World Wide Web: The First Self-Generating Dissemination Medium

As already mentioned in chapter 5, in his theory concerning communication media, Niklas Luhmann makes a distinction between dissemination media and effect media. It is my assumption that the Internet, and in particular the World Wide Web, is the first communication medium that combines the dissemination- and the effect-media qualities in one media structure. This provides the Internet with until now unseen potential for the mediated management of complexity.

This assumption is inspired by, but not identical with, Peter Bøgh Andersen's thesis that the World Wide Web is, as he says, a "semi-autopoietic" system. According to Andersen, the World Wide Web belongs

to the class of autopoietic systems because it is a system that is based on a basic recursive process, whose components cohere and influence one another, establishing a boundary between itself and its environment, displaying self-reference and self-observation, differentiating itself into subsystems that are not controlled by one intentional central agency (Andersen 1998, p. 38). Still, according to Andersen, the World Wide Web is not "fully" autopoietic, because it unilaterally presupposes social and psychic systems: It cannot exist without these systems, while they can exist without the Internet. Here, it is different from the social and the psychic systems, which mutually presuppose one another.

For me, the Internet—and in particular the World Wide Web—is not a communication system, and thus not an autopoietic system in the strict sense defined by Luhmann, that is, as "a completely closed system that creates its components out of which it arises through communication itself" (Luhmann 1992b, p. 254). The Internet, and the World Wide Web, is a communication medium in the sense that communication systems are constituted through a distinction between medium and form, between loosely coupled and strictly coupled elements. By being loosely coupled, nothing is decided *ex ante*, while yet not everything is possible. Language is a medium (and, according to Luhmann, thus not a system) in which many things—but not everything—can be said. As the basic communication medium, language "guarantees" the continuity of society's autopoiesis (Luhmann 1997, p. 205). Mass media (books, newspapers, broadcast media, etc.) and symbolically generalized communication media represent, as already defined, other types of communication media, that is, dissemination media and effect media, respectively.

Traditionally, it has been impossible to combine the two functional aspects of communication media, represented by dissemination media and symbolically generalized communication media. The development of dissemination media has been a development from oral via written to electronic dissemination, with electronic broadcasting as the so far ultimate example. The advantage has been that more and more actions have become communicatively accessible, thus increasing the level of potential social complexity from hunter-gatherer societies based on communities of limited interaction to our present global society. The disadvantage has been the explosive increase of communicative redundancy. Traditionally, the way of decreasing communicative redundancy has been to create social hierarchies, censorship, closed walls, organizational barriers, etc. In ways such as these, the number of potential communicative couplings has been reduced,

thus avoiding irrelevant or undesirable communications. However, by creating such borders and barriers, the advantage of communicative accessibility also disappears.

The "social invention" overcoming this contradiction has been the development of symbolically generalized communication media. Examples of symbolically generalized communication media are money, political power, scientific truth, the artistically sublime, etc. Thus, symbolically generalized communication media are structures of loosely coupled elements that orient communication toward certain conditions and thus increase the possibility of communicative acceptance, for instance through institutionalized mechanisms related to a given symbolically generalized communication medium. We normally accept the prices in the supermarket—and we accept that money is the relevant shopping medium—and we do not enter endless negotiations trying to compare different exchange objects according to ad hoc standards or protocols, as was the case in pre-money societies, in which all communication was based on nondifferentiated and only informally standardized and protocoled interaction.

It is my assumption that the Internet, and particularly the World Wide Web, is a medium that combines the benefits of the dissemination media and the benefits of the effect media into one "media structure." Thus, as symbolically generalized communication media emerged when social evolution created a level of complexity in space and time that could not be handled by nondifferentiated interaction systems, so digital media structures like the Internet and the World Wide Web emerge when social evolution reaches the level of hyper-complexity. It thus follows from my hypothesis that the Internet emerges as a result of the twentieth century's increased social complexity—not in the sense that society "creates" or "determines" technological developments, but in the sense that inventions created within the closed scientific and technological systems under certain conditions establish a structural coupling with the social system. In this sense, the Internet and the World Wide Web represent a "social" or "sociotechnical" invention, which is capable of tackling the problem of global digital accessibility without destroying the benefits of global access.

In order to qualify this assumption, a number of technical issues characterizing the Internet and the World Wide Web media structure must briefly be summarized. The first issue is the TCP/IP, that is, the combined transmission control protocol and Internet protocol. TCP standardizes digital transportation. IP identifies each single computer on the global digital network. Here, a simple and highly efficient global

dissemination medium is created, which is based on a standard, a protocol, and not on a central intentional agency. This characterizes the Internet in its basic form.

So far, however, only the medium for a potentially global interaction system has been created. In this medium, all host computers can be connected and can address each other individually. Thus, the second issue is the possibility of creating links, in order to establish a facility through which a user can connect one point in the global interconnected digital text of texts to another point, which is in some way related to the first point. As expressed by the inventor of the World Wide Web, Tim Berners-Lee, the potentially global network of computers "needed a simple way for people to represent links in their documents, and to navigate across links. (. . .) I decided that on my system, if someone wanted to put a hypertext link into a piece of text, the words noting the link would be highlighted in some way on the screen. If a viewer clicked on a highlighted word, the system would take him to that link" (Berners-Lee 2000, p. 22). This facility equals the functionality of the symbolically generalized communication media, here however as a technical facility built into the global computer network. It conditions communication by coupling communicators within frames of interest, thus applying the mechanism of a functionally differentiated subsystem's symbolically generalized medium to the electronic communication structure and increasing the possibility of communicative acceptance. However, the cost of conditioning communication is that risk is created, that is, the risk that the link—the suggested communicative coupling—is not felt to be relevant by the actual user, just as the declaration of love in a supermarket uses other codes than the code of money, which under normal conditions actually increases the efficiency of shopping communication. The general effect is that the functionality of the effect media is added to the functionality of the dissemination media and integrated into one digital media structure.

To achieve this effect, a more sophisticated protocol was needed. As Berners-Lee would put it, the art was to define the few basic, common rules of protocol that would allow a user to link a text element in a file on one computer to another text element (or to a file) in a file on another computer. For the Web, the three necessary elements were: universal resource identifiers (URIs), the hypertext transfer protocol (HTTP), and the hypertext markup language (HTML) (Berners-Lee 2000, p. 39). The fundamental issue is that these common rules of protocol do not imply the existence of a central computer or editor creating the links, but facilitate participants of communications to

create links according to their own liking, exactly as the symbolically generalized medium of money allows people to link the most different commodities but does not force them to set a specific price. Thus, a URI (or, as it is often mistakenly called, a URL) identifies first the protocol to be used to look up a certain document, then the address of the actual computer server where the document exists, and finally the specific document on the server.

The final and fundamental issue is that this function supports the reentry mechanism, which is the condition *sine qua non* for creating a complex, self-regulating structure: The World Wide Web (WWW) constitutes a technical medium allowing for recursion. With the example suggested by Peter Bøgh Andersen, the WWW allows not only for the exchange of texts, but also for the exchange of software. In particular, one can download software, which changes the functionality of the Web as a communication medium. Thus, the WWW has the capability of allowing its users to change its own capability (Andersen 1998, p. 19f), and again not because a central agent disseminates new software, but because decentralized users have access provided to such software. Compared to the theory of social systems, and more generally to the theory of form, this equals the reentry of the form in the form, according to the concepts of George Spencer Brown's *Laws of Form*. Through the process of reentry a system does not just refer to its own components (i.e., the files on the Web), but to the form, that is, to the distinction between the marked and the unmarked state (or, concerning the Web, to the software creating the difference between the marked and the unmarked state). A medium supporting this systemic function must thus allow the system to refer to its elements and to itself, just as language (the basic communication medium) allows communication to refer both to elements (communication about specific phenomena) and to itself (meta-communication).

Reentry is the functional type permitting the establishment of unlimited universes through limited resources, "the infinite in finite guise," as expressed by Louis H. Kauffman in his elaboration of the concept of self-reference (Brown 1971; Baecker 1993c, pp. 12–37; and Kauffman 1987, pp. 53–72). At the Net, the reentry function of the WWW is probably a basic condition for allowing the Web to expand as quickly as it has without becoming chaotic. In sociological terms, reentry represents the self-observational function of social systems, that we both observe phenomena and observe observations, for instance by discussing criteria for ongoing discussions. In the social system, functionally differentiated systems cannot observe society, but through these systems

symbolically generalized media are being developed that can serve as complexity-reduction observation and communication media. Similarly, for Internet-based communication, search engines and browsers serve as observational complexity-reduction machines. We observe our environment through these search engines exactly as we observe the goods of a supermarket through money as a symbolically generalized medium or social search engine. Through these search programs—browsers and intelligent agents—systematic observation and self-observation can take place, while observations of the browsers equal second-order or meta self-observation in society.

The Organization of the Internet

The functionalities of the Internet and the WWW have been summarized above, and it is clear that the Internet is an excellent medium for organizing communication, with the process of reentry (that is, of inscribing form into form) as the basic mechanism of dividing a society into smaller parts, subsystems, or organizations, which are in themselves social systems. This is exactly what has happened on the Net.

It is a basic characteristic of the Internet that spontaneous organization takes place. If you log on to the Internet, you can quickly join hundreds of associations, discussion groups, and cultural societies. Members of ecological groups meet on the Internet without ever meeting one another physically. If you put even the most exotic question, you can expect in a short time an answer that supplements it with further questions, suggestions for resolutions, references to literature, etc. Musical subcultures like hip-hop, techno, grunge, and raggamuffin "meet" on the Internet and exchange video and record news, and in no time at all you are in the reading room of the University of Colorado, where you skim the latest articles, browse in the local newspaper, and check the weekend weather in the Rocky Mountains.

It is often heard that the many linked organizations, with their various access and interaction procedures, "complicate" the use of the Internet unnecessarily. I think—with certain reservations, of course, about unnecessary overcomplexity, a shortage of general standards for procedures, etc.—that the opposite is the case. It is these many organizations and modes of organization that prevent a state of total transparency, which would make the Internet unusable, as it would be exposed to the sheer bombardment of undifferentiated information.

Although these spontaneous organizational actions take place in order to manage the enormous social complexity of the communication

system, making all global actions communicatively accessible, they also occur because the Internet possesses a huge power to reorganize. Formerly, "my" organization was at the University of Southern Denmark in Odense. That was where I had my professional colleagues, where I had my students, my friends, and my membership of administrative bodies; but today these geographical bonds are being dissolved. My students are in the Erasmus network all over Europe, I collaborate professionally with colleagues in the U.S.A., Italy, Brazil, etc. My professional and educational, i.e., academic organizational, boundaries are, in other words, no longer geographically determined and symbolized, but are functionally determined (i.e., determined by whom I need to communicate with and what I need to communicate about), just as they are symbolized by my interface with the Internet, not by arbitrary architectural and geographical factors like the red brick buildings of my university, or the distance I am capable of covering on my bicycle. Again, the neutralization of physical and geographical boundaries by the Internet as a digital dissemination medium is possible only because this medium has special potentials for building secondary complexity structures, i.e., because it has very special organizational potentials.

The Organizations of the Internet

Not only is the Internet a communication medium that stimulates organizing processes by, so to speak, organizing its own structure, thus providing powerful complexity-management mechanisms. The Internet is also—and for the same reasons—a communication medium with important potentialities for the development of new organizational forms. Consequently, with the development of the Internet, new types of organization have also emerged. These new electronic forms of organization include such phenomena as "elusive offices," "network universities," "virtual classrooms," "computer conferencing," "soft cities," "smart buildings," "electronic libraries," etc., i.e., networks where people do not interact face-to-face, but work together via computers and telenetworks, while still maintaining the special social units we call organizations, although now in the form of so-called network organizations.

One of the exciting things about these new organizations is that they are held together only by communication. The members do not go in and out of a building, they are not constrained by geographical boundaries, they do not interact physically. The new organizations are therefore "pure" organizations, and can thus be understood only in terms of

organization theory. One could say that these new forms of organizations do at last force us to look for an organizational theory *sui generis*.

In the so-called good old days, work was something one did at a workplace; office work was done in an office. A school class was a group of pupils in a classroom, a university was something you "went to," a city was an accumulation of people in buildings and streets, and if you wanted to borrow books, you had to go to the library. An organization was something physically or geographically localizable, and one could hardly conceive of organizations without thinking of buildings, places, bonds in physical matter. The concept of "organization" was, in short, closely associated with spatial and geographical understanding.

But today, these contexts are disappearing. One is "at the university" when one has turned on the computer, linking up with the ongoing computer conference, and the teacher becomes an information provider and network coordinator. Project work is often done today among groups of students from Europe and the U.S.A., for example, working together via electronic conferencing systems.

Back in the early 1980s, the American researcher S. R. Hiltz completely transformed the definition of an office. "Usually," she wrote, "one thinks of it as a place, with desks and telephones and typewriters. In thinking about the office of the future, one must instead think of it as a communications space, created by the merger of computers and telecommunications." According to Hiltz, these computer-mediated communication networks can best be thought of "as a new kind of social system, in which the familiar social processes in the workplace and the organization become subtly altered by electronically mediated interactive processes, creating new kinds of 'online communities'" (Hiltz 1984, pp. xv and 30).

A few years later, European researchers such as Huws, Korte and Robinson arrived at a similar definition. If we gaze just a little into the future, they claim, "the traditional concept of the workplace as a fixed geographical space will be replaced by more abstract notions of the working context as a set of relationships, a network, an intellectual space" (Huws, Korte, and Robinson 1990, p. 208). They call this network office "the elusive office". The "elusive office" is an office that "arises" when people—for example in Norway, Denmark, and England—communicate in a manner normally defined as office work without being physically together. The office is established by means of the electronically linked computers, and it disappears when the link is broken.

More generally the concept of the network office or the network organization corresponds with what Jack Nilles and others call the diffuse

organization (cf. also Laing 1991). Individual workers or small, specialized service companies work from home-based offices, or from local work centers in residential areas ("intelligent buildings," "shared facility centers," "telehouses," and various other names) for a large number of different and differently localized companies. The organizational structure is not only less hierarchical, it is based on "adhocracy," where new social and organizational networks are constantly being created and transformed. This means that such organizations are characterized by horizontal communication and that they depend upon dispersed information. In reality, the particular "thing" or "activity" that holds such organizations together, is communication. You cannot localize such organizations in space or, to some extent, even in time, since much of the interaction is asynchronous in character.

From the many examples I have summarized here, it is clear that social organizations emerge in their pure form as interactions among people based on communication. This prompts us to develop theories of organizations that are based on the fundamental tenet that social organizations are communication systems. But, it also allows us to discover organizational mechanisms and problems that were formerly hidden.

How is an organization demarcated, for example? The question was once superfluous, because the demarcation of an organization was simply not regarded as a problem—it was where it was, so to speak. But now, when the boundaries seem to be fluid, the question does arise, and now we can see that the traditional demarcations formed by buildings, walls, doors, gates, clocks, access codes, and so on are in reality only just a few of a larger number of possible symbolic boundaries around a communications system. In reality, buildings, doors, and guards, as far as social organization is concerned, are only symbols of boundaries. A building is—in an organizational context—a symbol.

Again, however, a basic question is whether these organizations are, as it is often believed, "less organized" than traditional organizations or rather are *differently* organized. For me, the latter answer is the correct one. In order to understand this, Herbert A. Simon's concept of "bounded rationality" must be introduced (cf. the presentation of the concept in chapter 4).

Hypercomplexity and the Challenge of Bounded Rationality

The background for recent changes of organizational theory and practice (from Weberian bureaucracies via scientific management-based

Fordist organizations to modern network-based or virtual organizations) can be found in changes of society during the same period, from an industrial to a postindustrial, or a hypercomplex, society, which cannot be managed by traditional, centralized organizations. However, only with the development of the Internet as a medium for organizational communication have these changes been made possible at a higher level. The reason is that the basic function of reentry characterizes not only the Net, but also the function of the organization, according to the principle of bounded rationality. While scientific management was based on the expectation that one central unit could observe and manage all individual actions in an organization, management based on the principle of bounded rationality realized that the basic function of management was to make self-management possible, that is, to allow local management procedures to inscribe themselves in the larger management form of central management.

As stated in chapter 4, this was first realized by Herbert A. Simon. In 1945 in his book *Administrative Behavior*, he presented the concept of bounded rationality as an alternative to the traditional belief in unlimited human rationality. He realized that the complex environment cannot be managed by a single human's rationality, but that we always face a deficit of rationality, i.e., that the complexity of an organization's environment exceeds the management capacity of the organization. Consequently, the basic function of an organization is to reduce complexity, and the challenge for managers is to develop complexity-management strategies and structures (Simon 1997).

While the implications for epistemology were discussed in chapter 4, let me briefly discuss the theoretical implications of this approach for organization theory and particularly for digital communication in organizations. Normally, it is believed that the function of managers is to make "correct" decisions. However, with the understanding of bounded rationality, the concept of "correct decisions," or the belief that such a thing as absolute decisional correctness can be achieved, is not relevant, because this idea implies that the decision made can be compared to all other potential decisions. For bounded rationality, this is not possible. Consequently, the making of informed decisions is not based on couplings, but on decouplings. This implies that we must rethink the mechanism of this basic social act.

As a consequence of this fundamental mechanism, it is an illusion to believe that the nature of making informed decisions is to observe and analyze all possibilities, to compare them, and then to choose one, i.e.,

The Communication Medium 187

the best. No, to make an informed decision is simply to activate one possibility and to leave others open.

To activate a possibility is to reduce complexity: I do this and not everything else. But at the same time, to activate a possibility is to leave all other possibilities deactivated, i.e., to run a risk, to produce risk.

Thus, based on the concept of bounded rationality, we have unfolded the basic paradoxical mechanism of complexity reduction. To make a decision is to exclude oneself from other possibilities, i.e., to reduce complexity; and to reduce complexity is to produce risk. Confronted with the challenge of risk, one may however include new possibilities, for instance by producing nondecisions. Through the mechanism of inclusion, risks are reduced and complexity is increased (Mathiassen and Stage 1997).

Let me illustrate the argument with a simple example, e.g., a typical decision-making process in a political arena:

1. A decision is made, i.e., the decision-making body has activated one possibility, and thus deactivated others, i.e., excluded itself from other possibilities.

2. The result is production of risk, and the more informed the decision-making body is—the more it is informed about the many deactivated alternative possibilities—the more obvious the risk potential is.

3. As a consequence, the decision-making body may be open to new possibilities: A final decision may be delayed, for instance by asking a committee of experts to analyze the situation. Thus, it is decided to nondecide. More possibilities are included; i.e., more possibilities are reactivated.

4. Immediately, risk is reduced ("at least we are not doing anything wrong"), but complexity is increased: It is time for a new decision-making round.

The implication of the above is that the basic challenge of organizations is to balance the reduction of complexity and the production of risk. An organization reduces complexity by constituting irreversible situations; for instance, by transforming a decision into an action. In this way, not only is the focus moved from complexity reduction to risk production, but the result of the risk-production analysis is decoupled from the initial decision process. Let me suggest another simple

example: After a series of risk analyses, it is decided to construct a bridge, although it may harm the environment. When the action is completed, it constitutes an irreversible situation. Consequently, the initial complexity-reduction cycle is left, but a new one will normally be initiated, for instance by entering a discussion as to whether a sanctuary for threatened species should be built. Thus, social actions constitute the end of one complexity-reduction cycle and constitute links to another cycle. A similar argument goes for institutionalizations, for routinized behaviors etc. They all represent acts made on the basis of conscious or unconscious decision-making cycles, and although they may lead into extremely risky or harmful situations, they are not experienced as such. They simply represent "business as usual."

Often, the question as to whether a social act is experienced as complexity reduction or as risk production depends upon the individual's position in relation to the decision-making process. Compare for instance the experience of a car driver and his or her passenger.

Organizations as Tools for Complexity Reduction and Risk Production

The idea of bounded rationality as the basis for the understanding of social and organizational behavior was further developed by Niklas Luhmann, with explicit references to Simon.[3] Actually, in his book about trust, *Vertrauen,* Luhmann characterizes Simon's concept of bounded rationality as a "mirror articulation of the complexity problem." Luhmann concludes that Simon's considerations can be condensed into one formula: "Due to socially increased complexity, individuals have to develop more active forms for the reduction of complexity" (Luhmann 1968b). One such social form is the formal organization. Thus, according to Luhmann, the phenomenon of formal organization—a phenomenon that received its conceptualization during the eighteenth century—develops as a basic complexity-reduction tool within an increasingly functionally differentiated society: "In complex societies a special type of social system gains increased importance, a system which in several areas of social life squeezes itself, so to speak, in between the social system and the individual interaction system, i.e., the social system type of organization" (Luhmann 1975, p. 12).

How should the concept of organization be defined? According to Luhmann, definitions based on goal-oriented behavior, division of work, hierarchical structures, etc. are much too narrow. For him, an organization is a social system, i.e., a closed system based on self-reference,

which has as its function the reduction of societal complexity through decision making—a complexity that cannot be managed only by ad hoc interacting groups—and whose borders are based on the question of membership: A social system is "organized" if "membership is coupled with certain conditions, i.e., if entry and exit are formally conditioned" (Luhmann 1988, p. 99; Luhmann 1984, p. 268f; Luhmann 1991, p. 202).

According to Luhmann, the way in which complexity is reduced cannot be predicted. On the contrary, it must be expected that with changes in the social environment, new complexity-reduction strategies will be developed.

Toward Increased Organizational Flexibility

For many years after the publication of Simon's book, the principle of bounded rationality was neither understood nor practiced. In organizations, the first reaction to the growth of environmental complexity was to increase internal bureaucracy. Private enterprises developed horizontal specialization and vertical layers, and public institutions created detailed rules and procedures in order to select external complexity.

Only in more recent years have other organizational strategies been put on the agenda. Instead of developing an endlessly growing capacity for complexity management in one unit, organizations have managed complexity through decentralization. Instead of establishing an increasing number of rules as sorts of complexity filters, organizations have experimented with flexibility, based on the philosophy that pressure from the environment should not necessarily be answered by filtering, but may also be met by adaptability. Instead of observing an organization's internal and external environment through one usually dominant code—the economic code of gains and losses—the economic account has been supplemented with ethical accounts, ecological accounts, qualification accounts, etc. One code has been replaced by several codes for environmental observations and adaptations. Instead of one decision-making center, which has been put under increased pressure, organizations have experimented with decentralized, but mutually coordinated decision centers. Instead of inflexible principles based on strong traditions, procedures based on organizational learning have been put on the agenda, because mutual learning is a precondition for adapting to a complex and changing social world. And even learning must itself be flexible, i.e., based on flexible learning procedures. As a consequence, learning procedures based on self-observation—second-order learning—have been introduced. Instead of centralizing many

production units within a single organization, production is based on networks of small production units, managed as just-in-time production, outsourcing, enterprise clusters, etc.

In order to make these complexity-management functions possible, the Internet is a central communication medium. First, due to its individualized coupling mechanisms—the TCP/IP—the Internet can provide any organization with a very rich "sensory" system. Instead of communicating through one gateway, according to one code, communication can happen through as many gateways as there are employees in the organization, and according to a large number of tailor-made communication codes. Second, due to the link mechanisms (the URL with its unlimited number of universal resource identifiers) a decentralized creation of communication themes can be achieved and can immediately be coupled to the communication structure so that potential senders and receivers can be coupled according to thematic criteria. Third, reentry functions are provided (the recursive exchange of software), supporting the possibility of creating very high levels of internal or secondary complexity, thus combining the rich external digital sensory system with a highly internal complexity-management structure.

These potentialities of the Internet do not make the criticism of digital communication obsolete. However, current critical analyses often do not characterize the Internet as such, as it is both a dissemination medium and an effect medium. But such potentialities are relevant insofar as they can help us to maintain a proper balance between the dissemination and the effect function. Transparency is necessary in order to maintain the individualized global reach of the Internet. Filtering through links, reentry mechanisms, and search facilities—all the "organizing features"—are necessary in order to manage the potentially unlimited complexity of Internet-based communication.

SEVEN

The Culture of the Hypercomplex Society

The Inflation in Culture

Why is the concept of culture used so often, and why have cultural studies and cultural theory become so popular? Why the apparent inflation in culture?

Part of the explanation lies in the tendencies in modern society that I have tried to describe in this book. The basic point is that modern society is typified by functional differentiation. In the first place, the individual in modern society is characteristically self-enclosed, so that his or her basic relationship is the relationship to himself or herself. Second, the institutions of society have become specialized into mutually exclusive expert systems, which are only loosely coupled to each other. There is no longer a God or universal authority to unite the various differentiated domains. On the contrary, each domain functions in accordance with the rules of its own experts. Scientific research is based on the code of truth, not on the assumption that God created the world. The economy develops in accordance with its own economic laws, which are neither divine nor governed by ethical or ecological considerations. Children are brought up in accordance with the latest insights of educationalists, not to reproduce the traditions and values of the family. We are referred to hospitals, we send our cars to the garage, without having the slightest clue about the actual repairs. We demand expert assistance when we are born, are educated, love, and die, and yet we are critical of the loss of unity and the many social differentiations that we experience.

In other words, society is a differentiated society. In the past, society

was subject to the universal perspective of God, i.e., "God" as a symbolic representation of unity and coherence. Today, society has been differentiated into a large—in principle, infinite—number of subsystems, each of which obeys only the demands of its own perspective. Once, there was a shared, symbolically generalized medium—not in the form of a physical channel of communication or a mass medium, but as a social construct by virtue of which one human being could understand another. Today, each subsystem understands itself and its surrounding world in terms of its own distinct medium, and so-called "shared understanding" does not exist as the precondition for the social system, but as the outcome of communication, i.e., as the always emerging meaning horizon.

For quite some time now it has been respectable to cultivate this differentiation. Everyone can now join in the chorus asserting the death of God, everyone knows and can repeat the argument about the death of the grand narratives and the impossibility of communication. So what we need today is not to repeat this banal story, but rather to formulate an alternative. But what *is* the alternative? The available alternatives appear to have been demolished by the twentieth century, which in this respect was a veritable laboratory for ideas of cohesion. Nietzsche's *Übermensch* is unlikely to muster many supporters. As for the proletariat as the unifying subject-object of history—to repeat the phrase of Georg Lukacs—brings a smile to one's lips. And although one can at present observe quite a few culturally normative tendencies and waves of rationality, morality, and religiosity, history nevertheless seems irreversible, so that such a return to cast-off values does not appear credible in the present circumstances.

The question is thus one of how cohesion can be established while at the same time respecting modernity as the great differentiator. How is cohesion—or "community" in the original sense—possible, not as the *opposite* of differentiation, but as an *outcome of* differentiation? In this concluding chapter, I will argue that cohesion doesn't necessarily conflict with differentiation, because the cohesion I am talking about is not the cohesion from the centralizing perspective of old; it is the cohesion that complex systems can establish, not in spite of their complexity, but as the result of the self-operations based on complex criticality.

It is here that the concept of culture presents itself; for now that universal order—based on God or human rationality—is dead, more and more people seem to hope that culture can function as the new Redeemer: Perhaps, they seem to think, it is culture that—against all odds—makes modern society possible.

Although I am skeptical about most of these efforts, I still think that, in a strange, unintentional kind of way, they represent an element of truth. The question is not how this differentiation can be undone, but how a complex social system can establish community. It can do so by installing an optical glass (a "perspective") for mutual observation. I shall call this perspective "culture." This concept of culture contrasts with most known concepts of culture, which point backward rather than forward. It is not culture as habits, or as values, or as the sum of art treasures, or as an institutionalized system of job-creation activities—I therefore need to refute these concepts of culture first. But it is culture as a way in which one human being can observe the many other human beings without either assimilating to them or desiring their subordination; that is, as a medium through which the many specialized and differentiated subsystems can observe all the other subsystems without requiring fusion or uniformity and can construct a social "self"—society as society—on the basis of these observations.

Before elaborating on this concept of culture—culture as second-order medium, not as "substance," "basis," or "precondition"—I must however invite the reader on a short tour through the recent history of the concept of culture.

The Quest for the Concept of Culture

Culture as What Makes Society Possible

What is it that makes society possible? As Luhmann has demonstrated in his article "Wie ist soziale Ordnung möglich?" (Luhmann 1981), this seems to have been the basic issue of contention for sociology and the social sciences at least since Thomas Hobbes. However, according to Luhmann, the interesting aspect is not the answering of this question, because it has already been answered so many times in so many different and—at the time when the answer was given—convincing ways. The interesting aspect is, first, that it is precisely the problem of modern society's differentiation that sets the agenda for modern sociology; and, second, that the different answers that have been popular at different times tell us something significant about the particular self-understanding of those ages.

A variety of proposals have been offered by the social sciences and sociology in the course of time: Religion has been singled out at different times as the force capable of cementing a fragmented society together; the idea has recently been relaunched by Daniel Bell. Human

nature—for example in the form of human goodness, the attraction to other human beings—has often been suggested. Economics has been a good candidate since the French physiocrats, culminating in Adam Smith's "invisible hand" as the magnetic force capable of holding the volatile atoms of society together. Political expediency, for example as manifested in the social contract, was proposed by Rousseau, and his suggestion has often been repeated since, most recently in the form of "communicative competence." The desire for law and justice has been suggested. And, at the moment, morality and ethics are enjoying a boom—one need only think of the many "ethical councils" set up to curb the autonomy of expert systems, and the recurring demands for more morality in politics and the economy.

Another candidate popular at present is culture. In this concluding chapter, I will subject the concept of culture to a more detailed investigation, partly because, as mentioned before, I think that in this concept I can draw together many of the analyses I have presented in the preceding chapters, partly because I believe that the concept of culture—at any rate in the interpretation I intend to give it—differs from many of the proposals that have lain on the table of society in the course of time, in their desire to reveal what can make society possible.

Preliminaries to a Theory of Culture

One of the main figures in modern cultural theory is Raymond Williams. In 1958 he published the pioneering *Culture and Society* (here I quote from the 1993 edition), about the social, and especially the conceptual, history of culture. This was followed in 1981 by *Culture*, which gave cultural sociology an identity and marked out its boundaries.

In *Culture and Society* Williams identifies four aspects of the modern concept of culture, disregarding the premodern sense of physical cultivation:

1. The general state of mind or consciousness (here culture is something the individual has as a result of having been or simply being cultivated)
2. The general state of intellectual development in society as a whole (here culture is in other words a collective concept; otherwise the concept resembles sense no. 1—it is a kind of "collectivization" of no. 1)
3. The totality of art or works of art (the culture of a society is equal to the sum of its works of art and, perhaps, artistic activities)

The Communication of the Hypercomplex Society

4. The overall material, intellectual, and spiritual way of life (this is a relatively late meaning, which is sometimes seen in the caricature version, that culture is "everything")

In all four senses, culture is thus a product and not a process. However, Williams went beyond this in 1981. He systematized the meanings of culture in a kind of semantic diagram (Williams 1993, p. 11).

1. Culture as a developed state of mind, considered as a *thing* (this encompasses nos. 1 and 2 and possibly also 4 above)
2. Culture as the processes of this development (culture as cultivation processes, cultural activities, cultural work, etc.)
3. Culture as the instruments of these processes (this corresponds with no. 3 above, insofar as the instruments of culture are understood to be the works of art, the artistic activities, and the artistic institutions)

This threefold division represents a slightly different structuring of the field than the one mentioned above, since Williams at this point—when he was still influenced by Marxist skepticism toward so-called "idealistic" phenomena—replaced "mental culture" with its institutional representation in society. The result is a division into the following three domains of cultural theory:

- the theory of material culture,
- the theory of social culture, and
- the theory of institutionalized culture.

The interrelationships outlined by Williams can be expressed in Table 4.

Table 4

Culture as product	Culture as things/ artifacts in society	The theory of material culture
Culture as process	Culture as dynamic phenomena/functions/ practices in society	The theory of social culture
Culture as instrument	Culture as domains/ institutions in society	The theory of institutionalized culture

Culture as a Meaning-bearing and Meaning-creating System

According to Williams's cultural theory, the first part of the twentieth century was dominated by two approaches, the idealist (which placed its main emphasis on the cultural and mental products, processes, and instruments, as a closed system) and the materialist (which viewed these products, processes, and instruments as products of—and as reproductive tools for the re-creation of—a social system).

In the 1970s, though, one could observe a convergence of these approaches, and Williams became an advocate of this convergence. Cultural practices and cultural production were no longer regarded as phenomena that could simply be derived from a social order independent of them, but were analyzed as intrinsically important elements in the constitution of that order. On this basis, Williams proposed the following important definition: Culture is "the *signifying system* through which necessarily (though among other means) a social order is communicated, reproduced, experienced and explored" (Williams 1981, p. 13, Williams's italics).

The definition is important for several reasons: first, because it is the first time the concept of "meaning" was introduced in this context; second, because Williams speaks of a "system," although it is a little difficult to see what exactly he means by the concept; and third, because it cuts across the traditional divisions into product and process, social basis and mental superstructure, etc.

Yet Williams's definition is also flawed by a number of unclear points and these give rise to further questions: What does he mean, for example, by "necessarily"? Does it represent the traces of an old social determinism he is reluctant to lay aside? Strictly speaking, one could drop the word. And why the parenthesis saying that there are also other means? Is this a bow to the old materialism/idealism schema, where society certainly also reproduces itself through other means than solely its culture? If one asserted that social relations are characterized precisely by being communicated, then the parenthesis could also be discarded. Finally, Williams may have added the processual to the concept of culture, but his concept of society still seems quite static in view of the quotation's concept of "a social order," which is used in the singular and stands outside the dynamic of the processual cultural system. The concept of "society" also has the ring of static determinism: On the one hand, society is apparently already a given and thus appears static; on the other hand, it appears in the end to be this social system (and not all sorts of others) that the cultural system, with a certain deterministic necessity, reproduces.

The Current Paradigm of Cultural Theory

If we are to believe the many sociological and cultural theory textbooks now available, various scientific schools and disciplines in the 1980s and 1990s seem to have come together in nothing less than an interdisciplinary paradigm for cultural theory. For example the English sociologist Anthony Giddens, in his textbook *Sociology*, offers an apparently unproblematical and self-evident definition of culture: "Culture consists of the *values* the members of a given group hold, the *norms* they follow, and the *material goods* they create. Values are abstract ideals, while norms are definite principles or rules which people are expected to observe" (Giddens 1993, p. 31).

This definition, which very clearly expresses the self-understanding of modern sociology, recurs for example in an instrumentalized version in the theory developed in the 1980s by Edgar Schein with reference to organizational culture (Schein 1985). According to Schein, culture can be conceptualized as a pyramid with the following layers:

- Artifacts
- Values
- Basic Assumptions

Although the names are slightly different, the concepts are the same, so that Giddens's "values" correspond with Schein's "basic assumptions," Giddens's "norms" with Schein's "values," and Giddens's "material products" with Schein's "artifacts."

There is also general agreement that a three-dimensional concept of culture like this is valid for both large and small social systems. At one end of the scale, the concept of culture has been applied to geographically extensive social systems, in relation to which, for example, so-called cultural imperialism has become a concept for the formation of the global society as a culturally hegemonic social system (cf., e.g., Tunstall 1977 or Tomlinson 1991). At the other end of the scale, "culture" has been used not only in collocations like "organizational culture" and "corporate culture," that is, for geographically limited social systems, but also for temporally delimited systems like specific youth cultures, passing fashion phenomena, or ephemerally realized phenomena like "queue culture."

Returning to the general, three-dimensional concept of culture, Raymond Williams worked toward a similar view. In his above-mentioned book *Culture* he summed up his work on the history of the concept of culture by presenting the following threefold division. Culture is in the

first place abstract notions, for example in the form of a collective consciousness, "a developed state of mind." Here we recognize the "values" or "the basic assumptions" of the sociological tradition. Second, culture refers to the *processes* brought about by this state and through which it is reproduced. This represents the normative aspect of culture. And third and finally, culture is the *instruments* of these processes, for example in the form of works of art, but also in the broader sense in the form of the "whole way of life." Although, in this last mentioned aspect of the concept of culture there is a certain functional element, it first and foremost reflects the fact that culture exists for us in the form of various objects and institutions.

This connection between the approaches of sociology and cultural analysis or cultural theory can be extended further to the traditional, anthropologically inspired theory of culture, as summed up in Kroeber and Kluckhohn's *Critical Review of Concepts and Definitions* (Kroeber and Kluckhohn 1952). According to Roland Posner's resumé of this overview, there are three dominant anthropological theories of culture: the theory of mental culture ("systems of ideas and values believed in"), the theory of material culture ("artifacts and the skills of producing and using them"), and the theory of social culture ("society [that] consists of institutions, including the rituals performed by them") (Posner 1989, p. 10).

Roland Posner in turn related this to cultural semiotics, with regard to which he proposes the following threefold division: "codes" as the name for mental culture or the basic assumptions, "sign users" as the name for the dynamic processes in society that crystallize into norms, and "texts" as the semiotic term for culturally meaning-bearing objects and institutions (Posner, pp. 27 and 40).

These links among the cultural theories of sociology, cultural analysis, anthropology, and semiotics can be summed up in Table 5 (inspired by Posner 1989).

To go a step further in the comparative analysis of modern sociology, cultural analysis, anthropology, and semiotics, it seems that these different approaches have not only established a paradigm for cultural theory; it also appears plausible to say that this paradigm has an essentialist foundation and a functionalist orientation. Culture is on the one hand "something one has," i.e., a kind of "substance" found in people or in areas in society; this something in addition "functions" as a kind of social center of gravity, as something drawing society or social organization together. Finally, culture exists *in* things and processes as the cultural *signifié* of these things and processes.

The Communication of the Hypercomplex Society

Table 5

Sociology	Cultural Analysis	Anthropology	Semiotics
Basic assumptions (Giddens: "values")	Culture as collective consciousness	Theory of mental culture (mentifacts)	Codes
Values (Giddens: "norms")	Culture as dynamic social processes	Theory of social culture (sociofacts)	Sign users
Artifacts (Giddens: "material products")	Culture as objects in society	Theory of material culture (artifacts)	Texts

Culture as a Self-Referential System, Processing Meaning

Despite the critical remarks, I still think that we can fruitfully build upon Raymond Williams's definition. First, as regards the part of the definition that states that culture is a meaning-bearing and meaning-creating system, we could add the clarification that culture is a self-referential system, processing meaning; that is, meaning that produces and develops itself through reference to itself. Then we could develop and clarify the part of the definition that says that culture thus communicates, reproduces, experiences, and explores the social order. Inherent in this is the idea of a purpose or function: Culture *intends* something by being culture. But rather than just declaring that—consciously or unconsciously—it intends to reproduce the social order, we could perhaps say that its intention is to explore itself and communicate about itself with a view to self-improvement (or even world improvement). The object is thus the "self-processing of experience," which again includes the notion of a self-referential and self-developing process. And then, there is the concept of "self-improvement," which I believe to be crucial. Culture as a self-referential and self-developing system does not blindly or automatically reproduce any particular social order, nor is it purposeless. Culture has a purpose. But, culture itself articulates and formulates this purpose: It draws up and discusses its own ethical standards; it deals constantly with a normative base it has itself produced.

Raymond Williams's book about the history of the concept of culture is exclusively about Britain. Thus, it does not deal with—does not even mention—the history of the concept of culture in Germany and France, for example. In this regard Norbert Elias provides an excellent approach. In the first chapter of his major work *Über den Prozess der Zivilisation* (Elias 1969), he points out how the German concept of *Kultur* corresponds with the French *civilisation*. Both concepts represent the resistance of the new bourgeoisie of the eighteenth century to the premodern

social order. In France, being civilized was the antidote to being the unfree product of mores and customs. The civilized person was the person who could emancipate himself intellectually and socially from the given, and could give the ego free rein over its rationality, knowledge, and social freedom. In Germany, on the other hand, true *Bildung* and culture contrasted with civilization, as the expression of the laxity and unfreedom inherent in decadence. "The idea of morality," said Kant in 1784 in his *Ideen zu einer allgemeinen Geschichte in weltbürgerlicher Absicht*, "belongs to culture. But the use of these ideas, which is simply predicated on the customary in honour and outward decency, constitutes only civilization" (Elias, p. 8).[1]

In the work of 1784, Kant himself makes culture into an emancipatory concept. "We are greatly cultivated by art and science, whereas we have been civilized to the point of the burdensome in all kinds of social decorum and propriety." Neither in the critique of pure nor in that of practical reason, though, does the concept of culture play a major role, and only in the late work of 1790, *Kritik der Urteilskraft*—The Critique of Judgement—is it given more detailed and interesting treatment. Here he defines *Tauglichkeit* as the aptitude to set ends for oneself, and "(independent of nature in one's power of determining ends), of employing nature as a means in accordance with the maxims of one's free ends generally. This alone remains what nature can effect relative to the final end that lies outside it, and as what may therefore be regarded as its ultimate end" (Kant 1971, p. 429; English translation part 2, p. 94).

Human *Tauglichkeit* is thus the ability of the individual to see the other through himself and himself through the other, i.e., the capacity for self-reference, and I further believe that it is this aptitude for the reduction of complexity through self-reference that has developed to a higher level and that, in its diversity and complexity, is reflected in Luhmann's works.

In relation to human *Tauglichkeit*, culture is the crucial resource: "The production in a rational being of an aptitude for any ends whatever of his own choosing, consequently of the aptitude of a being in his freedom, is *culture*" ["Die Hervorbringung der Tauglichkeit eines vernünftigen Wesens zu beliebigen Zwecken überhaupt (folglich in seiner Freiheit) ist die *Kultur*"] (Kant's emphasis. Kant 1971, English translation, part 2, p. 94). Culture embraces such aspects as the ability (intellectual skill, *Geschicklichkeit*) to set goals self-referentially and the will to set such goals freely and in a disciplined manner, which for

Kant means emancipation from the will that springs from the despotism of desire (which is of course just as great a threat to freedom).

Thus, in Kant, tendencies can be found toward the formulation of a broad concept of culture, where the most important structural characteristic is self-reference, and the greatest effect it has is upon the ability to make decisions. But, these tendencies appear only late in his work, and are not fully developed. However, it is still worth discussing whether the concept of culture represents this process in itself (plus its preconditions), or whether it is nothing but a concept for the necessary resources upon which this process must draw. At all events, it is this definition—that culture is meaning, producing and developing itself through self-reference—that I will develop.

Culture: Sociology's Idea of God

Despite the theoretical uncertainty exemplified here, the concept of culture plays a central role in sociology. Culture has become, in an expression to which I will return, sociology's idea of God. It is what makes the impossible—modern society—possible.

Paul Willis wrote in 1977 that culture "is the very material of our daily lives, the bricks and mortar of our most commonplace understandings" (Willis 1977, p. 185). Haralambos and Holborn express themselves even more clearly in their introduction to sociology:

> Many sociologists maintain that shared norms and values are essential for the operation of human society. Since humans have no instincts, their behaviour must be guided and regulated by norms. Unless norms are shared, members of society would be unable to co-operate with or even to comprehend the behaviour of others. Similar arguments apply to values. Without shared values, members of society would be unlikely to co-operate and work together. With differing or conflicting values they would often be pulling in different directions and pursuing incompatible goals. Disorder and disruption may well result. Thus an ordered and stable society requires shared norms and values. (Haralambos and Holborn 1995, p. 6)

With a not unfamiliar circular argument, the possibility of society is based on the existence of culture, while culture is justified by saying that society would be impossible without it. Culture is the answer to the unanswerable. We thus return to what, since Georg Simmel's *Soziologie* at the beginning of the twentieth century—indeed since Hobbes, according to Luhmann—has been the fundamental problem of sociology: "Wie ist Gesellschaft möglich?" (Simmel 1968). The question has

as a rule been answered with a postulatory "because!"—a "because" that, as pointed out, has often been given the name "culture."

The Concept of Culture: Between Closure and Openness

The question is now, of course, *why* it is so difficult to define the concept of culture. It seems to me to be because the concept has had to replace the concept of "God." "Culture" seems to have become our secularized God.

By this I mean that the point of departure for a modern concept of culture is that modern society is characterized by ever-increasing functional differentiation. If humans and the social institutions differentiate themselves from a cohesive community, they are forced to find something *else* that gives them identity, goes the usual argument. This is quite simply essential if they are to regard themselves as human beings or as social institutions. People, for example, are no longer human in the sense of being identical with something nonhuman, by being the children of God; therefore, they must be human by virtue of something else, and this something else has, among many other names, been given the name "culture." If a function that has previously been fulfilled through membership in a community is separated from this community, then this function must perpetuate itself through itself. It can no longer perpetuate itself by referring to something outside itself; therefore it must do so by turning inward and referring to itself.

In reality, however, this creates a dilemma: On the one hand, such differentiated functions must perpetuate themselves by referring to themselves, that is, by establishing a systematic closure from the surrounding world. On the other hand, this isolation from the global community forces them to create a medium whereby they can communicate across the differentiated local communities.

The Vanishing Concept of Culture

One aspect of the traditional concept of culture is that "it" gives a functionally differentiated institution identity. Something specific in society is given the status of a universal social identity, often in the sense that one specific institution, functional subsystem or social group generalizes its specific identity into becoming "society's identity."

The German cultural analyst Ernst Cassirer argued long ago against this false generalization in the introduction to his great *Philosophie der symbolischen Formen*: "The various manifestations of intellectual cul-

ture, language, scientific knowledge, mythology, art, religion, thus become, for all their internal differences, elements of one single great complex of problems—become a multiplicity of approaches, all tending toward the single end of transforming the passive world of pure impression in which the mind at first seems caught, into a world of pure intellectual expression" (Cassirer 1964, p. 12, my translation). The alternative is that the philosophy of the intellectual forms of the individual functionally differentiated subsystems must "result in their history, which depending on the object will represent and specify itself as the history of language, of religion and myth, of art, etc." (Cassirer 1964, p. 16, my translation). It should be emphasized that Cassirer does not stop at this differentiation; I will return to this later in the chapter.

A "cultural theory" that wishes to reflect the functional differentiation of modern society should thus stop calling itself cultural theory and instead deal with the social differentiation of the individual subsystems. This is the project proposed by Niklas Luhmann in a kind of manifesto to the introduction of the first of the three volumes of *Gesellschaftsstruktur und Semantik*: "In the following we abandon the thesis that culture or the semantic-symbolic complex is a distinct differentiable system of action (. . .). For us, weaker, less overdetermined concepts like compatibility, the limits of compatibility, correlation are sufficient for the formulation of the problem (. . .). The theoretical problem thus shifts to the question of how and by what means the social structure limits the arbitrary. To answer this we need a theory of the forms and consequences of social differentiation" (Luhmann 1980, p. 17). The aim is thus to analyze how society reduces arbitrariness, i.e., complexity. The answer is that arbitrariness is reduced by the differentiation of domains of knowledge, which in itself involves a reduction of complexity in the domains in question, but which at the same time means that the broad overall view is lost. We can "perceive differentiation as a maximisation of internal relations combined with a concurrent minimization of external relations" (Kølsen de Wit 1994, p. 35, my translation). The result is that modern society is a social system that consists of many subsystems differentiated from one another. Drawing on the famous anecdote about Laplace's answer to Napoleon and the place of God in his *Système du Monde*—that he had no need of such a hypothesis—we can say that Luhmann in this phase of his authorship not only had no need of the concept of culture; the concept of culture, with its universalizing demands, conflicted with the assumption of functional differentiation. For Luhmann, it was erroneous as a concept for society, and at best misleading as a concept for social subsystems.

According to the Luhmann of the 1980s, the consequence was that the concept of culture had been rendered superfluous as anything but a kind of reservoir of possible themes, ready for the quick resumption of specific communicative processes. Culture has in other words been reduced to society's "theme larder" (Luhmann 1984, p. 224). As we shall see in the following and concluding section of the chapter and the book, this marginalization of the concept of culture changed. "Culture" has again moved into the center of social theory—not, however, as a substance in or basis of society, but as a special, second-order medium in society, as the medium through which society observes culture as observation medium, i.e., as a medium through which society aims at doing the impossible: to observe itself from a position outside society.

Conclusion: Culture as Second-Order Conditionalizer

Memory as the Frame for Variation of Future Actions

Any society refers to its own, self-produced memory, its "past" or "history." Within the particular form of self-reference operating in the form of the difference between past and present, "culture" can be defined as the "optical instrument," which translates memory into a frame for variation of future actions, thereby reducing complexity with regard to what is and isn't possible (Luhmann 1997, in particular the section on memory, pp. 576–594; here and in the following I am also informed by Baecker 2000).

As we have seen in the preceding sections, this definition of culture does not conform to traditional definitions of the word. According to tradition, culture is the essence of common past or common practice: that which makes us identical. However, in a hypercomplex society, such a total formula does not exist anymore. "Hegel had, as is well known, no heirs" (Luhmann 1997, p. 592). Consequently, a society that has become so complex that it cannot reproduce such a fixed point spontaneously must reform the concept of culture as that necessary common sorting mechanism, the function of which is that while nothing is predictable, not everything is possible. In other words, culture is a particular way—a second-order "socio-optical device"—of managing complexity. In a hypercomplex society, culture has become a concept of comparability: "Through the concept of culture the orientation toward identity is transformed into comparability and thus mobilized. (. . .) It

seems that our culture operates in such a way that it reads differences into the future, that is, ways of distinguishing which provide frames within which the future can oscillate" (Luhmann 1997, pp. 590 and 592, my translation).

The History of the Concept of Culture

The development of the concept of culture, analyzed above, can be read into the scheme of the social semantics of the traditional, the modern and the hypercomplex society.

In a traditional society, "culture" was only used as a form of specification: One talked about "agriculture" and meant the cultivating interaction with land and nature, and during the early Middle Ages one labeled Christianity the *cultura dolorum*, a culture of suffering (Baecker 2000a). But, does this imply, as Dirk Baecker concludes in his stimulating book *Wozu Kultur?* that this represented a particular definition and use of the concept "culture"? No, it is my opinion that by using the concept in this way, one referred to something different from what we do today. Thus, "culture" in this sense does not refer to a phenomenon in the traditional society that can be compared to a similar phenomenon in our current society. Rather, this understanding of the use of "culture" in the traditional society is *our* interpretation of a word, which was used in a literal sense for the management of land, or the transformation of religious doctrines. I would rather suggest that the concept of culture was not at all used for those phenomena that we today would call "culture." One distinguished between "us" and "them," human beings and barbarians, civilized people and wild species. With reference to Spencer Brown's concept of form, this implies that a simple distinction between us (the marked state) and the other (the unmarked state) was made, without reentering this distinction into itself. The others were unobservable, at least as culture.

It is precisely the reentry of the distinction into itself that marks the transformation into a modern use of the concept of culture. More precisely, one might say that the concept of culture was used in order to operationalize this reentering of the distinction into itself. According to Dirk Baecker, the German natural rights philosopher Samuel von Pufendorf seems to have been the first who changed the meaning of culture from something referring to agriculture to its becoming a basic social substantive. In his considerations concerning natural rights, von Pufendorf talks about culture as a designation of human civilization. For von Pufendorf, civilization represents a state

of human happiness in contrast to the unhappy natural state, in which human beings were bound by the necessities of nature. The human being has become free, and this freedom to be able to cultivate oneself, that is, to emancipate oneself from the state of being oppressed by internal and external nature (an act, which later by Kant is related to enlightenment), is labeled "culture" (Baecker 2000a, p. 44 and, almost identically, p. 64).

Approximately one hundred years later Jean-Jacques Rousseau turns this figure upside down, and in his *Discours sur les sciences et les arts*, he evaluates the natural state as the happy one, because it represents authenticity, while the cultural state creates unhappiness, because here human beings have lost their natural identity. Despite the differences, the important question is not whether one state or the other is better. The important fact is that society differentiates itself into culture and society (cf. Luhmann 1995a), and that this differentiation represents an anthropocentric doubling of society: The human being can as human being observe itself as a nature-being and as a civilized being, and can compare these two states of being. In this way, modern human beings have achieved the possibility to make comparative studies of both a geographical and a historical character: They can compare themselves with others, and they can compare their present state with earlier states. They can—to return to the concepts of Spencer Brown—reenter the traditional distinction between us (the marked state) and the other (the unmarked state) into itself, and thus observe the others as representatives of other cultures, or they can observe themselves as others, that is as "wilds." The concept of culture developed into a plural concept of cultures, which culminated in the Romantic period's celebration of authenticity, be it represented by foreign cultures or by history's golden ages.

How can culture be characterized today, in our current hypercomplex condition? Some would say that the modern concept of culture has been radicalized. I would go the whole length and suggest that we have witnessed yet another transformation of the concept of culture. During the twentieth century, the concept emancipated itself from its anthropocentric roots, that is, from its basis in the difference between good and bad. This implies that today culture can be observed in itself. Consequently, we do not ask whether one or the other culture is good or bad, but we ask whether the cultural optics that differentiate (or do not differentiate) between good and bad are good or bad. In the words of Spencer Brown, we observe culture as form, that is, as a distinction

between a marked and an unmarked state, which reenters the difference into itself. We have discovered that, for culture also, there can be no distinction without motive, and we are observing the motive of culture within a new optical distinction—Is our cultural distinction good or bad?

As a consequence, the concept of culture has emancipated itself and can be exploited as a political tool and as a management concept. Cultural politics have become nonnormative, and cultural management is one among other decision-making tools helping modern managers to reduce complexity, by using the concept of culture to frame the decision making of their employees. Normally, this is called a decentralization of decision making, but we have seen that it is more precisely a way of transforming memory (real or constructed) into a frame for the oscillation of decision making.

Dirk Baecker has identified the ambiguous character of this concept of culture. On the one hand, it represents the knowledge that all life-forms in our contemporary society are contingent, that is could be different. On the other hand, this concept of culture does this only indirectly or "secretly," because it does so through identity and orientation. When we compare one fashion with another, one life-form with a foreign life-form, we do so partly with the opinion that everything is equally valid, partly through a concept of culture, which signals that one can make a distinction between us and them. This is properly the result of being in a social-semantic transition phase between an anthropocentric and a polycentric interpretation of culture.

Table 6

	Theocentrism	Anthropocentrism	Polycentrism
Name	Culture	Cultures	"Culture"
Observation structure	Observation of "us" versus "the other"	Observation of "cultures" (including the observer's own culture)	Observation of "culture" as observation medium
Function	World structuring into civilized versus wild: Stability through maintenance of "natural identity"	World structuring into center versus periphery: Stability through maintenance of social identity	Creation of comparability: Dynamic stability through comparabilization of differences

However, if this is true, the consequence is that the polycentric concept of culture must be supplemented by another concept, which can provide an orientational function that the concept of culture can no longer give us. If this step is not taken, the concept of culture seems to undermine itself. If one states that one is a religious believer, one must always include the possibility that other observers will ascribe one other motives. Thus, religious declarations cannot be spontaneous, but will always be calculated, at least for the reason that others will observe them as calculated. When an aesthetic judgment is made—or just a judgment of taste—it is always necessary to include the possibility that it could have been different. Any action must expect to be interpreted by somebody, and it must interpret itself—yes, it must indeed choose itself—under the consideration of potential interpretations. With an unusual evaluation Luhmann has emphasized the "corrupting consequences" of this development, that society doubles its self-observation so that it not only observes itself through religion, economics, politics, art, etc., but also observes the religious, economic, political, and artistic observations as culture, that is, as observational forms that could have been different.

It is not difficult to understand why culture has developed into this present state, and we saw a parallel development of art in chapter 3. With this concept of culture, enormous amounts of complexity-management resources have been released, and this has in particular given us a set of organizational management concepts and tools that make it possible to let employees with their qualifications, competencies, and creativity operate as a processing system, which could be different, and which is therefore adjustable without being handicapped by the adjustments.

However, the negative impact of this concept of culture is that it has precluded itself from making the decision of whether we should choose one or the other possibility. Consequently, this decision must be made by another instance. We have to supplement the concept of culture, which has become so operational that it has lost its ability to make decisions, with another concept. For this purpose the American philosopher Richard Rorty has put forward the concept of appreciation, which represents that action that attaches the distinction "good/bad" with a given form of decision—but which always adds that although this distinction could have been made otherwise, appreciation cannot be appreciated. As—according to Spencer Brown—there can be no distinction without motive, a motive that can be motivated only through a distinction, the spiral ends with an open potentiality. But it ends.

For me, it is the ability to combine this second-order concept of culture with an operation of appreciation that is open, but still cannot be reentered into itself that characterizes the modern, educated human being. The nonendless recursive ironist, he or she could be coined—or the serious ironist.

Notes

Introduction

1. Which, as a matter of fact, was then modified into American-English by the equally careful copy editor Rodney Williams.

1. The Hypothesis of Hypercomplexity

1. Gunther Teubner has attempted to specify this difference in more detail. He says that where Foucault maintains that each given historical period is constituted by a given episteme, Luhmann talks about "modernity's multiplication of epistemes in society"; see Teubner 1989, p.737.
2. An extract from *De hominis dignitate* in Elizabeth Livermore Forbes's translation in *Journal of the History of Ideas* 3, 1942, p. 348. Cassirer's article in *Journal of the History of Ideas* 3, 1942, p. 320, uses J. A. Symonds's translation: "Thou, restrained by no narrow bounds, according to thy own free will, in whose power I have placed thee, shalt define thy nature for thyself." In his German treatise *Individuum und Kosmos in der Philosophie der Renaissance* (1927, cf. note 2) Cassirer bases his version partly on Burckhardt's translation. The result is: "Dich allein bindet keine Schranke, es sei denn, dass Du selber nach deinem Willen, den ich Dir verliehen, sie Dir vorschreibt."
3. In the following I build upon Ernst Cassirer (1927), and especially upon his "Giovanni Pico della Mirandola: A Study in the History of Renaissance Ideas," in *Journal of the History of Ideas* 3, 1942, pp. 123–144 and 319–346. The later article has also been published in Paul Oskar Kristeller and Philip P. Wiener (eds.) (1968) (page references are to this edition). The second part of this long article deals in particular with Pico's oration *De hominis dignitate*. It is also followed in the original periodical by a seven-page translated extract from Pico's speech—the first translation into English. Cassirer's reading of Pico, as the proclaimer of the modern contrasts with Avery Dulles's analysis of Pico, as the writer who so to speak concludes medieval society. Cf. Avery Dulles (1941), *Princeps Concordiae. Pico della Mirandola and the Scholastic Tradition.* Dulles's claim that Pico was a premodern realist is refuted by Cassirer 1942,

p. 123. There are of course strong traces of Scholasticism in Pico, but his thinking has a quite different, forward-looking thrust.
4. This problem is thematized in Umberto Eco's book *Foucault's Pendulum*: Modern man has always sought the center of the world, and has never found it, because the center is everywhere.
5. Consequently, I do not make a distinction between "simple" and "reflexive" modernity, but between modernity and hypercomplexity. Thus, concerning this issue I differ from the analysis proposed by Ulrich Beck (1986) in *Risikogesellschaft: Auf dem Weg in eine andere Moderne*. However, I find many of his observations interesting and valuable. Similar attempts to move from the analysis of a "simple" to a "reflexive" modernity can be found in Anthony Giddens (1990 and 1991), cf. *The Consequences of Modernity* and *Modernity and Self-Identity in the Late Modern Age*. These affinities between Beck and Giddens found expression in a joint publication: Ulrick Beck, Anthony Giddens, and Scott Lash (1994), *Reflexive Modernization: Politics, Tradition and Aesthetics in the Modern Social Order*.
6. Quoted from Petrarch: "On His Own Ignorance," in E. Cassirer, P. O. Kristeller, and J. H. Randall, Jr. (1948) p. 105f. See Plato's definition of the good or virtue—*areté*—as the highest power, for example in Socrates's dialogue with Meno.
7. A simple example can be found in Prusak and Cohen 1998, pp. 137–160.

3. The Aesthetic Self-Observation of the Hypercomplex Society: Theocentrism, Anthropocentrism, and Polycentrism

1. Cf. Lillian Schwartz's computer reproduction of the refectory with Leonardo's decorations on the long wall, continuing "into" the picture and thus creating a strong illusion (Schwartz 1995, p. 82).
2. Or, more correctly, any differences in size rather express a difference in rank or importance than in spatial distribution.
3. As a consequence of this, the churches have nowadays been turned into museums, while the art museums have become temples where divine art—or works of art as the representatives of divine artists—are worshipped.
4. As an illustration of this, in the famous musical *Jesus Christ Superstar* Judas is the actual main character. Also, the story ends before the resurrection of Jesus.
5. Niklas Luhmann has discussed this in a number of works. Cf. for example Luhmann et al. (1990).
6. The same issue is presented by Luhmann in the final section of his book on art, *Die Kunst der Gesellschaft*, in a systems theoretical discourse. The difference is illustrating: "With growing freedom, the uncertainty of criteria will increase, and distinguishing between success and failure in art will become more difficult. (. . .) However, so long as the autonomy of the art system prevails, there will always be a medium that motivates the search for convincing forms. If anything is possible, then the criteria for selecting what is admissible must be tightened. In the long run, handing out commuters' passes instead of

a selection can hardly satisfy. Only the overcoming of difficulties makes a work significant: Hoc opus, hic labor est." (Luhmann 2000, p. 315).
7. The major work is Niklas Luhmann 1995, *Die Kunst der Gesellschaft*. In addition one can mention Niklas Luhmann 1994b, *Die Ausdifferenzierung des Kunstsystems*, which contains an interesting interview with Luhmann. Last but not least, I would recommend the article by Niklas Luhmann (Luhmann 1990b) devoted to contemporary art in particular "Weltkunst."
8. In addition to Luhmann, in aesthetic theory this idea has been explored by, e.g., Gilles Deleuze (1968) and Jean-François Lyotard (1983).
9. This artwork has been analyzed by Anne-Marie Duguet, and the following discussion is inspired by personal conversation with her.
10. From what in an artistic perspective would be a technological nowhere.

4. The Pure Self-Observation of the Hypercomplex Society: The Emerging Orthodoxy of Paradoxicality

1. In fact one can find the very first expression of a heliocentric view in Copernicus's *Commentariolus*; cf. Gingerich 1993 pp. 28 and 163.
2. Ibn al-Haytham is also known as Alhazen, which is the "European" version of Ibn al-Haytham. Averroës is also known under the name of Ibn Rushd, which simply means "son-in-law." It was Averroës who claimed that propositions may be philosophically true although they are theologically incorrect, thus making an important contribution to the secularization of science and to its differentiation as a system enclosed in itself based on the code of true/false.
3. It is difficult to date the origin of the work exactly; cf. Sabra in al-Haytham 1989. In the references I give the date as A.D. 1030. The first Latin translations are based on Arabic copies of the manuscript from 1083–84.
4. Such reflections have once again become popular today with second-order cybernetics; cf. for example von Foerster 1981, Luhmann 1988b, and Luhmann 1990a.
5. This is the question that Searle discusses in his book in the context of a linguistic philosophy. Cf. Searle 1995.
6. Others have dated the event 1413 or 1425, cf. Kubovy 1986.
7. The idea that there is a direct line of development from Brunelleschi via Alberti to artists has developed into established fact in art history—cf. White 1967, pp. 113–121; Kubovy 1986, pp. 32–52; Kemp 1990, pp. 11–14; and Pirenne 1970, p. 182.
8. For example Cecil Grayson writes that "there is no real confirmation, which can support this assertion, except from the experiments, which are described in his biography 'Life' by Manetti, and if it were true that these experiments had been carried out, they provide no instruction as to how to repesent a three dimnesional space on a two dimensional surface" (cf. Grayson's introduction to the reprint of the translation of Alberti's books on painting and sculpture, in Alberti 1972, p. 11. There is also an interesting discussion in Elkins 1992).
9. To add yet another aspect to the matter, it can be mentioned that mass attraction as "action at a distance" was perceived as something occult. In public, Newton refused to present any hypothesis on the nature of mass attraction,

but privately, according to Gingerich, he wrote to Richard Bentley: "That mass attraction should be a thing's immanent and essential phenomenon, such that a body can influence another at a distance through a vacuum, without any communication whatsoever, through the help of and through the action and power which can be transferred from one to the other, is for me so great an absurdity, that I don't believe any person with a philosophical, competent ability to think of such matters could fall for it" (quoted from Gingerich 1993 p. 151).

10. In a postscript to his book Gingerich confirms that this is probably its most important result. In articles written by Gingerich in the period 1972–1989 he "investigates in many different ways the idea, that Copernicus's intuitive spring towards a helio-centric cosmology was a decision arrived at in his thoughts, in opposition to the obviously sense-based perception and proposal in the lack of any physical proof whatsoever. They make in other words a well-constructed argument against the empirical view of the sixteenth century scientific revolution" (Gingerich 1993 p. 423). For that very reason a more detailed examination of the sociocultural background of Copernicus's scientific revolution is important.

11. Although both artistic and scientific development had important religious significance, I have not discussed the reactions of the church. Often the inherent implications that I have pointed out were not clear to contemporary society. However, the heliocentric cosmology was condemned as soon as it was realized that it was a model of reality. "As long as helio-centrism was understood to be an appropriate fiction, its study constituted no threat for the men of the cloth." But "the holy church's Decree no. XIV, made on the 5 March 1616, brought *De revolutionibus* onto the list *donec corrigatur*, until possible changes" (Gingerich 1993, p. 273f).

12. Warren Weaver is most well known for popularizing Claude E. Shannon's mathematical information theory. This will be returned to later.

13. Luhmann also attempts many other places "to remove the heroic" from contemporary society. On the basis of the classical concept of integration, this kind of society is "disintegrated" because it is not orientated toward some kind of substantial concept of unity. On the basis of a systems-theoretical understanding, this kind of society is perhaps more appropriately "overintegrated" and therefore under threat. "It has quite certainly on the basis of the functional system's autopoiesis a stability beyond comparison (...). But at the same time it is also able to irritate itself to a degree not found in previous societies. A large number of structural and operative connections ensure the mutual irritation of the part-systems, and total systems have—based upon their form of functional differentiation—given up the attempt to intervene and regulate this process" (Luhmann 1997, p. 618).

5. Communication, Media, and Public Opinion of the Hypercomplex Society

1. Cf. Mortensen 1973; Sereno and Mortensen 1970; Dimbleby and Burton 1992; McQuail and Windahl 1993. In its "Basic Models" chapter the last

mentioned book presents a number of these transport and transmission oriented models cf. pp. 13–53, but with only a single paragragh on alternative approaches, cf. pp. 54–57. One of the most up-to-date and complex versions is arguably found in McQuail 1975. The formalized version of it is in Price 1996, pp. 38–45. The book however presents many alternative approaches. Even in the supposedly revised book by Crowley and Mitchell 1994, the chapter by William Leiss: "Risk Communication and Public Knowledge" (pp. 127–139) openly returns steadily to transmission theory, which is quite surprising because Klaus Krippendorff in the same book (pp. 78–104) also explicitly presents a constructionist theory, cf. the article "A Recursive Theory of Communication."

2. The first version can be found in Katz and Lazersfeld 1955. Here the "opinion makers" are introduced as a step between dissemination media and the public.
3. An early version of this theory is found in the collection of articles edited by Blumler and Katz 1974.
4. In the development of this theory, the Danish media researcher Klaus Bruhn Jensen has played a prominent role; cf. Jensen 1991.
5. It should be emphasized that Shannon's mathematical theory of communication should not be understood as a communication transfer theory. Rather, it is based on probability and is thus much more in line with a constructivist theory of communication; cf. Baecker 2000.
6. Although the following is inspired by Luhmann's theory of communication, it is as already stated different from this theory. What I present is not a theory of social systems as systems of communication, but a theory of communication as the structural coupling of mutually closed psychic systems.
7. While my theory of communication is different from Luhmann's sociological communication theory, in this section on symbolically generalized media I intend to summarize Luhmann's analyses of functionally differentiated systems such as the economic system (Luhmann 1988a), the political system (Luhmann 2000a), the scientific system (Luhmann 1990), the judicial system (Luhmann 1993), the art system (Luhmann 1995), the religious system (Luhmann 2000b), the mass media system (Luhmann 1996/2000), the educational system (Luhmann 2002), and the love system (Luhmann 1982). In his introduction from 1996 to Luhmann's oeuvre, Detlef Krause has provided a similar overview (Krause 2001, pp. 40–49).
8. It should be noted that Luhmann uses the concept of information according to Shannon's definition: Information is a function of improbability.
9. The following is based upon the theory of publicity and public meaning as developed in recent systems theory. Niklas Luhmann has written a few articles about public opinion and the public sphere, cf. Luhmann 1990b, pp. 170–182; Luhmann 1992a, pp. 77–86; Luhmann 1996, pp. 183–189, about the public. Last, but not least, Luhmann deals with the subject in Luhmann 2000a, particularly chapter 8. However, the most thorough article on the topic from the perspective of systems theory is probably Baecker 1996. The following is inspired by Dirk Baecker's analysis.
10. It must be underlined that the indisputable principle for public observation doesn't make it disappear or "implode into itself." Baudrillard overinterprets this aspect of publicity's observation when he concludes that it leads to the

216 *The Hypercomplex Society*

disappearance of the social or that public meaning takes upon itself a veil of silence. Public observation means a particular observation, and not an "observation of disappearance." The reader is referred to Jean Baudrillard 1983.

6. The Communication Medium of the Hypercomplex Society: The Digital Network

1. As already dealt with in chapter 5, this is a basic subject of Luhmann's work and has been presented in many books and articles. However, it has been summarized in his last *opus magnum, Die Gesellschaft der Gesellschaft*, with its specific focus on the impact of distribution media; cf. Luhmann 1997, pp. 190–412.
2. Source: Internet Software Consortium (http://www.isc.org/). Cf. also Network Wizards http://www.nw.com/zone/host-count-history. It should be noted that the figures are based on two different surveys. Up till 1997, the Internet Software Consortium used a survey method that counted the number of domain names that had IP addresses assigned to them. However, as more and more organizations restricted download access to their domain data, from January 1998 a new survey method was launched. This survey counts the number of IP addresses that have been assigned a name. Although the latter method gives a more realistic number, it should be kept in mind that data from the old and new surveys is not directly comparable.
3. Cf. Luhmann1964; Luhmann 1968a; Luhmann 1968b. See also Horster's interview with Luhmann in Horster 1997, p. 34f.

7. The Culture of the Hypercomplex Society

1. It was Gorm Harste who drew my attention to this in his working paper *Verdensborgerret*, 1993. But I read both Elias and Kant slightly differently from Harste in his paper, which is basically not concerned with the concept of culture.

Bibliography

Aarseth, Espen J. (1997). *Cybertext. Perspectives on Ergodic Literature.* The John Hopkins University Press. Baltimore and London.
Adorno, Theodor W. (1966). *Negative Dialektik.* Suhrkamp Verlag. Frankfurt [English translation (1973) *Negative dialectics.* Routledge & Kegan Paul. London.
Adorno, Theodor W. (1970). *Ästhetische Theorie.* Suhrkamp Verlag. Frankfurt.
Alberti, Leon Battista (1972). *On Painting and On Sculpture.* Cecil Grayson (ed.), Phaidon. London (translated from *Della Pittura* [first published 1435]).
al-Haytham, Ibn (1989). *The Optics of Ibn al-Haytham,* translated with an Introduction and Commentary by A. I. Sabra. The Warburg Institute. London [first published 1083].
Andersen, Peter Bøgh (1994). "The semiotics of autopoiesis. A Catastrophe-theoretic approach," in *Cybernetics & Human Knowing* 2, 4, pp. 17–36.
Andersen, Peter Bøgh (1998). "WWW as Self-organizing System," in *Cybernetics & Human Knowing* vol. 5 no 2.
Baecker, Dirk (1993a). *Kalkül der Form.* Suhrkamp Verlag. Frankfurt.
Baecker, Dirk (1993b). *Probleme der Form.* Suhrkamp Verlag. Frankfurt.
Baecker, Dirk (1993c). "Im Tunnel," in Dirk Baecker (ed.): *Kalkül der Form.* Suhrkamp Verlag. Frankfurt. Pp. 12–37.
Baecker, Dirk (1996). "Oszillierende Öffentlichkeit," in Rudolf Maresch (ed.): *Medien und Öffentlichkeit. Positionierungen, Symptome, Simulationsbrüche.* Klaus Boer Verlag. Munich.
Baecker, Dirk (2000). "Die Theorieform des Systems," in: *Soziale Systeme* 6, vol. 2, pp. 213–136. Leske + Budrich. Opladen.
Baecker, Dirk (2000a).*Wozu Kultur?* Kulturverlag Kadmos. Berlin.
Bak, Per (1996). *How Nature Works. The Science of Self-Organized Criticality.* Springer Verlag. New York.
Bateson, Gregory (1991). *Sacred Unity. Further Steps to an Ecology of Mind.* Harper Collins. New York.
Bateson, Gregory (2000). *Steps to an Ecology of Mind.* The University of Chicago Press. Chicago and London [First edition: Bateson, Gregory (1972). *Steps to an Ecology of Mind.* Ballantine Books. New York].
Baudrillard, Jean (1983). *In the Shadow of the Silent Majorities, or The End of the Social, and other Essays.* Semiotext(e). New York.

Baudrillard, Jean (1987). *L'autre par lui-même*. Éditions Galilée. Paris.
Beck, Ulrich (1986). *Risikogesellschaft: Auf dem Weg in eine andere Moderne*. Frankfurt [English translation (1992). *Risk Society. Towards a New Modernity*. Sage Publications. London].
Beck, Ulrich, Anthony Giddens & Scott Lash (1994). *Reflexive Modernization. Politics, Tradition and Aesthetics in the Modern Social Order*. Polity Press. Cambridge.
Bell, Daniel (1960). *The End of Ideology. On the Exhaustion of Political Ideas in the Fifties*. The Free Press. New York.
Bell, Daniel (1973). *The Coming of Post-Industrial Society. A Venture in Social Forecasting*. Basic Books. New York [new edition with new foreword by Daniel Bell 1999].
Bell, Daniel (1976). *The Cultural Contradictions of Capitalism*. New York.
Bell, Daniel (1979). "The Social Framework of the Information Society," in Michael L. Dertouzos and Joel Moses (eds.). *The Computer Age: A Twenty-Year View*. The MIT Press. Cambridge, Mass. Pp. 163–211 [also in Tom Forester (ed.): *The Microelectronics Revolution*, Basil Blackwell, Oxford, 1980, pp. 500–549].
Berners-Lee, Tim (with Mark Fischetti) (2000). *Weaving the Web*. Texere. London and New York.
Blaug, Mark (1962). *Economic Theory in Retrospect*. Cambridge University Press. Cambridge.
Blumler, J. G. and E. Katz (eds.) (1974). *The Uses of Mass Communications*. Sage. Beverly Hills.
Brown, George Spencer (1971). *Laws of Form*. George Allen and Unwin. London [first edition 1969. German translation (with new introductions and appendices): Spencer-Brown, George (1997). *Gesetze der Form*. Joh. Bohmeier Verlag, Lübeck].
Burns, Tom (1992). *Erving Goffman*. Routledge. London and New York.
Carey, James W. (1989). *Communication as Culture*. Unwin Hyman. Boston.
Cassirer, Ernst (1927). *Individuum und Kosmos in der Philosophie der Renaissance*. B. G. Teubner. Leipzig and Berlin.
Cassirer, Ernst (1942). "Giovanni Pico della Mirandola. A Study in the History of Renaissance Ideas," in *Journal of the History of Ideas* 3. Pp. 123–144 and 319–346.
Cassirer, Ernst (1964). *Philosophie der symbolischen Formen*. Wissenschaftliche Buchgesellschaft. Darmstadt [first edition 1923].
Cassirer, Ernst, P. O. Kristeller, and J. H. Randall, Jr. (1948). *The Renaissance Philosophy of Man*. University of Chicago Press. Chicago.
Castells, Manuel (1996). *The Rise of the Network Society*. Blackwell Publishers. Malden, Mass. and Oxford, UK.
Castells, Manuel (1997). *The Power of Identity*. Blackwell Publishers. Malden, Mass. and Oxford, UK.
Castells, Manuel (1998). *End of Millennium*. Blackwell Publishers. Malden, Mass. and Oxford, UK.
Castells, Manuel (2001). *The Internet Galaxy. Reflections on the Internet, Business, and Society*. Oxford University Press. Oxford.
Crowley, David and David Mitchell (eds.) (1994). *Communication Theory Today*. Polity Press. Cambridge.
Dahrendorf, Ralf (1968). *Homo Sociologicus: ein Versuch zur Geschichte, Bedeutung und Kritik der Kategorie der sozialen Rolle*. Westdeutscher Verlag. Opladen.

Dehlholm, Kirsten, Per Theil, and Lars Qvortrup (2003). *Hotel Pro Forma* [Danish and English version]. Arkitektens Forlag. Copenhagen.
Deleuze, Gilles (1983). *Cinéma 1. L'Image-Mouvement*. Les Editions de Minuit. Paris [English translation (1986): *Cinema 1. The Movement-Image*. The Athlone Press. London].
Deleuze, Gilles (1985). *Cinéma 2. L'Image-Temps*. Les Editions de Minuit. Paris [English translation (1989): *Cinema 2. The Time-Image*. The Athlone Press. London].
Deleuze, Gilles (1994). *Difference and Repetition*. Columbia University Press. New York [translated from *Différence et Repetition*. Presses Universitaires de France. Paris 1968].
Dertouzos, Michael (1997). *What Will Be*. HarperEdge. New York.
Dimbleby, Richard and Graeme Burton (1992). *More Than Words. An Introduction to Communication*. Routledge. London and New York [first edition 1985].
Drucker, Peter F. (1989). *The New Realities*. Butterworth Heinemann. Oxford.
Duguet, A.-M. (1997). "Jeffrey Shaw: from expanded cinema to virtual reality," in Shaw, J. and A.-M. Duguet *Jeffrey Shaw: A User's Manual*. Edition Cantz. Bonn.
Dulles, Avery (1941). *Princeps Concordiae. Pico della Mirandola and the Scholastic Tradition*. Cambridge, Mass.
Durkheim, Émile (1982). *The Rules of Sociological Method*. Macmillan. London [first published 1895].
Eco, Umberto (1988). *Il pendolo di Foucault*. Bompiani. Milan.
Eco, Umberto (1995). *The Search for the Perfect Language*. Blackwell. Oxford UK and Cambridge, Mass.
Elkins, James (1992). "Renaissance Perspectives," in *Journal of the History of Ideas* 53. Pp. 209–230.
Elias, Norbert (1969). *Über den Prozess der Zivilisation*. Verlag Franke AS. Bern.
Enzensberger, Hans Magnus (1993) *Aussichten auf den Bürgerkrieg*. Suhrkamp Verlag. Frankfurt.
Ferry, Luc (1992). *Le nouvel ordre écologique : L'arbre, l'animal et l'homme*. Grasset. Paris.
Foerster, Heinz von (1984). *Observing Systems*. Intersystems Publications. Seaside Calif.
Foucault, Michel (1975). *Surveiller et punir*. Gallimard. Paris [English translation (1991): *Discipline and Punish. The Birth of the Prison*. Penguin Books. London].
Fuchs, Peter and Luhmann, Niklas (1989). *Reden und Schweigen*. Suhrkamp Verlag. Frankfurt.
Gates, Bill (1995). *The Road Ahead*. Viking. England.
Giddens, Anthony (1990). *The Consequences of Modernity*. Stanford University Press. Stanford, Calif.
Giddens, Anthony (1991). *Modernity and Self-Identity. Self and Society in the Late Modern Age*. Stanford University Press. Stanford, Calif.
Giddens, Anthony (1993). *Sociology*. Second Edition. Polity Press. Cambridge [first published 1989].
Gingerich, Owen (1993). *The Eye of Heaven. Ptolemy, Copernicus, Kepler*. The American Institute of Physics. New York.
Goffman, Erving (1971). *Relations in Public*. Allen Lane. London.
Günther, Gotthard (1976, 1979, and 1980). *Beiträge zur Grundlegung einer operationsfähigen Dialektik* Vols. 1–3. Felix Meiner Verlag. Hamburg.

Habermas, Jürgen (1962). *Strukturwandel der Öffentlichkeit. Untersuchungen zu einer Kategorie der bürgerlichen Gesellschaft.* Hermann Luchterhand Verlag. Neuwied. [English translation (1989) *The Structural Transformation of the Public Sphere. An Inquiry into the Category of Bourgeois Society.* Polity Press. Cambridge].

Habermas, Jürgen (1981). *Theorie des kommunikativen Handelns.* Suhrkamp Verlag. Frankfurt.

Habermas, Jürgen (1985). *Der philosophische Diskurs der Moderne.* Suhrkamp Verlag. Frankfurt.

Haralambos, Michael and Martin Holborn (1995). *Sociology. Themes and Perspectives* (fourth edition). Collins Educational. London.

Harste, Gorm (1993).*Verdensborgerret* [Cosmopolitan Rights]. Menneske & Natur, Working Paper 31. Odense University. Odense.

Hart, Jeffrey A., Robert R. Reed, and François Bar (1992): "The Building of the Internet. Implications for the Future of Broadband Networks," in *Telecommunications Policy.* Vol. 16, 8. Pp. 666–689.

Hauser, Arnold (1964). *Der Manierismus.* Beck. Munich.

Hiltz, S. R. (1984) *Online Communities. A Case Study of the Office of the Future.* Ablex Publishing Corporation. Norwood, N.J.

Hjelmslev, Louis (1943) *Omkring Sprogteoriens Grundlæggelse.* [The Foundation of Linguistic Theory]. Akademisk Forlag. Copenhagen.

Horster, Detlef (1997). *Niklas Luhmann.* Verlag C. H. Beck. Munich.

Husserl, Edmund (1963). *Cartesianische Meditationen und Pariser Vorträge.* Husserliana. Bd. 1. Martinus Nijhoff, Haag [first published 1929–1931].

Huws, Ursula, Werner B. Korte, and Simon Robinson (1990). *Telework. Towards the Elusive Office.* John Wiley & Sons. Chichester.

Jensen, Klaus Bruhn (1991). "Reception Analysis: Mass Communication as the Social Production of Meaning," in Jankowski, Nicholas W. and Klaus Bruhn Jensen (eds.), *A Handbook of Qualitative Methodologies for Mass Communication Research.* Routledge. New York.

Johnson, William R., Jr. (1991). "Anything, Anytime, Anywhere: The Future of Networking," in Derek Leebaert (ed.) *Technology 2001. The Future of Computing and Communications.* The MIT Press. Cambridge, Mass.

Jones, Steven G. (1998). *Cybersociety 2.0* Sage Publications. Thousand Oaks, Calif.

Juhler, Mette (unpublished). *Interaktiv multimediekunst—som polygenereret formgivningsproces.* [Interactive Media Art as a Poly-generative Moulding Process] Aalborg University.

Kant, Immanuel (1971). *Kritik der Urteilskraft.* Philipp Reclam Jun., Stuttgart [first published 1790. English translation (1991), *The Critique of Judgement.* Clarendon Press, Oxford, 13. impression.

Katz, E. and P. F. Lazersfeld (1955). *Personal Influence.* Free Press. Glencoe.

Kauffman, Louis H. (1987). "Self-Reference and Recursive Forms," in *Journal of Social and Biological Structure* 10. Pp. 53–72.

Kemp, Martin (1990). *The Science of Art.* Yale University Press. New Haven and London.

Kierkegaard, Søren (1962). *Indøvelse i Christendom.* Collected works vol. 16. Gyldendal. Copenhagen [first published 1848. English translation (1991), *Practice in*

Christianity. Kierkegaard's Writings, vol. XX. Princeton University Press, Princeton, N.J].
Kierkegaard, Søren (1963) *Sygdommen til Døden.* Collected works vol. 15. Gyldendal. Copenhagen [first published 1848. English translation (1980), *The Sickness unto Death.* Kierkegaard's Writings, vol. XIX. Princeton University Press, Princeton, N.J].
Kierkegaard, Søren. *Papirer* (papers) VIII 2, B 193.
Krause, Detlef (2001). *Luhmann-Lexikon.* Lucius & Lucius. Stuttgart [first edition 1996].
Kroeber, A. L. and C. Kluckhohn (1952). Reprint 1963. *Culture: A Critical Review of Concepts and Definitions.* Cambridge, Mass. Random House. New York.
Kristeller, Paul Oskar and Philip P. Wiener (eds.) (1968). *Renaissance Essays.* Harper & Row. New York and Evanston, Ind.
Kubovy, Michael (1986). *The Psychology of Perspective and Renaissance Art.* Cambridge University Press. Cambridge.
Kuhn, Thomas S. (1962). *The Structure of Scientific Revolutions.* University of Chicago Press. Chicago.
Kølsen de Wit, Camilla Inga (1994). *En kybernetisk systemudviklingsteori.* Unpublished thesis. Aarhus University, Århus.
Laing, Andrew (1991). "Changing Business: Post-Fordism and the Workplace." DEGW, London.
Laswell, Harold D. (1948). "The Structure and Function of Communication in Society," in Bryson (ed.), *The Communication of Ideas.* Harper and Brothers. New York.
Latour, Bruno (1994). "On Technological Mediation," in: *Common Knowledge* 3. Pp. 29–64.
Latour, Bruno (1996). "Om aktørnetværksteori" [On Actor Network Theory], in, *Philosophia* 25, 3-4, Århus.
Leinz, Gottlieb (1979). *Die grosse Zeit der italienischen Malerei.* Herder. Freiburg.
Luhmann, Niklas (1964) *Funktionen und Folgen formaler Organisation.* Duncker und Humblot. Berlin.
Luhmann, Niklas (1968a). *Zweckbegriff und Systemrationalität. Über die Funktion von Zwecken in sozialen Systemen.* Tübingen.
Luhmann, Niklas (1968b). *Vertrauen. Ein Mechanismus der Reduktion sozialer Komplexität.* Ferdinand Enke. Stuttgart.
Luhmann, Niklas (1975). "Interaktion, Organisation, Gesellschaft," in *Soziologische Aufklärung 2.* Westdeutscher Verlag. Opladen.
Luhmann, Niklas (1980). *Gesellschaftsstruktur und Semantik. Studien zur Wissenssoziologie der modernen Gesellschaft.* Volume 1. Suhrkamp Verlag. Frankfurt.
Luhmann, Niklas (1980a). "Gesellschaftliche Struktur und semantische Tradition," in *Gesellschaftsstruktur und Semantik. Studien zur Wissenssoziologie der modernen Gesellschaft.* Volume 1. Suhrkamp Verlag. Frankfurt.
Luhmann, Niklas (1981). "Wie ist soziale Ordnung möglich?" in *Gesellschaftsstruktur und Semantik.* Volume 2. Suhrkamp Verlag. Frankfurt.
Luhmann, Niklas (1982). *Liebe als Passion.* Suhrkamp Verlag. Frankfurt.
Luhmann, Niklas (1984). *Soziale Systeme. Grundriss einer allgemeinen Theorie.* Suhrkamp Verlag. Frankfurt. [English translation (1995), *Social Systems.* Stanford University Press. Stanford, Calif.].

Luhmann, Niklas (1988). *Macht.* Ferdinand Enke Verlag. Stuttgart [first edition 1975].
Luhmann, Niklas (1988a). *Die Wirtschaft der Gesellschaft.* Suhrkamp Verlag. Frankfurt.
Luhmann, Niklas (1988b). *Erkenntnis als Konstruktion.* Benteli Verlag. Bern.
Luhmann, Niklas (1990). *Die Wissenschaft der Gesellschaft,* Suhrkamp Verlag. Frankfurt.
Luhmann, Niklas (1990a). *Soziologische Aufklärung 5. Konstruktivistische Perspektiven.* Westdeutscher Verlag. Opladen.
Luhmann, Niklas (1990b). "Gesellschaftliche Komplexität und öffentliche Meinung," in *Soziologische Aufklärung 5: Konstruktivistische Perspektiven.* Westdeutscher Verlag. Opladen.
Luhmann, Niklas (1990b). "Weltkunst," in Niklas Luhmann, Frederick D. Bunsen, and Dirk Baecker (1990). *Unbeobachtbare Welt. Über Kunst und Architektur.* Verlag Cordula Haux. Bielefeld.
Luhmann, Niklas (1991). *Soziologie des Risikos.* Walter de Gruyter. Berlin and New York.
Luhmann, Niklas (1992). *Beobachtungen der Moderne.* Westdeutscher Verlag. Opladen [English translation (1998), *Observations on Modernity.* Stanford University Press. Stanford, Calif.].
Luhmann, Niklas (1992a). "Die Beobachtung der Beobachter im politischen System: Zur Theorie der öffentlichen Meinung," in Jürgen Wilke (ed.): *Öffentliche Meinung: Theorie, Methoden, Befunden. Beiträge zu Ehren von Elisabeth Noelle-Neumann.* Karl Alber. Freiburg.
Luhmann, Niklas (1992b). "What Is Communication?" in *Communication Theory* vol. 2 no. 3.
Luhmann, Niklas (1993). *Das Recht der Gesellschaft.* Suhrkamp Verlag. Frankfurt.
Luhmann, Niklas (1994a). *Kunstsystemets evolution* [The Evolution of the Art System]. Det kgl. danske Kunstakademi. Copenhagen.
Luhmann, Niklas (1994b). *Die Ausdifferenzierung des Kunstsystems.* Benteli Verlag. Bern.
Luhmann, Niklas (1995). *Die Kunst der Gesellschaft.* Suhrkamp Verlag. Frankfurt. [English translation (2000), *Art as a Social System.* Stanford University Press. Stanford Calif.].
Luhmann, Niklas (1995a). "Kultur als historischer Begriff," in *Gesellschaftsstruktur und Semantik: Studien zur Wissenssoziologie der modernen Gesellschaft* band 4. Suhrkamp Verlag. Frankfurt.
Luhmann, Niklas (1996). *Die Realität der Massenmedien.* Westdeutscher Verlag, Opladen [English translation (2000), *The Reality of the Mass Media.* Polity Press. Cambridge].
Luhmann, Niklas (1996a). *Entscheidungen in der 'Informationsgesellschaft.'* Lecture given on November 1, 1996 in Auditorium Maximum der Humboldt-Universität zu Berlin. Berlin.
Luhmann, Niklas (1996b). "Im Gespräch: Niklas Luhmann. 'Wahrheit ist nicht zentral,'" in *Sontagsblatt,* 1996 no. 42.
Luhmann, Niklas (1996b). *Die neuzeitlichen Wissenschaften und die Phänomenologie.* Picus Verlag. Vienna.
Luhmann, Niklas (1996c). "Die Sinnform Religion," in *Soziale Systeme* 2. No. 1. Pp. 3–34.

Luhmann, Niklas (1997). *Die Gesellschaft der Gesellschaft*. Suhrkamp Verlag. Frankfurt.
Luhmann, Niklas (1997a). *Iagttagelse og paradoks* [Observation and Paradox]. Gyldendal. Copenhagen.
Luhmann, Niklas (2000). *Organisation und Entscheidung*. Westdeutscher Verlag. Opladen.
Luhmann, Niklas (2000a). *Die Politik der Gesellschaft*. Suhrkamp Verlag. Frankfurt.
Luhmann, Niklas (2000b). *Die Religion der Gesellschaft*. Suhrkamp Verlag. Frankfurt.
Luhmann, Niklas (2002). *Das Erziehungssystem der Gesellschaft*. Suhrkamp Verlag. Frankfurt.
Lyotard, Jean-François (1988). *The Differend. Phrases in Dispute*. University of Minnesota Press, Minneapolis [translated from *Le Différend*. Les Éditions de Minuit, Paris 1983].
Machlup, Fritz (1962). *The Production and Distribution of Knowledge in the United States*. Princeton University Press. Princeton, N.J.
Marx, Karl (1971). *Grundrisse der Kritik der politischen Ökonomie*. Europäische Verlagsanstalt. Frankfurt [manuscript finished 1857–58].
Mathiassen, Lars and Jan Stage (1997). "The Principle of Limited Reduction," in Mathiassen, Lars, *Reflective Systems Development*. Pp. 161–179. Department of Computer Science, Aalborg University. Aalborg.
McQuail, Denis (1975). *Communication*. Longman. London and New York.
McQuail, Denis and Sven Windahl (1993). *Communication Models for the Study of Mass Communication*. Longman. London and New York [first edition 1983].
Meyrowitz, Joshua (1985). *No Sense of Place. The Impact of Electronic Media on Social Behavior*. Oxford University Press. New York and Oxford.
Mortensen, David (1973). *Basic Readings in Communication Theory*. Harper & Row. New York.
Munson, Eve Stryker and Catherine A. Warren (eds.) (1997). *James Carey. A Critical Reader*. University of Minnesota Press. Minneapolis and London.
Negroponte, Nicholas (1995). *Being Digital*. Alfred A. Knopf.
Negrotti, Massimo (ed.) (1991). *Understanding the Artificial*. Springer Verlag. London.
Negrotti, Massimo (1993). *Per una teoria dell'artificiale*. Franco Angeli. Milano.
Panofsky, Erwin (1969). *Renaissance and Renascences in Western Art*. Harper & Row, New York.
Pico della Mirandola, Giovanni (1942). *De hominis dignitate*. Partly translated by Elizabeth Livermore Forbes in *Journal of the History of Ideas* 3 [first published 1486].
Pirenne, M. H. (1970). *Optics, Painting & Photography*. The Syndics of the Cambridge University Press. London.
Posner, Ronald (1989). "What Is Culture? Toward a Semiotic Explanation of Anthropological Concepts," in Walter A. Koch (ed.): *The Nature of Culture*. Brockmeyer. Bochum.
Price, Stuart (1996). *Communication Studies.* . Longman. London and New York.
Prigogine, Ilya and Isabelle Stengers (1979). *La Nouvelle Alliance. Métamorphose de la Science*. Editions Gallimard. Paris.
Ptolemy, Claudius (1989). *L'optique de Claude Ptolémée,* dans la version latine

d'après l'arabe de l'émir Eugène de Sicile, édition critique et éxégétique augmentée d'une traduction française et de compléments par Albert Lejeune, E. J. Brill, Leiden et al. With an "Introduction historique" by Albert Lejeune [first published c. A.D. 175].

Prusak, Laurence and Don Cohen (1998). "Knowledge Buyers, Sellers, and Brokers: The Political Economy of Knowledge," in Dale Neef, G. Anthony Siesfeld and Jacquelyn Cefola (eds.), *The Economic Impact of Knowledge*. Butterworth Heinemann. Boston et al.

Puglisi, Luigi Prestinenza (1999). *Architecture in the Electronic Age*. Birkhäuser. Biel-Benken.

Qvortrup, Lars (1998). *Det hyperkomplekse samfund. Fjorten fortællinger om informationssamfundet*. [The Hypercomplex Society. Fourteen Stories about the Information Society]. Gyldendal. Copenhagen.

Qvortrup, Lars (2000). *Det lærende samfund. Hyperkompleksitet og viden*. [The Learning Society. Hypercomplexity and Knowledge]. Gyldendal, Copenhagen.

Ramachandran, V. S. (1990). "Visual perception in people and machines," in Blake, A. and T. Troscianko (eds.) *AI and the Eye*. Wiley. Chichester. Pp. 21–77.

Ricardo, David (1971). *Principles of Political Economy and Taxation*. Penguin, London [first edition 1817].

Roberts, David (1999). "Wissenschaft und Kunst. Gedanken zur soziologischen Imagination bei Niklas Luhmann," in Theodor M. Bardmann und Dirk Baecker (eds.), *"Gibt es eigentlich den Berliner Zoo noch?" Erinnerungen an Niklas Luhmann*. UVK. Konstanz.

Schein, Edgar (1985). *Organizational Culture and Leadership*. Jossey-Bass. San Francisco.

Schramm, Wilbur (1954). *The Process and Effects of Mass Communication*. University of Illinois Press. Urbana.

Schwartz, Lillian (1995). "The Art Historian's Computer," in *Scientific American*, April.

Searle, John R. (1995). *The Construction of Social Reality*. Allen Lane. Harmondsworth.

Sereno, Kenneth E. and C. David Mortensen (eds.) (1970). *Foundations of Communication Theory*. Harper & Row. New York.

Shannon, Claude E. and Weaver, Warren (1964). *The Mathematical Theory of Communication*. University of Illinois Press. Urbana [first published 1948].

Simmel, Georg (1968). *Soziologie. Untersuchungen über die Formen der Vergesellschaftung*. Duncker & Humblot. Berlin [first published 1908].

Simon, Herbert A. (1997) *Administrative Behavior*. The Free Press. New York. [first published 1945].

Slevin, James (2000). *The Internet and Society*. Polity Press. Cambridge.

Sløk, Johannes (1957). *Tradition og nybrud. Pico della Mirandola*. Rosenkilde og Bagger. Copenhagen.

Smith, Adam (1976). *Wealth of Nations*. Clarendon Press. Oxford [first published 1776].

Tarski, Alfred (1944). "The Semantic Conception of Truth," in *Philosophy and Phenomenological Research* 4, pp. 341–375.

Teubner, Gunther (1989). "How the Law Thinks: Toward a Constructivist Epistemology of Law," in *Law and Society Review* 23. Pp. 727–757.

Thompson, John B. (1995). *The Media and Modernity. A Social Theory of the Media.* Polity Press. Cambridge.
Toffler, Alvin (1980). *The Third Wave.* William Morrow and Company. New York.
Tomlinson, J. (1991). *Cultural Imperialism.* Pinter Publishers. London.
Tunstall, J. (1977). *The Media are American.* Constable. London.
Tække, Jesper (2002). "Cyberspace as a Space Parallel to Geographical Space," in Lars Qvortrup (ed.), *Virtual Space: The Spatiality of Virtual Inhabited 3d Worlds.* Springer Publishers. London.
Virilio, Paul (1989). *La machine de vision.* Editions Galilée. Paris.
Virilio, Paul (1996). *Cybermonde, la politique du pire.* Textuel. Paris.
Watzlawick, Paul and J. H. Beavin (1967). "Some Formal Aspects of Communication," in *American Behavioral Scientist*, vol. 10 (8).
Watzlawick, Paul, J. H. Beavin and D. D. Jackson (1967). *Pragmatics of Human Communication.* Faber and Faber. London.
Weaver, Warren (1947). "Science and Complexity," in Warren Weaver (ed.). *The Scientists Speak.* New York.
White, John (1967). *The Birth and Rebirth of Pictorial Space.* London [first edition 1957].
Wibroe, Mads, K. K. Nygaard and P. B. Andersen: "Games and Stories." In: Lars Qvortrup (ed.): *Virtual Interaction: Interaction in Virtual Inhabited 3D Worlds.* Springer, London et al. 2001.
Williams, Raymond (1981). *Culture.* Fontana, London.
Williams, Raymond (1993). *Culture and Society.* Hogarth Press. London [first edition 1958].
Willis, Paul (1977). *Learning to Labour: How Working Class Kids Get Working Class Jobs.* Columbia University Press. New York.
Wolf, Robert Erich and Ronald Millen (1968). *Renaissance and Mannerist Art.* Harry N. Abrams. New York and London.
Zahavi, Dan (1997). *Husserls fænomenologi* [Hussserl's phenomenology]. Gyldendal. Copenhagen.
Zhai, Philip (1998). *Get Real. A Philosophical Adventure in Virtual Reality.* Rowman & Littlefield Publishers. Lanham, Md.

Index

page references appearing in italics refer to illustration captions

Aarseth, E., 71
adhocracy, 185
Administrative Behavior (Simon), 41, 186
Adorno, T. W., 64, 70
aesthetic reason, 17
Aesthetic Theory (Adorno), 64
al-Haytham, I., 96, 97
Alberti, L. B., 53, 62, 63, 66, 67, 68, 98
Algamest (Ptolemy), 94, 95, 96
Altzeit, viii, 6
Andersen, P. B., 176, 177, 178, 181
anthropocentric society, 13
anthropocentrism, 7, 9, 11, 15, 23, 27, 36, 50, 100, 101, 120, 207
 art forms, 87–88
 crisis of, 88–89
 to polycentrism, 63–75
 to theocentrism, 52–54
 Also see polycentrism, theocentrism
anthropology, 33
appreciation, 208
Aristotelian physics, 94
ARPANET, 175
Ars Electronica festival, 78
art
 and beauty, 66, 88, 90
 as a closed system, 50
 differentiation and self-reference of, 62–63
 function of, 68
 and the human being, 60–61
 as intervention, 63
 linear perspective in, 54, 60, 73, 88, 98
 to cybertext, 90
 interactive multimedia art, 75–85
 observing the world, 52–54
 "unnaturalness of contemporary art, 63–65
astronomy, 100
Augustine, 115
Averroës, 96

Bach, J. S., 121
Bacon, R., 97
Baecker, D., 160, 181, 204, 205, 206, 207
Bak, P., ix, 141
Bangemann report, 164
Bar, F., 176
Bateson, G., 8, 85, 109, 137, 139, 144
Baudrillard, J., 155, 163, 166
beauty, 66, 88, 90, 117
Baecker, D., 113
Beavin, J. H., 60, 132, 134, 140
Beck, U., 3, 8
Beckett, S., 70
Beiträge zur Grundlegung einer operationsfähigen Dialektik (Günther), 106
Bell, D., vii, 3, 40, 42, 101, 106, 168, 169, 193

Benayoun, M., 82, 85
Berg, A., 70
Berners-Lee, T., 180
Bildung, 200
blind interaction, 133
bounded rationality, 5, 13, 41, 104, 105, 185–88
Brahe, T., 99
Brecht, B., 78
Bridging the Gap conference, vii
Brown, G. S., 7, 68, 112–15, 121, 141, 181, 205, 206, 208
browsers, 182
Brunelleschi, F., 53, 97
Bruno, G., 31
Burns, T., 133
Bush, G. W., 152

calculated risk, 11
Carey, J., 125, 126, 134
Cartesian Meditations (Husserl), 16
Cassirer, E., 26, 202, 203
Castells, M., 3, 166, 167
causa proxima, 27
causa universalis, 27
center-periphery differentiation, 171
characteristica universalis, 9, 13
Christiansen, A. D., 80
Church of Our Lady (Kritsa, Crete), 54
Clinton, B., 152
cohesion, 192
Coming of the Post-Industrial Society, The (Bell), vii, 101, 168
communication, 139–40
 according to Kierkegaard, 134–137
 asymmetry of, 140–42
 as double contingency, 132–34
 as selection, 142–44
 as transmission, 126–29
communication media, 144–45
communication theory
 changes in, 129
 communicatio, 137–39
complex simplicity, 101
complexity, 36, 38
 complexity of, 48–49, 101–105
 and the family, 46–48
 hidden problems of, 8–10

 problem of, 10, 13
 reduction, 188
 technology for the management of, 45–46
 theory of, 3–4, 5
Configuring the Cave (Shaw), 82
contrat social, 15
Copernicus, N., 31, 94, 95, 96, 99
Creating the Superhighways of the Future: Developing Broadband Communications in Britain, 164
Critical Review of Concepts and Definitions (Kroeber and Kluckhohn), 198
Critique of Judgment (Kant), 65, 66, 67, 200
Cultural Contradictions of Capitalism, The (Bell), vii
cultural semiotics, 198
culture
 definition of, 196, 197
 and God, 201–2
 inflation in, 191
 as a meaning-bearing and meaning-creating system, 196–97
 mental, 195
 concept of, 193–94, 202
 history of concept, 205–9
 as second-order conditionalizer, 204
 theory of, 194–95, 197–98
 vanishing concept of, 202–4
Culture and Society (Williams), 194, 197
cyberkinetics, 102
cybernetics, 109

da Vinci, L., 25, 53, 54, 57, 58, 61–62, 100
Das Kapital (Marx), 32
Dahrendorf, R., 119
De revolutionibus (Copernicus), 94, 96
de Tocqueville, A., 158
Dehlholm, K., 69
del Bondone, G., 54, 55, 56
del Castagno, A., 54, 55, 61
decentralization of decision-making, 207
Deleuze, G., 84
Della Pittura (Alberti), 53, 62, 98
deparadoxicalization, 120

Dertouzos, M., 3, 9, 38, 165
dialectical materialism, 5
Die Gesellschaft der Gesellschaft (Luhmann), 34, 35, 93
Die Realität der Massenmedien (Luhmann), 151
digital
 challenge of digital complexity, 169
 intimate community, 38
 perspectives, 76
 tribes, 172
Dinesen, T. B., 80
Discours sur les sciences et les arts (Rousseau), 206
dissemination media, 145
dissipative structures, 41
Dobson, S., ix
double contingency, 140
dromology, 37
Duchamp, M., 75, 79, 121
Duguet, A.-M., 78, 79
Dürer, A., 98
Durkheim, E., 33, 106

Eco, U., 130
effect media, 145
eigenvalue, 103
Elements (Euclid), 112
Elias, N., 199
Elkins, J., 98
Éluard, Madame N., 73
"elusive office," 184
End of Millennium (Castells), 3
Enzensberger, H.-M., 12, 34
epistemes, 6, 22
Erasmus, 31
ergodic literature, 71
Euclid, 112
Eugenius, General, 95
Europe and the global information society, 164
evolution, 21
exchange value, 39

family
 and complexity, 46–48
Ferry, L., 28
Fibre Wave II (Watanabe), 77

Ficino, 28, 29
first-order cybernetics, 14, 105, 106
flexibility, organizational, 189
focused interaction, 133
Foerster, H. von, 7, 103, 105, 106
Forbes, E. L., 24
Ford, H., 43
Ford Motor Company, 43
form-observation, 51
Fortuna, R., 69
Foucault, M., viii, 6, 22
foundational semantic, 22
freedom, 27, 28, 29, 119
frictionless capitalism, 38, 131
Fuchs, P., 141
functional differentiation, 171

Gates, B., viii, 3, 9, 38, 131
Gemeinschaft, 174
Geschicklichkeit, 200
Gesellschaftsstruktur and Semantik (Luhmann), 21, 203
Giddens, A., 197
Gingerich, J., 94, 95, 96, 99
global information marketplace, 174
global village, 172, 174
Goffman, E., 133, 134
Golden Calf, The (Shaw), 78, 79
good, 28
Grayson, C., 98
Günther, G., 7, 86, 106, 107, 108, 109

Habermas, J., viii, 3, 17, 106, 120, 131, 141, 143, 157–58
Haralambos, M., 201
Hart, J. A., 176
Hegel, G. W. F., 158, 175, 204
heliocentric cosmology, 96
hermeneutic circle, 80
Hill, G., 79
Hiltz, S. R., 184
Hjelmslev, L., 109, 110
Hobbes, T., 131, 193, 201
Holborn, M., 201
Hotel Pro Forma, 69, 72, 73, 75
House of the Double Axe, The (Hotel Pro Forma), 69
How Nature Works (Bak), ix

230 The Hypercomplex Society

human principle, 36
Husserl, E., 7, 16, 33, 75, 89, 106, 107
Huws, U., 184
hypercomplex society, viii, 3, 6–8, 34, 35
 and art, 72
 culture of the, 191, 204
 definition of, 6, 117
 and the digital network, 163
 hypothesis of, 10–14
 practical self-observation of, 21
 pure self-observation of, 92
 self-description of, 117
hypercomplexity, viii, 34–35
 challenge of bounded rationality, 185–88
 definition of (Luhmann), 35
 epistemological transformation, 100–105
 hypothesis of, 3
 and modernity, 22, 32–39
 controversy over, 37–39
 paradigm of, 14
hypertext link, 180
hypertext markup language (HTML), 180
hypertext transfer protocol (HTTP), 180

Ideen zu einer allgemeinen Geschichte in weltbürgerlicher Absicht (Kant), 200
immersion, 76, 83–85
Impressionism, 73, 75, 86, 88
 general message of, 89
inclusion, 187
information society, 8, 14, 33
information theory, 109
Innocent VIII, Pope, 26
interaction, 133
InterCommunication Center (Tokyo), 77
intellectual technology, 45
intelligent agents, 182
interaction, 76, 79–83
interactive multimedia art. *See* art
Internet, viii, 17, 37, 71, 118, 174, 175–77
 as a communication medium, 173
 as a complexity-management medium, 166–68

 organization of, 182–83
 organizations of, 183–85
 statistics about, 176
 Also see World Wide Web
Internet Galaxy, The (Castells), 167

Jackson, D. D., 60, 132
Johnson, W. R., 164
Jones, S. G., 174
Joyce, J., 70

Kant, I., 7, 15, 16, 65, 66, 70, 106, 119, 140, 158, 200, 201, 206
Kantian epistemology, 16
Kauffman, L. H., 181
Kemp, M., 58, 98
Kierkegaard, S., 24, 30, 63, 134–37, 138, 143
Kitab al-Manazir (al-Haytham), 96
Kluckhohn, C., 198
knowledge economy, 40
Korte, W. B., 184
Kroeber, A. L., 1998
Kubovy, M., 58, 98
Kuhn, T. S., 99, 100, 146
Kølsen de Wit, C. I., 203

La machine de vision (Virilio), 53
La Trinità (Masaccio), 64, 72, 98
Le tunnel sous l'Atlantique (Benayoun), 83
Laing, A., 185
Laplace, P. S., 31, 115
Latour, B., 70, 71
Last Supper (da Vinci), 25, 53, 61, 100
Last Supper (Tintoretto), 59
Laswell, H., 17, 128
Latour, B., 126
Laws of Form (Russell), 112, 113, 181
leadership, 42, 43
Legible City, The (Shaw), 82
Leibniz, G. W., 9, 13
Leinz, G., 56
Lejeune, A., 95
Les Règles de la méthode sociologique (Durkheim), 33
Lewinsky, M., 152
Ligeti, G., 70

linear perspective. *See* art
local digital community, 9
Luhmann, N., viii, 5, 6, 7, 11, 16, 21, 22, 35, 37, 41, 68, 86, 92, 103, 104, 111, 112, 113, 116, 117, 120, 121, 137, 138, 139, 141, 147, 152, 154, 156, 169, 170, 171, 174, 176, 178, 201, 202, 203, 205, 206, 208
 autopoietic systems, 50
 concept of culture, 193–94
 on differentiation, 119
 on communication media, 177
 double contingency, 139
 episodes of societal process, 93
 function of language, 71
 judgment of taste, 67
 on meaning, 140
 medium and form, 144
 secondary complexity structures, 167
 social and organizational behavior, 188, 189
 and sociology, 34
 theory of mass media, 151–55
 transcendental illusion, 126
Lukacs, G., 192
Luther, M., 31

Machiavelli, N., 31
Machlup, F., 40
Manetti, A., 98
Marx, K., viii, 3, 10, 24, 32
Masaccio, 64, 72
mass attraction, theory of, 99
mass media, 125, 151–55, 161, 162, 178
 function of, 153
 "irritation," 153
 ritual view, 125
 transmission view, 125
material culture
Mathiassen, L., 187
Maturana, H., 103
McLuhen, M., 174
meaning, 110, 140, 170, 196
 three dimensions of, 22
memory, 204
mental culture, 195, 198
Meyrowitz, J., 165, 170, 173, 174

Mill, J. S., 158
Millen, R., 59
Mirandola, G. P. della, 15, 24, 52
modernity, 22
 and hypercomplexity, 32–39
 controversy over, 37–39
 traditional society and, 23
Monet, C., 36, 89
Monkey Business Class (Hotel Pro Forma), 72
Mørkøv Church (Denmark), 54
Mumson, E. S., 125

Nasjonalt Informasjonsnettverk, 164
National Information Infrastructure: An Agenda for Action, 163
necessity, 119
Negroponte, N., 3, 9, 38
Neuzeit, viii, 6
Newton, I., 99
Nietzsche, F., 192
No Sense of Place (Meyrowitz), 165
Nørgaard, P., 70
Nygaard, 82

observation optics, 15
Observing Systems (von Foerster), 103
On Free Will (Erasmus), 31
Oncotype, 80
optic theory, 96–97
Optics (Ptolemy), 95
Oratio (Pico), 26
organizations, 188
organized complexity, 101, 103, 104
other, 114

Panofsky, E., 63
paradoxicality, 120
Parsons, T., 134, 139, 169
Pascal, B., 15, 23, 37
Pecham, J., 97
Petrarch, 28
Philosophie der symbolischen Formen (Cassirer), 202
Piaget, J., 60
Picasso, P., 73, 74, 75
Pico, 25, 26, 27, 28, 30
Plato, 15, 28

polycentrism, 7, 15, 16, 21, 23, 35–37, 50, 207
 and anthropocentrism, 63–75
 art forms, 89–91
 epistemology of, 65–72
 observing, 72–75
 Also see anthropocentrism, theocentrism
polycontextual observation, 16, 105, 107
polylogy, 120
Portrait of Nusch Éluard (Picasso), 74
positivism, 13
Posner, R., 198
Power of Identity, The (Castells), 3
practical reason, 17
Pragmatics of Human Communication (Watzlawick), 132
Prigogine, I., 32, 41, 71, 115
Prince, The (Machiavelli), 31
Principia mathematica (Whitehead and Russell), 112
Production and Distribution of Knowledge in the United States, The (Machlup), 40
projection, 76–79
Ptolemy, 94, 95, 96, 99
public opinion, 155
public sphere, 158
publicity, 155–56
 boundary, 156
 definition of, 159
 observation principle, 156
Pufendorf, S. von, 205
pure reason, 17, 92

Quesnay, F., 32, 39
Qvortrup, L., 34, 69, 86

Rafael, 64
Ramachandran, V. S., 60
rational/rationality, 28, 38
rational philosophy, 5
Recoil (Oncotype), 80, 81, 82
Reden und Schweigen (Fuchs), 141
Reed, R. R., 176
reentry, 186
Reforms Towards the Intellectually Creative Society of the Twenty-first Century, 164
Rheingold, H., 165
Ricardo, D., 3, 32, 39
Rise of the Network Society, The (Castells), 3
risk, calculated, 11
risk production, 188
risk society, 8
ritual view of mass media, 125
Road Ahead, The (Gates), 3
Roberts, D., 68
Robinson, S., 184
Rorty, R., 208
Rousseau, J. J., 15, 31, 194, 206
Russell, B., 112, 115

Sabra, 97
Schjødt, M., 80
Schleiermacher, F., 80
Schein, E., 197
Schönberg, A., 70
Schramm, W., 130
Schwartz, L., 58
science
 classical and transclassical, 108
 cultural influence on, 98–100
 modernity of, 30
 scientific socialism, 5
Search for the Perfect Language, The (Eco), 130
second-order complexity, 6, 14
second-order cybernetics, 5, 14, 102, 103, 106
second-order observation 29
segmentary differentiation, 170
self, 30
self-improvement, 199
self-organized criticality, 141
self reflection, 105
Sentinal Trust for Creative Education, 112
Shannon, C. E., 8, 103, 130
Shaw, J., 78, 79, 82
Sickness Unto Death, The (Kierkegaard), 30
Simmel, G., 106, 201
Simon, H. A., 4, 5, 13, 41, 104, 118, 185, 186, 188

Slevin, J., 176
Sløk, J., 28
Smith, A., viii, 32, 39, 194
social culture, 198
social differentiation, 170, 171
society
 definition of, 159
 epistemological transformation of, 94–86
 functional differentiation of, 29–32
 semantics of, 93
 and social structure, 94
sociology, 33
Sociology (Giddens), 197
Soziologie (Simmel), 201
Soziale Systeme (Luhmann), 35
space, 31
Stage, J., 187
Stengers, I., 32, 115
stratified differentiation, 171
Strukturwandel der Öffentlichkeit. Untersuchungen zu einer Kategorie der bürgerlichen Gesellschaft (Habermas), 157
symbolically generalized media, 145, 146
 code, 146
 contingency formulae, 147
 dogmatizations, 147
 forms of resonance, 148
 program, 146–47
 secondary codes, 147
symbiotic mechanisms, 147
system references, 148
Système du monde (Laplace), 32

Tableau economique (Quesney), 32
Tall Ships (Hill), 79
Tauglichkeit, 200
TCP/IP, 179, 190
Telecommunications Policy, 175
Teubner, G., 6
Theil, P., 69
theocentrism, 11, 14, 15, 23, 27, 50, 100, 207
 art forms, 87
 Also see anthropocentrism, polycentrism

Thillemann, P., 80
time, paradox of, 118
Tintoretto, J., 54, 59
Toffler, A., 3
Tomlinson, J., 197
Tönnies, F., 165, 174
totalizing world systems, 31
transcendental philosophy, 33
transclassical rationality, 107
transmission
 communication as, 126–29
 view of mass media, 125
transport model
 implicit assumptions, 129–31
 objections to, 131–32
transport paradigm, 127
Tunstall, J., 197
Tække, J., 173

Über den Prozess der Zivilisation (Elias), 199
Übermensch, 192
uncertainty, 21
understanding control, 172
United States Department of Commerce, 176
universal resource identifiers (URI), 180
University of Illinois, 106
University of Southern Denmark, 183
unlimited rationality, 13
use value, 39

value
 exchange, 39
 labor theory of, 39
 use, 39
Varela, F., 103
Verfremdung, 78
Vertrauen (Luhmann), 188
Vingar åt Människans förmåga, 164
Virilio, P., 3, 37, 38, 53
Vision of an Intelligent Island, A, 163

Warren, C. A. 125
Watanabe, M. S., 77
Watzlawick, P., 60, 132, 134, 139, 140, 143

Wealth of Nations (Smith), 39
Weaver, W., 8, 101, 103, 104, 106, 107, 127, 130
What Will Be (Dertouzos), 9
White, J., 55, 98
Whitehead, A. N., 115
Wibroe, M., 82
Wiener, N., 5, 102, 103
Williams, R., 194, 195, 196, 197, 199
 four aspects of culture, 194–95
Willis, P., 201

Witelo, 97
Wohlgefallen, 65
Wolf, R. E., 59
World Wide Web (WWW), 177–82
 Also see Internet
Wozu Kultur? (Baecker), 205

Yeltsin, B., 152

Zahavi, D., 33
Zhai, P., 176

Digital Formations

General Editor: Steve Jones

Digital Formations is the new source for critical, well-written books about digital technologies and modern life. Books in this series will break new ground by emphasizing multiple methodological and theoretical approaches to deeply probe the formation and reformation of lived experience as it is refracted through digital interaction. Each volume in *Digital Formations* will push forward our understanding of the intersections—and corresponding implications—between the digital technologies and everyday life. This series will examine broad issues in realms such as digital culture, electronic commerce, law, politics and governance, gender, the Internet, race, art, health and medicine, and education. The series will emphasize critical studies in the context of emergent and existing digital technologies.

For additional information about this series or for the submission of manuscripts, please contact:

 Acquisitions Department
 Peter Lang Publishing
 275 Seventh Avenue 28th Floor
 New York, NY 10001

To order other books in this series, please contact our Customer Service Department:

 (800) 770-LANG (within the U.S.)
 (212) 647-7706 (outside the U.S.)
 (212) 647-7707 FAX

or browse online by series:
 WWW.PETERLANGUSA.COM